Royal Hertfordshire
MURDERS AND
MISDEMEANOURS

Royal Hertfordshire
MURDERS AND MISDEMEANOURS

Pamela Shields

AMBERLEY

With thanks to my family, Jeff and Steve Shields and friends,
Mark Playle and Hanae and Marac Kolodzinski.

First published 2010

Amberley Publishing
Cirencester Road, Chalford,
Stroud, Gloucestershire, GL6 8PE

www.amberleybooks.com

British Library Cataloguing in Publication Data.
A catalogue record for this book is available from the British Library.

ISBN 978 1 84868 313 6

Typesetting and Origination by Amberley Publishing.
Printed in Great Britain.

CONTENTS

ABOUT THE AUTHOR

Pamela Shields, a journalist, lives in Hitchin, Hertfordshire. She has run courses and given talks on her books all over the county. Before becoming a full time writer she earned a crust as an art teacher, a tutor in theatre administration, a tour guide in London and Paris, tutored the Guiding for Tourists Course at City University London and as a Press Officer for The Prince's Trust. www.scribbling4bread.wordpress.com.

OTHER BOOKS BY PAMELA SHIELDS

Hertfordshire Secrets & Spies
The Private Lives of Hertfordsire Writers
Hertfordshire A-Z
The Little Book of Hitchin
Essential Islington: From Boadicea to Blair
Islington: The First 2000 Years

www.pamela-shields.co.uk

BIBLIOGRAPHY

Bennett, Michael *The Battle of Bosworth* Sutton 1999

Carpenter, Edward & Gentleman, David *Westminster Abbey* Weidenfeld & Nicolson 1987

Carr, Wesley *Westminster Abbey* Jarrold Publishing 1987

Cathcart, Helen *The Queen Mother Herself* Hamlyn 1980

Coulton, G. C. *Chaucer and his England* Methuen 1968

Earle, Peter *Henry V* Weidenfled & Nicholson 1972

Field, Ophelia *The Favourite: Sarah Duchess of Marlborough* Sceptre 2002

Griffiths, Ralph A. & Thomas, Roger S. *The Making of the Tudor Dynasty* Sutton 2005

Haswell, Jock *The Ardent Queen: Margaret of Anjou* Peter Davies 1976

Hickman, Katie *Daughters of Britannia* Flamingo 2000

Hilliam, David *Kings, Queens, Bones & Bastards* Sutton 2004

Jones, Terry *Who Murdered Chaucer?* Methuen 2003

Kelsall, Jane *Humphrey Duke of Gloucester* pub by Friends of St Albans Abbey

Lindsay, Jack *Nine Days Hero Wat Tyler* Dobson Books 1964

Luke, Mary M. *Catherine The Queen* Frederick Muller 1967

Meade, Marion *Eleanor of Aquitaine* Phoenix 2001

Moore, Wendy *Wedlock: How Georgian Britain's Worst Husband Met His Match* Phoenix 2009

Mortimer, Ian *The Time Traveller's Guide to Medieval England: A Handbook for Visitors to the Fourteenth Century* Vintage 2009

Murphy, Beverley A. *Bastard Prince; Henry VIII's Lost Son* Sutton 2003

Oxford Dictionary of National Biography

Parker, Derek *The Trampled Wife; The Scandalous Life of Mary Eleanor Bowes* Sutton 2006

Plowden, Alison *The House of Tudor* Sutton 2003

Plowden, Alison *The Stuart Princesses* Sutton 1996

Plowden *The Young Elizabeth* Sutton 2001

Ridley, Jasper *Cardinal Wolsey, Sir Thomas More and the Politics of Henry VIII* Viking Press New York 1983

Ridley, Jasper *Elizabeth I* Constable 1987

Ridley, Jasper *Lord Palmerston* Panther 1972

Roberts, Eileen *The Wall Paintings of St. Albans Abbey* published by Friends of St Albans Abbey

Saaler, Mary *Edward II* Rubicon 1997

Seymour, William *Battles In Britain 1066-1547* Book Club Associates 1975

Somerset, Anne *Elizabeth I* Phoenix 1997

Victoria County History: Hertfordshire

Weir, Alison *Elizabeth the Queen* Jonathan Cape 1998

Weir, Alison *Katherine Swynford The Story of John of Gaunt and his Scandalous Mistress* Vintage 2008

Weir, Alison *Isabella She-Wolf of France Queen of England* Jonathan Cape 2005

Whitmore, Richard *Hertfordshire's Queen,* Countryside Books 1997

ACKNOWLEDGEMENTS

Thanks must go first to Sarah Flight of Amberley Publishing for commissioning this book in the first place. What I know about photography you could spit into a gnat's eye so I am equally grateful to the stalwarts who provided the photographs without whom there would be no book. Special thanks to special friends Hanae and Marac Kolodzinski www.marack.net; Mark Playle www.playlephotography.co.uk for their dedication and commitment to the project, Ian Pearce BBC Three Counties Radio and my son Jeff Shields.

My thanks also to: Brenda Frayne, County Art Administrator, Hertfordshire County Council; Christine Reynolds, Assistant Keeper of Muniments, www.westminster-abbey.org; Cristina Harrison, Curator, Much Hadham Forge Museum; David Thorold, Keeper of Archaeology, Verulamium Museum, St. Albans Derry Nairn, *History Today* Magazine; Frances Valentine, Hertford Town & Tourist Information Centre, Hayley Lewis, Marketing and Visitor Officer, Cathedral and Abbey Church of St Alban; Helena Price Hertford Town & Tourist Information Centre; Hertfordshire Archives and Local Studies (HALS) County Hall Hertford, Jenny Sherwood, Chairman, Berkhamsted Local History & Museum Society, Jeremy Smith Rudolf Steiner School Kings Langley, (Dr) Jill Barber, Head, Heritage Services Archives and Local Studies County Hall Hertford, Joe Carruna, Mace Bearer, Julia Low, Senior Guide, Cathedral and Abbey Church of St Alban; Julia Swan NADFAS Guide Moor Park Rickmansworth, Lord and Lady Bowes-Lyon of St Pauls Waldenbury; Mandy Challis, Marketing & Promotions Manager Hertford Town Council; Miriam Juviler Marketing Manager Tring Park School for the Performing Arts; Neil Robbins, Curator, Lowewood Museum, Hoddesdon; Philip Sheail, Guide, Hertford Castle and Simon Heffer, Associate Editor, *Daily Telegraph* (*Like the Roman: The Life of Enoch Powell*).

Introduction

This book is not about royalty *per se*, it's about the part the county of Hertfordshire has played in the lives of many monarchs (those with little or no connection to the county are not included).

England's throne has been occupied by Cassivelaunus (a Belgian Celt) Alfred the Great and his son Edward the Elder (German Anglo-Saxon) Canute (a Scandinavian – as was his descendant Harold I). William I was the first of sixteen French Kings. Ousted by the Welsh Tudors, they were succeeded by the Scottish Stuarts who in turn were succeeded once more by Germans (Hanoverians).

It's anyone's guess where the first inhabitants of England – Angle Land – came from. When Julius Caesar conquered Gaul (roughly present-day Belgium) it was inhabited by the Belgae, a Celtic tribe. Their language, Brythonic, the oldest in Europe (present day Welsh) originated along the banks of the Danube. Those who objected to being subjugated crossed the channel and found refuge in what we now call Britain and were absorbed into the indigenous culture. Because of their language they were known as Brythons (where we get Britain from). The Brythonic language survived the Roman invasion of AD 43 when we were colonised as part of the Roman Empire. For four hundred years we were, for want of a better word, Italians.

When the Romans left, in came the Angles from Denmark and Saxons from Germany. Germans settled in the south, East Saxony (Essex) Middle Saxony (Middlesex) South Saxony (Sussex) and West Saxony (Wessex). Angles in the north called their bit Angle Land (England). When Anglo Saxons fought the Danes, Offa, King of Denmark and Norway won.

If a monarch was born in England does that make him English? Does s/he think of themselves as English? Henry I, who was born here, did. On the other hand, Richard I who was also born here was not the least bit interested in England. Edward III, fiercely patriotic, also styled himself King of France.

Many of our monarchs were not born to rule but were destined to do so because the first-born son died young (Richard I, Edward II, Richard II, Henry VIII, Charles I, George VI). Others committed regicide to get there (Henry I, Henry IV, Edward IV, Richard III, Henry VII). As for right over might, in the case of William I and his son Henry I, might. The rightful successor to Richard II was Roger Mortimer so neither Henry IV, a regicide, his son Henry V, nor his grandson Henry VI had much right. Edward IV, another regicide, who took the crown from Henry VI, was illegitimate. The Plantagenet dynasty was jaw droppingly brutal. Brother betrayed brother, sons betrayed fathers, wives betrayed husbands, mothers betrayed sons.

St Albans Abbey played an important part in the lives of many royals. Its chroniclers often had personal axes to grind. Matthew Paris in particular was waspish about royals he disliked. In a class of his own, he was not subservient to royalty or to Rome. The world came to his door, just a day's ride from London. The Abbey was peopled by rich, educated, worldly, aristocrats. Until Henry VIII did his dastardly deed it had an unbroken tradition of chronicling events as they happened. Other famous monk historians included Roger of Wendover and Thomas Walsingham. The Abbott was used to entertaining grandees. Henry III stayed at the Abbey on prolonged visits at least nine times and Henry VI loved it there.

Hertfordshire saw uprisings against the Crown in the Barons wars against King John, the Peasants' Revolt against Richard II, the Wars of the Roses against Henry VI and from warring factions on both sides of the English Civil War.

Thanks to the wonders of modern technology, Google Earth now allows us to see precisely where the places mentioned in the book are located.

1

CASSIVELAUNUS *v.* JULIUS CAESAR: WHEATHAMPSTEAD

Who, in Britain, in their right mind, would take on the mighty Julius Caesar of Rome? A chap from Wheathampstead, that's who. Schoolchildren in Wales are taught – or were – that Cassivelaunus is a Welsh hero. In England, outside Wheathampstead, few have heard of him.

It's weird visiting Wheathampstead today knowing that in 54 BC this was the HQ of the Catuvellauni, a savage, indigenous, successful, Celtic tribe, the largest in Britain. Catuvellauni is Brythonic – Welsh – for 'expert warrior'. The huge earthworks, known locally as the Devil's Dyke are the remains of their capital.

At least, we think it is. When Julius Caesar wrote about his Gallic Wars he said it was a stronghold north of the Thames near the capital town of Cassivellaunus: 'Now the Britons, when they have fortified the intricate woods in which they are wont to assemble for the purpose of avoiding the incursion of an enemy with an entrenchment and a rampart, call them a town'. Evidence for a tribe here was found by eminent archaeologist, Sir Mortimer Wheeler in the 1930s. A few of his finds are in Verulamium Museum, St. Albans.

In the old days, long after its past was forgotten, locals were mystified as to who dug the huge ditch. They concluded it could have only been the devil hence Devil's Dyke. One plaque in Devil's Dyke reads:

This Entrenchment is part of a British City built in the 1ˢᵗ century BC.
It was probably here that Julius Caesar defeated the British King Cassivellaunus in 54BC

Another says:

The Devil's Dyke was presented by The Rt. Hon. Lord Brocket to commemorate the
coronation of their Majesties King George VI
and Queen Elizabeth 12 May 1937.

The Devil's Dyke, Wheathampstead © MAK

Brocket was not right honourable. Two years later on 20 April 1939 he was in Germany as Hitler's personal guest at his fiftieth birthday party. He held Nazi meetings at Brocket Hall where von Ribbentrop Hitler's foreign minister had his own bedroom. Brocket was a virulent anti-Semite. His pro-Nazi views resulted in his internment on the Isle of Man during the war. Charles Cain, a brewer, the first so called Lord Brocket bought his title from Lloyd George. He added a Nall to his name when he married becoming pseudo double-barrelled Nall-Cain but his story belongs in another book.

Julius Caesar, the Roman Empire's greatest general, was furious when defeated tribes in Gaul made a fool of him by crossing the Channel to find sanctuary here among the Brythons. His ingenious solution was to make Britain part of his Roman Empire. Sorted.

Caesar's Report to the Senate described 'Cassivelaun' as the head of the British Empire, an adversary whose conquest was a huge achievement. To defeat a mere local tribesman would not have impressed 'Friends, Romans and Countrymen' back home, he had to portray him as a worthy opponent as indeed he was considering he headed a cobbled together Dad's Army against the most formidable fighting force in the world and masterminded his attack from an Iron Age settlement of mud and wattle huts in Wheathampstead. If royalty means a line of succession, Cassivelaunus was royalty until his tribe threw in their lot with the Romans in AD 43.

In 55 BC with 10,000 soldiers under his personal command Caesar crossed the Channel from Boulogne. Some sources say the Brythons sought a truce, others that Caesar left after being harassed, still others that his invasion was a damp squib because,

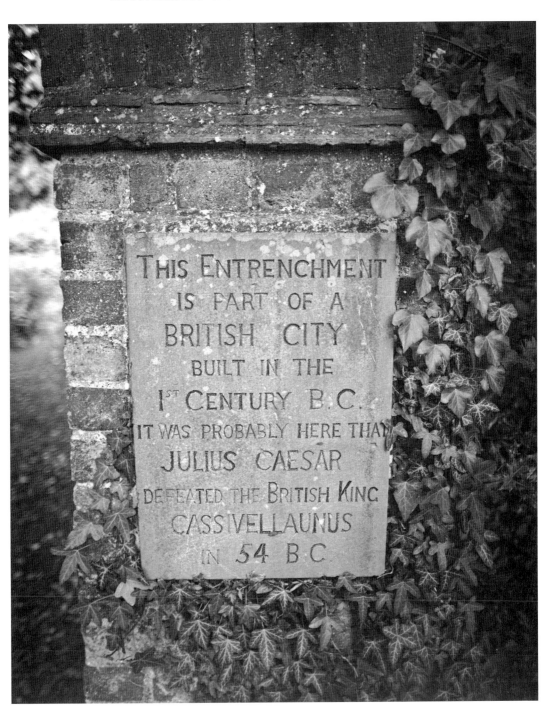

Plaque (i) Devil's Dyke © Mark Playle

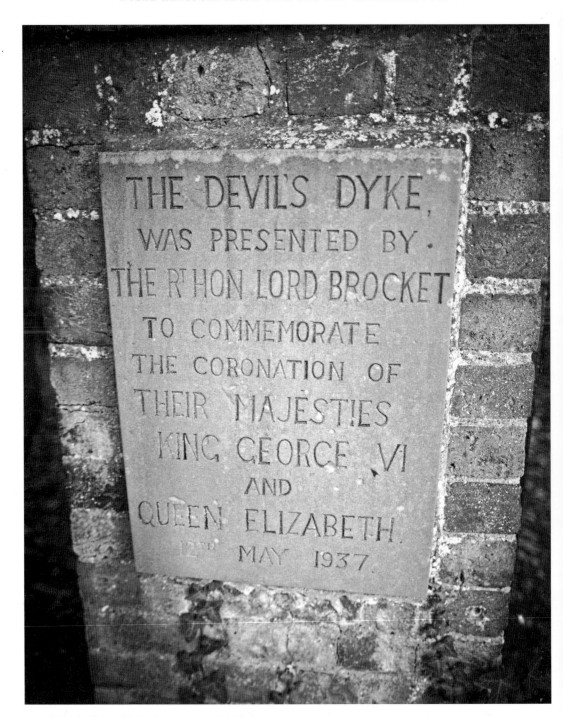

Plaque (ii) Devil's Dyke © Mark Playle

brought up in the tideless Mediterranean, our tides were a mystery to him. Unable to get ships to shore he couldn't land enough soldiers to secure the country. Few Roman soldiers could swim and many were terrified of water.

Whatever the truth, Caesar went home. He had, nevertheless, put the wind up the Trinovantes tribe in Kent who sent envoys to Rome to ensure they would be well treated should he come back. They wanted Mandubracius, their King in exile, home, but were, justifiably, nervous for his safety because Cassivellaunus had assassinated the boy's father. They promised to help Caesar defeat him if he protected the lad. Caesar agreed, sent him back with the envoys and won the loyalty of tribes in south and west Britain.

Caesar had also put the wind up Cassi Vellaunus (Vellaunus of the Cassi tribe). Knowing Caesar would return he was elected King of the Catuvellauni a powerful federation of Brythonic tribes who occupied what is now London, Bedford, Buckingham, Cambridge, Oxford, Northampton and Hertfordshire where there were settlements near Redbourn, Baldock, Bishops Stortford, Braughing and Welwyn. He was put in command of a large army, a sort of TA, raised specifically to resist Caesar.

The next year, 54 BC, Caesar was back. This time with a guarantee of local back up he had 30,000 troops and 800 ships built to a new design to cope with British tidal waters. He set sail from Boulogne on the 6th of July and landed unopposed in Kent the next day.

Cassivellaunus attacked his outposts but was driven back to present day Brentford. He had stakes driven into the river bed but when he saw the size of the Roman army on the bank opposite he retreated inland. Caesar followed him to the Stour where Cassivellaunus was waiting for him this time with chariots – two horses pulling a driver and a warrior in the rear hurling javelins. Although Caesar in his Report derided the use of chariots in warfare as out dated he didn't say how effective they were against his infantry. The sight of four thousand chariots and eight thousand horses thundering towards you must be a terrifying sight. Caesar's Commentaries on the Gallic Wars are the first written description of the country known to the Romans for 400 years as Britannia.

Cassivellaunus' army was amateur. Cobbled together in a hurry it suffered from lack of training. He found it impossible to control his men against such a formidable, professional army. Caesar's army was not part of the Roman state, it was the Roman state. Valuing military achievement above all else, Romans wanting glory had to prove themselves first and foremost as army commanders.

Cassivelaunus retreated to Bigbury, a hill fort a camp near the Stour crossing. By the time Caesar captured the fort Cassivelaunus had gone. At Bigbury, hearing the news that a storm had driven his ships onto the rocks Caesar returned to Kent and built a fort. This gave Cassivelaunus a ten day reprieve. He pushed north into Hertfordshire, some sources say to Ravensburgh Fort (present day Hexton near Hitchin) refortified after Caesar's foray the year before. The remains of the largest Iron Age hill fort in South-East England (*c.* 400 BC) can still be seen.

Tribes who defected to the winning side told Caesar the whereabouts of the Cattivellauni capital at Wheathampstead. All along the line of march there Caesar was

under attack until the promised back up arrived from the Trinovantes and other tribes with grudges against Cassivelaunus.

Caesar attacked Cassivelaunus in his fortress at Wheathampstead. Although Cassivellaunus surrendered, Caesar's success was not a foregone conclusion. If Cassivelaunus had not killed the king of the Trinovantes they would have fought for him. Only their defection saved Caesar from being driven out by the sheer weight of British numbers.

When Lugotorix, a Briton of noble birth, was captured, Cassivellaunus sued for peace. Terms involved the surrender of hostages, an annual tribute to Rome and an agreement not to invade Trinovantes territory. At Wheathampstead, hearing news of serious problems in Gaul, Caesar returned to Rome. He left no garrisons behind, he had not conquered Britain and did not build the traditional triumphal arch. He did not come back. Did he consider Britain not worth having? Did events at home overtake his plans? Julius Caesar managed to triumph over his enemies for eleven years before being assassinated in 44 BC by Brutus, his closest friend. The motive? Jealousy.

It would not have been shameful for Britain to have been governed by such a man. Caesar was a gifted general, statesman, orator, historian, architect and engineer.

As for Cassivellaunus, an unnamed King succeeded him when he died around 30 BC. His successor married a daughter of King Mandubracius of the Trinovantes to enable them coexist in peace. To prosper, the Catuvellauni needed peace. Britain was exporting grain to the Roman Empire and importing olive oil, wine and luxury goods. The Catuvellauni was an inland tribe, their exports and imports had to be transported through hostile territory, they needed access to the coast. This king died about 20 BC leaving the Catuvellauni in the hands of his son King Tasciovanus, the grandson of Cassivellaunus. By this time the tribe had moved from Wheathampstead to what is now St. Albans. Tasciovanus issued coins with VER (the river) mint marks. In 10 BC he issued coins bearing the mint mark CAMU (lodunum) Trinovantes territory.

By AD 41 the Catuvellauni were ruled by King Cunobelin who Roman historians called King of the Britons. When he attacked the Atrebates in the south, they asked Claudius, Emperor of Rome for help. Claudius spent two years planning the invasion. When he arrived the Catuvellauni was still the most dominant tribe in Britain. Now led by Cunobelin's son Caractacus. he fought off the Romans in southern England before decamping to Wales where he organised guerilla warfare. Betrayed by one of his own, he and his family were captured and shipped off to Rome. When he saw the splendour Romans lived in he could not understand why they had ever bothered to invade Britain. Caractacus died in Rome of old age.

The Brythonic language survived alongside Latin. In the end the Catuvellauni embraced Roman rule and lifestyle. By AD 50 Ver Ulamium, the third largest town in Britain, had granted the locals Roman rights and privileges. Tribes further away from the towns never accepted Roman rule. Ten years later, for the second, but not the last, time in its history, St. Albans became the scene of yet another battle. This time between the Cativellauni and the Iceni from Norfolk led by the Celtic Queen Boadicea/Boudicca She-Wolf of East Anglia. When Boadicea refused to give up her land to the Romans, she was publicly flogged and her daughters were raped.

In stature she was very tall, in appearance most terrifying,
in the glance of her eye most fierce, and her voice was
harsh; a great mass of the tawniest hair fell to her hips;
around her neck was a large golden necklace; and she wore a
tunic of divers colours over which a thick mantle was
fastened with a brooch. This was her invariable attire.
– Cassius Dio, Roman historian

Verulamium, near Londinium was sophisticated, a long way from Boadicea's Thetford. Compared to Verulamium Thetford was backward. Locals in Verulamium liked the Roman way of life with its good roads, theatres and bath houses. Who wouldn't? They had no quarrel with the Romans. The Cativellauni were not conquered they were assimilated. They knew they were a target for Boadicea so by the time she arrived those who could had already left town taking their possessions with them. Boadicea razed their homes and slaughtered those left.

It was Prince Albert who commissioned the bronze statue of Boadicea and her daughters on Westminster Bridge. Male London cab drivers scoff, 'typical woman – no reins'. Female cab drivers retort, 'she's a woman – she doesn't need them'.

When the Romans left four hundred years later, Celtic Britain underwent ethnic cleansing by Anglo-Saxon invaders. What remained of the indigenous population of what became England either died out or took to the hills. Three hundred years later, Offa's Dyke acted as a genetic barrier between the Welsh and the English. Five hundred years after that the Welsh were still causing so much trouble that Edward I built a ring of castles to put them down.

The Welsh had the last laugh when Jasper Tudor, earl of Pembroke, son of the Welshman Owen Tudor, succeeded in getting his Pembroke born nephew Henry Tudor on the throne of England to reign as Henry VII.

2

OFFA:
HITCHIN; OFFLEY; ST ALBANS

King Offa II who ruled (for want of a better word) the English for forty years was considered by the mighty Charlemagne (Holy Roman Emperor aka *Charles the Great, King of Belgium*, Saxony, Italy, Spain and Bohemia) as his equal.

Hitchin, a Royal Manor since King Ethelbert owned it in the 500s, once had a church built by Offa. Not many small market towns in England can say that. St. Mary's is now on the site. Dedicated to St Andrew, it was a Benedictine monastery until 910 when it was destroyed by fire and the monks moved to St. Albans Abbey.

Offa, officially recognised by the Pope as *Rex Anglorum* – King of the English – was the most important king in Anglo-Saxon England until Alfred the Great came along a hundred and fifty years later. He ruled from 757 until his death in 796.

According to its local website Offa was born in the Mercian stronghold of Benington. We know he died in Offley near Hitchin because his death was recorded by Mathew Paris, chronicler monk of St. Albans Abbey, founded by Offa. Paris, who worked under the chronicler Roger of Wendover when Henry III was on the throne, joined the Benedictine Order in 1217 at seventeen. He was at the Abbey until he died in 1259.

Not that his famous Dyke is not mightily impressive but Offa should be remembered for far more than a pile of earth. He unified England and gave it a stable currency. He introduced the penny as the monetary unit and was the first English king to put his image on a coin. Offa's penny was the basis of English currency until the 1200s. In 1923 one was found on a cart track between Hitchin and Offley.

Offa's cousin Aethelbald, king of Mercia, was murdered in 757. In the civil war which followed, a chap called Beornred seized the throne. When he was hounded out of London he retreated to Benington to hold a Great Council to fathom out how to rout the Danes. As it turned out, they proved less of a threat than Offa who decided to fight him for Mercia. His claim to the throne was based on his great-great-grandfather brother of King Penda of Mercia. He also claimed descent from his fourth-century namesake Offa of Angeln, king of the Angles. Mercia was well worth fighting

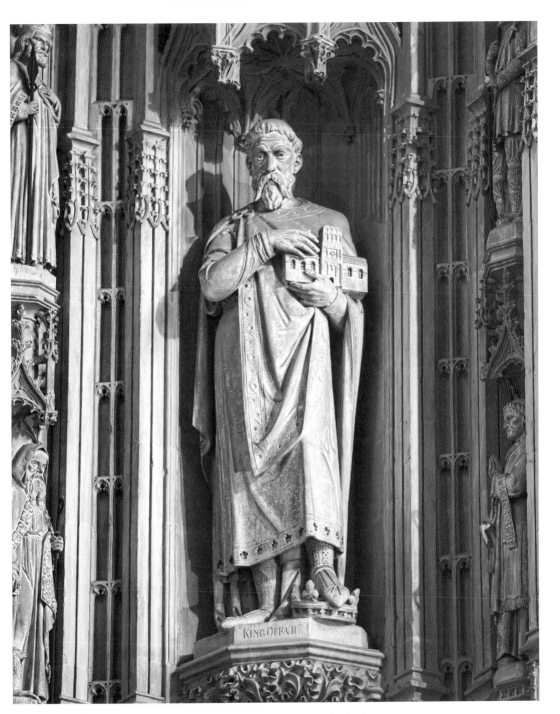

King Offa: Wallingford Screen St Albans Cathderal © Mark Playle

St Mary's Church Hitchin © MAK

St Albans Cathedral © MAK

for. It included Northamptonshire, Huntingdonshire, Worcestershire, Cheshire, Shropshire, Gloucestershire, Oxfordshire, Buckinghamshire, Middlesex, Lincolnshire Cambridgeshire, Bedfordshire and Hertfordshire.

Matthew Paris wrote that Offa based camp at Hitchin to fight Beornred at Pirton, Pegsdon and in the decisive battle at present day Offley (Offa's Lea) where Offa, now King of Mercia by right and by might, built a palace to commemorate his victory. It's thought that present day Offley Place stands on the site and that Offa lived in Hitchin while it was being built.

Legend has it that Offa searched for and found the remains of Saint Alban the first Christian martyr in Britain. He founded St. Alban's Abbey to honour him. Albanus who lived in Verulamium (St. Albans) around the end of the third century gave shelter to an itinerant Christian, Amphibalus. Impressed by his guest, Albanus converted to Christianity. When Roman soldiers searched for him, Albanus changed clothes with Amphibalus, helped him escape and was arrested in his place. Standing trial, asked to make offerings to Roman gods, Alban said he believed in one God, 'the true and living God'. Sentenced to death, he was taken out of the city, across the river and up a hillside where he was beheaded.

The Benedictine monastery founded by Offa around 793 was replaced in 1077. Over the arch in the North Presbytery aisle of the cathedral there is a wall painting of Offa.

In England, of the eight major shrines from hundreds destroyed, St Albans Cathedral has two. The Shrine of Alban is towards the east end. In its restored state one can see the

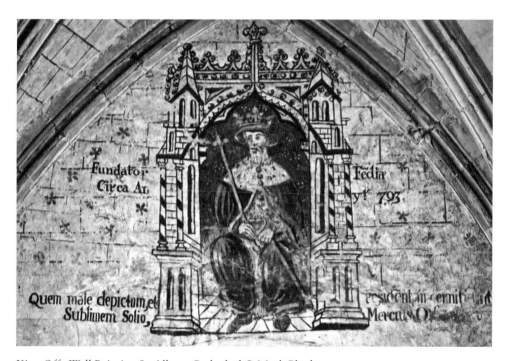

King Offa Wall Painting St. Albans Cathedral © Mark Playle

scourging of Alban. The seated figure below may represent King Offa. Within the gables of the shrine are seated figures. On the south side is Offa holding a model of the abbey.

Offa's laws were so sound that Alfred the Great adapted them. Offa was mentioned by Alfred's biographer: '...*Offa...had a great dyke built between Wales and Mercia from sea to sea*'. Started in 785 it's still traceable from the Wye Valley to Wrexham. To keep the Welsh in Wales where they had been driven to keep them out of Angle Land Offa built 170 miles of fortified earthworks from Chepstow in the south to Prestatyn in the north. One of the most impressive of man-made barriers, Offa oversaw its construction. In some places it reaches sixty feet with a twelve-foot ditch on the Welsh side. In places it still retains its original impressive dimensions, in other parts the Dyke has disappeared due to 1200 years of farming.

Offa was a brilliant soldier, statesman and politician creating wealth and security for England. He even managed to persuade Pope Adrian to free him from the authority of the Archbishop of Canterbury, Offa's enemy, and bestow an Archbishopric on Mercia in return for 365 gold pieces a year (one is in the British Museum). A letter sent in 798 by Pope Leo III to Offa's successor, King Coenwulf, requested he continue Offa's donation. Offa also managed to get his son Ecgfrith consecrated by the Pope as king to ensure an undisputed succession. Ecgfrith died within the first year of his reign. A distant cousin succeeded him.

According to Matthew Paris, in July 795 Offa was 'gathered to his fathers' having died at Offley. For some unknown reason he was buried not in Offley, Hitchin or

Shrine of Saint Alban, St Albans Cathedral © Mark Playle

St Albans but in Bedford fifteen miles from Offley. He founded his Benedictine monasteries in Hitchin and St. Albans just before he died. Is this where he planned to be buried? Paris said Offa was buried in a chapel on the banks of the Ouse. The Hiz in Hitchin is a tributary of the Ouse. Nowhere on the Ouse was there a church grand enough to house the body of a King except in Hitchin. The Oxford DNB says his son Ecgfrith thwarted plans by the Abbott of St Albans to have his father buried in the Abbey and insisted on Bedford. Why?

Matthew Paris: '... [Offa] whose body when brought to the town of Bedford is said to have been buried in royal manner in a certain chapel, because the urgency of the occasion so demanded it, so situated within the city on the banks of the River Ouse. But it is reported to this day, so the statement of almost all the people of the neighbourhood runs, that the said Chapel becoming ruinous through long use of the violence of that river, became submerged and, owing to the rapacity of the stream, was completely destroyed along with the actual tomb of the king, or at least, as some assert, was hurled in ruins irresistibly into the bed of the river. Whence, even at the present time, that tomb, when the inhabitants of the place bathe at the spot in summer, is seen swallowed up in the deep water'.

St. Paul's Church, Bedford dates from the eighth century. Bearing in mind it was in July, high summer, when Offa died the 'urgency of the occasion so demanded' may refer to fear of the corpse decomposing. It was Mathew Paris who put on record that Offa lived in Offley. To his disgust St. Albans Abbey failed to secure the body of its great benefactor.

Even more mysterious – considering the Sutton Hoo hoard was buried in 620 with a local king and Offa King of England died much later in 796, except for a few coins in the British Museum his hoard has never been found. Kings were buried with their enormous treasure. Where is it? In the Ouse? (Come on *Time Team*). In 1016, King Aethelstan owned a sword which belonged to Offa. Experts on the recently discovered Staffordshire Hoard say that it's probably that of the Mercian court armourer around 655. Mercian kings gave the armourer weapons recovered in battle to recycle jewels, gold and silver to decorate new sword blades. Offa is sure to have had an armourer.

3

ALFRED AND EDWARD THE ELDER: HERTFORD; WARE

The name *Heortfordscir* was first recorded in 866. Alfred came to the throne In 871. The Peace of Wedmore in 886 established an agreed boundary between Wessex and the Danelaw. Part of this frontier was the River Lea which runs through Hertfordshire. The Danelaw included counties north of an imaginary line running from London to Bedford up to Chester, the original north-south divide. It's thanks to father and son we have the county town of Hertford – more accurately, Hart Ford, the ford where the hart came to drink. Hart is an old name for stag.

Alfred was no country bumpkin. Cultured and well travelled, he made his first visit to the continent when he was four. He fought off the Danish invaders nine times. They had taken the Saxon kingdoms of Northumbria, East Anglia and parts of Mercia which were now under Dane Law. Only his kingdom, West Seaxon – Wessex – was left. He successfully held it in a decisive battle in 878. Alfred's truce with Guthrum, the Viking king demanded Guthrum be baptised a Christian and England be divided into the Anglo-Saxon southern kingdom and the Danelaw.

The Anglo-Saxon Chronicle records that in 895, the Danes decided to fortify the Lea and moved a large force up river for twenty miles (one of their swords was found in the river). Alfred, who practically invented guerrilla warfare, made sure they couldn't get down again. He followed them with an army and engaged the Danes in a skirmish. Beating them off, he built forts further down the Lea cheekily using the Danes' ships as a bridge. Then in a stroke of genius diverted the course of the river via a series of weirs making the river impassable. Present day Kings Weir, Wormley, marks the start of a stretch of the Old River Lea. Alfred's brilliant Machiavellian tactical weirs can also still be seen in Hertford and Ware – the Saxon 'Waras' – Ware – comes from the weirs he built.

When the Danes tried to return to the Thames, they found the Lea divided into tributaries too shallow for boats. Trapped, unable to row back to the Thames, they had to march across country to the River Severn. Learning a lesson from the threat posed by ships, Alfred formed a navy.

The Hart (i) © MAK

The Hart (ii) © Mark Playle

The defeated Danes left England and formed Normandy – North Man. One day they would be back in the shape of William the Conqueror.

After Alfred's death his son Edward (the Elder) active in his father's campaigns against the Vikings continued the fight to save Wessex from the Danelaw. He was very successful. In 912 to defend the Lea on a permanent basis he founded the town of Hart Ford.

Today's Hertford retains the Anglo-Saxon grid pattern in the street layout. Edward built a fortress on the Lea where the Beane and Mimram met and two fortresses on the Lea one on each side of the bank. Hertford remained a Royal Borough until 1974.

The town was still spelled Hart Ford in 1633. We know that because of Reverend Sam Stone. Born in Fore Street, he emigrated to America for religious reasons – he was a Puritan. He is listed among famous Americans. The Pilgrim Fathers crossed the Atlantic in The Mayflower in the 1620s. Stone bought land from native Algonquin Indians in Connecticut and founded Hartford in memory of his home town. His bronze statue is at Mill Bridge in Hertford.

Edward the Elder married three times and had fourteen children. His son King Edmund Ironside was defeated by Canute, King of the Danes in 1016.
In 1911 came the final change, when Lord Salisbury leased the Castle to Hertford Corporation at a nominal rent The gatehouse was converted to Council offices and the gardens became a public pleasure ground.

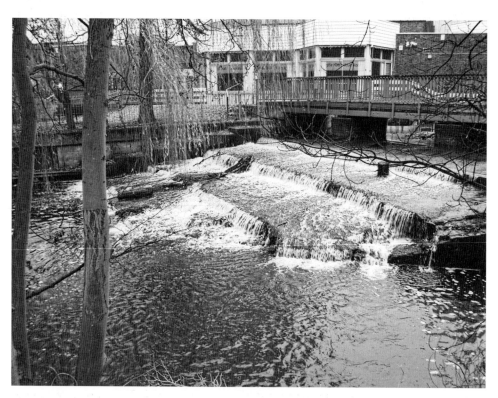

Hertford Weir © Jeff Shields

4

CANUTE AND EARL TOVI: HITCHIN; WALTHAM ABBEY

The Danish king, Sweyn 'Fork beard', invaded England in 1003. Ten years later, the English nobility was so disillusioned with King Ethelred (The Unready) they acknowledged Sweyn as king. In 1016 his son King Canute/Knut received the last Danegeld. Knut never did say he could stop the tide coming in. On the contrary, when hangers on insisted he could, he proved he could not.

He rewarded his loyal standard bearer Earl Tovi – second to him in rank – by giving him the Royal Manors of Hitchin and Waltham. As he was also King of Denmark and Norway, during his long absences in Scandinavia, Canute left Tovi to govern England. Canute's son HarthaCnut died while guest of honour at Tovi's wedding in Lambeth.

Canute's standard which Tovi carried into battle, a white silk banner with a black raven, was believed to possess magic qualities. If he was going to win, it opened its beak and flapped its wings. If he was to be defeated, it did not stir. The raven banner struck fear into Anglo-Saxons who believed it had had evil powers. Ravens, in Scandinavian poems about warfare, sit on the shoulders of Odin. At dawn he sends them out to fly over the world. They come back to tell him all they heard and saw. Ravens were special to Viking sailors who used them to find land. Ravens cannot swim or land on water so when released if they see dry land they head there and don't come back. If there is no dry land they return to the boat. This is how the Vikings discovered Iceland. Noah used a raven to find land before using a dove.

It's said that Canute who based his Royal Mint at Hertford went native. He became more English than the English and chose to settle here. Why would he not? England was the most prosperous country in Europe.

As for Tovi, Hitchin was definitely worth having. Its sheep meant wool for export and an abundance of barley for London breweries made the town wealthy. He used its revenues to build a church in Waltham to hold yet another remnant of the True Cross. When he died his son squandered his inheritance and Hitchin reverted to the Crown.

Hitchin © MAK

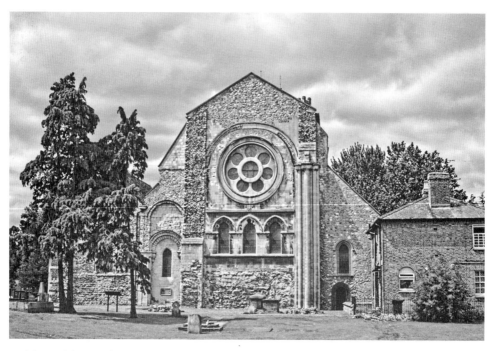

Waltham Abbey (i) showing grave of King Harold in the foreground © Mark Playle

Sampler: Waltham Abbey (ii) © Mark Playle

Waltham Abbey (iii) © Mark Playle

Canute died in 1035 succeeded by his worthless quarrelling sons Harold I and Hardecanute. The next in line was Edward the Confessor, son of King Ethelred (the Unready) of Wessex. He gave Hitchin and Waltham to Harold Godwinson, earl of Wessex, who succeeded him briefly as Harold II. Harold used his revenues from Hitchin to rebuild Tovi's church, the remains of which are under the present church. It became an abbey in 1184.

In 1066 Harold carried Tovi's Cross from Waltham into the Battle of Hastings. We all know how that ended. William the Conqueror took the throne of England. Harold, the last Anglo-Saxon king of England, was laid to rest in his favourite church Waltham Abbey. Edith Swan Neck the mistress who bore him six children buried him before the High Altar. The stone slab in the grounds behind the abbey which marks the spot (see photograph Waltham Abbey (i)) is covered in flowers on the anniversary of his death. William II stripped the abbey of valuables for the cathedral in Caen where his father was buried. Waltham Abbey's 100,000 visitors a year include many from Caen.

5

WILLIAM I AND HENRY I: BERKHAMSTED

Edward the Confessor – strange epithet – presumably had a penchant for confessing his sins – granted the monks of Westminster revenues from land in Wheathampstead and Harpenden to build an Abbey. The original Deed dated 1060 can be seen in County Hall Hertfordshire History and Local History Archives. One witness was Earl Harold Godwinson. According to Oxford DNB Edward was buried in Westminster Abbey the day Harold was crowned there. Abbey archives however, record that the first coronation was of William the Conqueror. How galling is that? Before 1066 there was no fixed location for a coronation. Bath, Canterbury, Kingston-Upon-Thames and Winchester were all used. William, to reinforce his claim to England, chose Edward's Westminster Abbey for his crowning on Christmas Day.

Edward the Confessor had no children. William, duke of Normandy said Edward promised he would be his heir. If he did you wonder why because Edward's heir was his grandson, Edgar Atheling. To add to the mystery, Earl Harold Godwinson (Harold II) said Edward on his deathbed named him as his successor.

How many outside Hertfordshire know that it was in Berkhamsted that humiliated Saxons relinquished England's crown to William, Duke of Normandy? In August 1066 – a date engraved on English hearts – England, once a Roman colony – became a French colony.

Leaving the carnage of Hastings William marched on Dover and Canterbury before arriving on the outskirts of London. Meeting resistance in Southwark he set fire to it. When Londoners also refused to submit William rampaged through Surrey, Hampshire and Berkshire massacring anyone who stood in his way. He finally pitched camp in Berkhamsted and waited for London to surrender. It did.

Archbishop Ealdred, the Bishops of Worcester and Hereford, Earls Eadwin and Morcar met William in Berkhamsted. Eyewitnesses Guy of Amiens and William of Poitiers said the surrender took place in the royal hall of a Saxon fortress of Beorchehamstede. Like the French and Paris during the Second World War the City

Fathers did not want the City destroyed so William did not take London. He was never known there as William the Conqueror, he never did conquer it, he was and is always William the Bastard. He had to ask permission from the Lord Mayor to enter the Square Mile as monarchs still do today.

William immediately began to fortify his new kingdom with castles. He gave the newly-created manor of Berkhamsted to his half brother Robert Count of Mortain (which is in Normandy) who built Britain's first Norman castle, one of a defensive ring around London.

William's son Henry took it from Robert's son. It's still owned by the royal family. The earthworks visible today date from this period. The motte (mound of earth taken from the dug out moats) and bailey (courtyard) castle with its ten towers was defended by two huge moats with a natural water meadow acting as a third. In 1839 the railway gobbled up the outer moat.

In 1972 a padlock was put on the entrance gate. It seemed the end of Berkhamsted Castle until Mr Stevenson, a local chap, volunteered to act as unpaid Key Keeper, opening the grounds every morning and closing them at night. Umpteen committees sat on umpteen meetings and finally said yes which was fortuitous for Berkhamsted, Hertfordshire and the nation.

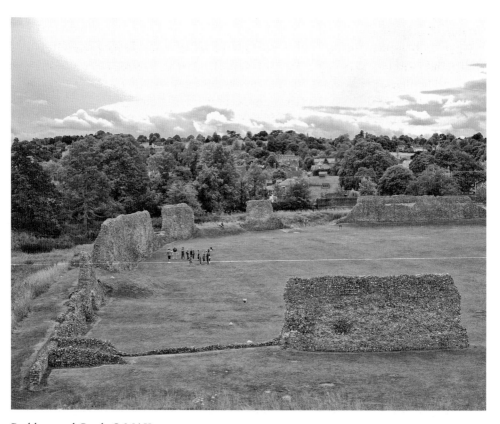

Berkhamsted Castle © MAK.

There is also a fine Norman motte at Hertford. Following the Conquest, a castle was established there which for 300 years belonged to Royalty (it now belongs to Lord Salisbury). Miraculously, the original motte of William, the flint walls of his grandson Henry II and the gatehouse of Edward IV survive. Considering what Hertfordshire was like in 1066 you do wonder. Did William really believe the locals would take him on? If so he was ignorant of our wonderful indifference. Apart from Hereward the Wake in East Anglia apathy ruled.

William was crowned king of England on Christmas Day 1066. It was customary for the Archbishop of Canterbury to place the crown on the royal head but Stigand refused 'to crown one who was covered with the blood of men and the invader of others' rights' so William was crowned by The Archbishop of York. The moment the crown was placed on his head his guards, mistaking the traditional Hurrahs! for an uprising, descended on the people outside, put them to the sword and set fire to their houses until William appeared in his Coronation robes at the Abbey door and stopped them. As the congregation had fled, the ceremony was concluded with few onlookers.

When William taunted the English for being so easily conquered Abbot Frederic of St. Albans Abbey pledged his wealth and position to the Saxons. He urged Aldred, Archbishop of York and Earls Edwin and Morcar to get rid of William and place Edgar Aetheling on the throne. William retaliated by giving all their land and property between Barnet and London to Westminster Abbey where he had installed his own Norman Bishop.

When William, who owned Normandy, took Brittany and Maine, successive kings of England fought to keep them. Edward III declared himself King of France; his son Edward The Black Prince defeated the French at Poitiers and Crécy. When his great grandson Henry V of Agincourt conquered France, England regained its national pride. His son, Henry VI, was crowned King of France a title not abandoned by kings of England until 1801 despite them owning no land in France. The last bit, Calais, fell during the reign of Mary Tudor in the 1550s. The French Revolution of 1792 meant that France no longer had a king French or English. Bizarrely, in the Channel Islands, British monarchs still bear the title Duke of Normandy although France has no dukes and Normandy is a collection of Départements.

In old age, William grew very fat. In 1087, told that King Philip of France said he looked pregnant, he set fire to Mantes near Paris. Soon afterwards he fell from his horse and died. He is buried in Caen Cathedral.

William had four sons. The eldest, Robert, became Duke of Normandy, Richard, the second, died while hunting, the third, William became king of England, the fourth Henry who inherited nothing was of the opinion that England was his by right as he was the only one of his brothers born here (Selby, Yorkshire). Although he died in Normandy he left instructions he was to be buried in England. His tomb was in Reading Abbey until Henry VIII destroyed the monasteries. A Tudor monarch, Henry showed no loyalty to anyone least of all the son of a Norman invader.

William II died while hunting. On 2 August 1100 he was with his brother Henry in the New Forest when an arrow hit him in the chest. Henry left him bleeding on the forest floor, rode to Winchester, took control of the treasury, declared himself king

and got himself crowned at Westminster Abbey all in four days. William was taken to Winchester Cathedral; legend has it that his blood dripped from the cart all the way there. He was buried in the tower which collapsed the following year.

Henry had a few connections with Hertfordshire. He, his wife Matilda and heir presumptive Prince William often stayed in St. Albans Abbey for Christmas and New Year. Then there was Berkhamsted Castle. When he took it from his cousin, William (son of Robert) duke of Mortain and gave it to his Chancellor, Ranulph, Mortain joined forces in battle with Henry's brother Robert, Duke of Normandy who was also treated shamefully by Henry. In September 1106 Henry defeated them both. He threw Robert in prison and left him to rot until he died there twenty-eight years later.

Chancellor Ranulph rebuilt the original wooden Berkhamsted castle. By 1123 it was grand enough for Henry to hold court there. During his reign and that of his grandson Henry II, the castle remained in the hands of the Chancellors. Ranulph was very important to Henry who is remembered for inventing the Exchequer. He counted out taxes on a chequer board – hence exchequer – and overhauled the tax system making it very difficult for tax collectors to cheat him. When Henry created new baronies at Benington and Walkern he built castles there too. The earthworks can still be seen at Benington.

Prince William, who Henry idolised, died in 1120 when he drowned returning from Normandy in the royal yacht, *The White Ship*, which sank. His only other legitimate heir was his daughter Matilda who Londoners did not want. They chose instead her cousin Stephen (one official portrait shows him cross-eyed) who had been brought up by Henry. Stephen, who held court in St Albans in 1143, agreed that Matilda's son, Henry, would be his successor.

The last four Kings of England, William I, William II, Henry I and Stephen were Norman French. The next, Matilda's son, Henry II, was Angevin French, the first of the fourteen Plantagenets kings of England. The first three, Henry II, Richard I and his brother John, were closely connected to France. Henry III, Edward I, Edward II, Edward III and Richard II were closely connected to England.

6

HENRY II: HERTFORD; BERKHAMSTED

Henry II was the first of fourteen Plantagenet kings of England. His son, the future Richard I, who became known as Richard the Lionheart, spent the first year of his life in St. Albans.

The most powerful monarch in Europe, Henry's empire stretched from the Scottish borders to the Pyrenees. In 1155, Henry was also given Ireland by Nicholas Breakspear, the only English Pope. Breakspear as Adrian IV wanted Henry to bring the Church in Ireland under Rome.

Born in Bedmond Hertfordshire in 1100 Nicholas Breakspear was baptised in St. Lawrence the Martyr, Abbots Langley and probably attended St. Albans School. His Coat of Arms has a broken spear which might refer to family battles during the Norman invasion a mere thirty-four years before his birth. Born on a farm, he ended up ruling the Vatican. The farm (a painting is in Vatican archives) survived until the 1960s (plaque in Bedmond Road in front of new houses). His father, Robert of the Chamber was at St Albans Abbey but when Nicholas tried to join he was rejected. You do wonder what the great and the good thought when he became their boss.

The decision to make Father Breakspear Pontiff was unanimous. Perhaps, as in those dangerous times it was a poisoned chalice, there were no other takers. He certainly didn't want it. Appalled, he tried to refuse saying he wished he had never left Bedmond. He chose the name Adrian after the Pope who sanctioned the founding of St Albans Abbey. His only visit home was in 1152. It's thought his mother may have witnessed her son's huge achievement but there is no record of either parent attending his coronation in Rome. His red marble sarcophagus in the crypt of St Peter's Rome has deer skulls representing Hertfordshire, roses representing England and the inscription: *Hadrianus Papa IIII*. Breakspear died in 1159, reputedly after swallowing and choking on a fly while eating.

His commemorations in Hertfordshire include: a plaque in St. Lawrence; a bust in St Saviour's; Pope, Adrian and Breakspear Roads; Nicholas Breakspear Week in Abbots

Langley: The Wallingford Screen in St Albans Cathedral and a painting in County Hall Hertford.

Henry II, the first child of Matilda (Henry I's daughter) and Geoffrey of Anjou was born in Le Mans, France. His delighted grandfather, Henry I, crossed the channel to see his heir and bounced the baby on his knee. Very attached to his grandson, he spent time playing with young Henri. He had of course lost his own beloved son and heir William when he drowned on the royal yacht *The White Ship*.

Geoffrey of Anjou was forced to marry Matilda when he was fourteen and she twelve years older a widow of twenty-six. Because he always wore a sprig of plante genet (yellow broom) he was known in England as Plantagenet. Although the ill matched pair disliked each other from the outset and neither pretended otherwise – they knew their duty. The stormy marriage produced three sons. Henry, the eldest, the favourite of his adoring mother at fourteen fought King Stephen in battle for his mother's claim to the English throne. At eighteen when his father died he became Count of Anjou and Duke of Normandy. Henry married the ex Queen of France, Eleanor of Aquitaine, twelve years his senior. Like father, like son. While married to King Louis she was rumoured to share the beds of both Henry and his father Geoffrey. Eleanor, heiress of the Duke of Aquitaine was the richest woman in Europe. She was also beautiful, intelligent, cultured, powerful and quite remarkable.

If feminists need a rôle model let them look no further than Eleanor of Aquitaine. She insisted going on Crusade with her husband King Louis of France but at Antioch started a passionate love affair with her uncle Raymond ten years older, refused to join her husband in Jerusalem and demanded a divorce. Louis abducted her and to Jerusalem she did go.

Back home again in Paris she then fell for Henry. The attraction was mutual. Within two months she managed to divorce Louis and marry Henry. Crowned in Westminster Abbey their turbulent marriage produced five sons and three daughters. Born into a dysfunctional family, Henry spawned a worse one.

Henry and Eleanor's first baby William died age two at Wallingford Castle in Berkshire. He was buried at the feet of his great-grandfather, Henry I at Reading Abbey. Neither tomb survived Henry VIII's Reformation.

When Henry introduced his illegitimate son, Geoffrey, named after his father, into the royal nursery, a furious Eleanor was publicly humiliated. His mother was a prostitute. Henry had at least a dozen illegitimate children including one by the fiancée of his son Richard (Richard I) who understandably, refused to marry her.

From 1155 to 1163 Chancellor Thomas Beckett, Henry's closest friend and who, unlike the King, dressed like a king, held the honour of Berkhamsted Castle. The stone ruins we see today date from Becket's time. After he spent the huge sum of £800 (£400,000) of the King's money to do it up it became one of Henry's favourite places to stay. He spent Christmas there in 1163.

When the Archbishop of Canterbury died in 1161 Henry appointed Becket to the position to gain control of the church. Becket's first living was rector at Bramfield near Hertford. Henry's plans went badly wrong when Becket got religion and resigned the Chancellorship. Henry ousted him from Berkhamsted Castle accusing him of

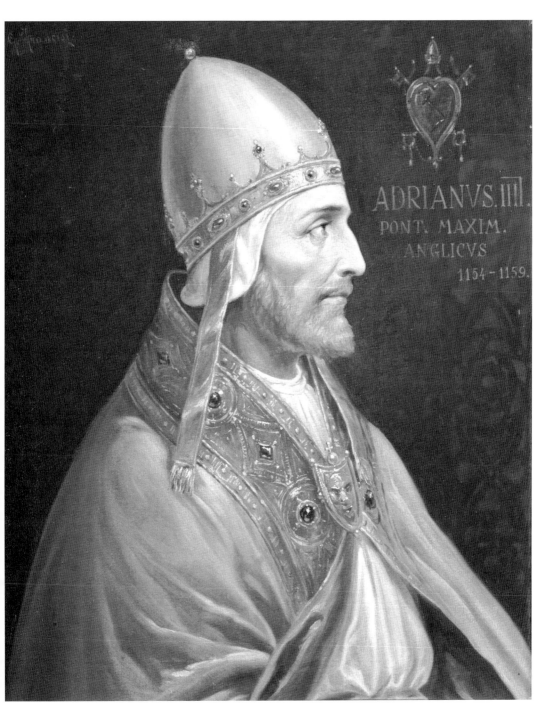

ADRIANVS.IIII.
PONT. MAXIM.
ANGLICVS
1154 - 1159.

Nicholas Breakspear the English Pope © Hertfordshire County Council

misappropriating cash from the Treasury to rebuild it without permission. Henry was out to get him. In October 1164 Becket was found guilty of embezzlement. To humiliate him further on 24 May 1170 Henry had his son Henry – known as Young Henry – crowned at Canterbury Cathedral by the Archbishop of York. After a brief reconciliation Henry invited Becket to re-crown Prince Henry in a second ceremony. When Becket excommunicated the Archbishop of York, a furious Henry, spending Christmas in Normandy, raged: 'Will no one rid me of this troublesome priest?'

Four knights did. They crossed the Channel to Canterbury Cathedral, where they tried to force Becket to return with them and face the King. He refused. Next morning they attempted to drag him out of the cathedral calling him a traitor. Becket chose martyrdom. When one of the knights struck him with his sword the others followed suit. Becket died 29 December 1170.

Henry's fury subsided into grief. He famously did public penance by walking barefoot into Canterbury Cathedral where he ordered the monks to scourge him. He apologised to St Albans Abbey for the murder and gave it the manor of Brickendon as part of his reparation. The murder will forever define Henry's reign but some of Becket's biographers say he was so obnoxious if Henry had not done for him somebody else would have.

Becket was made a saint in 1173 and his shrine in Canterbury Cathedral became a focus for pilgrimage. Because rich, important people from all over the Continent had nowhere suitable to stay while in England Henry built Dover Castle and modernised Berkhamsted and Hertford Castles using them as a prestigious hotel chain for high ranking pilgrims and for himself on his visits to England. Henry practically rebuilt Hertford Castle between 1170 and 1174. It was Henry who built the impressive massive seven foot thick flint and stone walls we see today. The castle already had two protective moats and the river Lea. Just who did he think would invade? Henry spent Christmas 1170 at Hertford.

Henry's real punishment came in his betrayal by his beloved sons. Henry, the newly-crowned young king possessed grand titles but no power. He rebelled against his father and was joined by his brothers, Richard and Geoffrey. In England, Eleanor, equally keen to see Henry brought down, disguised herself as a man and tried to join her son's rebellion in France but was taken prisoner by Henry. Young Henry then quarrelled with his brother Richard. Aided and abetted by Geoffrey he began to ravage Aquitaine but fell ill and died leaving Richard heir to the throne. He would have been Henry III.

When the ageing Henry II fell ill at Le Mans, his son Richard attacked the town. Henry ordered the suburbs be set on fire to impede his advance but the wind changed and the fire set alight his much loved birthplace. A conference was called at which Henry was humiliatingly forced to accept Richard's terms. Persuaded to give his son the kiss of peace, Henry whispered in his ear "God grant that I die not until I have avenged myself on thee".

Before leaving for Chinon Henry, now dying, asked for a list of names of those who betrayed him. The first was that of his beloved John, his youngest son. Utterly crushed, he read no further. At Chinon, his illegitimate son Geoffrey remained with him to the end. "You are my true son," he said, "the others, they are the bastards". When he died

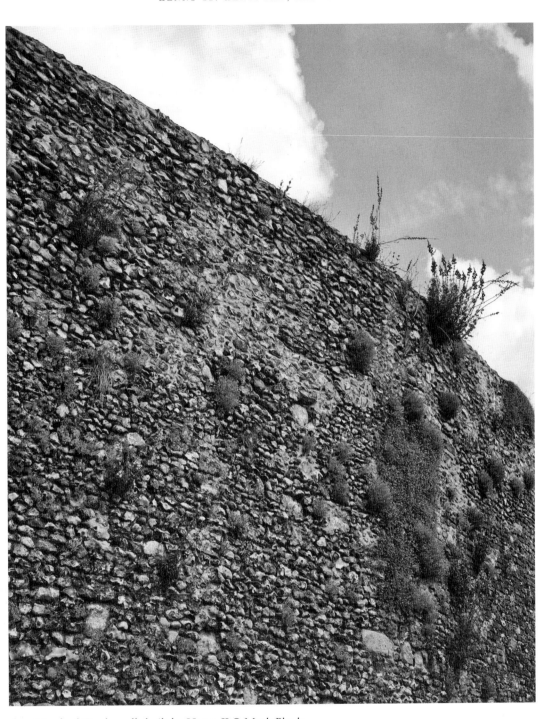

Hertford Castle walls built by Henry II © Mark Playle

Hertford Castle Wall © Mark Playle

6th July 1189 his servants found a crown, sceptre and ring, probably taken from a religious statue and took him from Chinon to the Abbey of Fontevrault in Anjou for burial.

Shakespeare's 'How sharper than a serpent's tooth it is to have a thankless child' comes to mind. The story of Lear is of course about an aging king who divides his kingdom amongst his three children. Two pretend to love him but treat him cruelly. He also has a bastard son. As the story unfolds his offspring show their true colours and betray their father.

The new King of England, Richard I, gazed at his father's corpse with no emotion.

7

RICHARD I:
ST ALBANS

The three lions proudly displayed on 'Ingerland! Ingerland!' football shirts are not English. They are French. They are the arms of Geoffrey of Anjou adopted by his grandson Richard I who became known The Lionheart.

Unlike soccer fans, Richard felt no loyalty to England. He treated the country as his private bank to raise money for the Crusades. Apart from the first year spent as a baby in St. Albans he spent only a few months of his adult life in England. If he had any loyalty to England it was probably to Hertfordshire.

His mother Eleanor of Aquitaine gave birth to Richard in Beaumont Palace Oxford on 8 September 1157. On that same day a St. Albans woman, Hodierna Neckham, also gave birth to a son, Alexander. Whether she gave birth at Beaumont Palace or in St. Albans is not known. Richard, Eleanor's third son, was her favourite. His father, Henry II, favoured John, the baby of the family. Every other member including the parents of that dysfunctional family loathed each other.

Small wonder Richard had the heart of a lion. He was reared on milk from St. Albans. Imagine being suckled at the same breast as the future King of England. Awesome but that's what happened to Alexander Neckham when Prince Richard was handed over to his mother. The connection between the families is not known, perhaps Hodierna was recommended to Eleanor. Whatever the story, Hodierna was Richard's wet nurse and foster mother. His early upbringing was left to her. When Richard became king he granted Hodierna a generous annual pension. Alexander grew up to be a teacher; his foster brother grew up, by default, to be a king. His older brother, young Henry, heir to the throne, died young.

Richard became the standard by which kings of England were judged after Walter Scott's *Ivanhoe* which presented a glamorous image of him, as does the equestrian statue outside the houses of parliament. You can't help wondering if the prudish Victorians who paid for the statue knew that Richard was homosexual. It's said that the bed did not separate him from King Philip II of France. It's strange that Richard, who was not

The Three Lions: Souvenir in car window: World Cup 2010 England football shirt)
© Mark Playle

the slightest bit interested in England and Oliver Cromwell, who murdered a king of England were chosen to represent English kingship. Although considered by many a hero Cromwell made quite sure his was not the first signature on the King's death warrant. He refused to sign until two others did so.

As for Richard, did he deserve his place in the nation's heart? Nine hundred years later it's difficult for us to judge. What price can you put on a nation's pride? On the 'feel good' factor? He made England proud. He was our Winston Churchill. He asked his people to fund his Crusade and they did. He asked them to pay a King's Ransom for him and they did. They needed a hero. We need heroes.

Jubilation greeted Richard's landing at Portsmouth from France on 13 August 1189 to prepare for his coronation on 3 September at Westminster. It turned out to be dramatic. A bat disturbed from its sleep flew from the rafters and flapped frenziedly around the King's head throughout the ceremony. This was considered a bad omen. During the banquet which followed in Westminster Hall, a public riot broke out. Due to prejudice against Jews, Richard told them not to attend the service in the Abbey or the banquet to protect them from devout Christians inflamed by Richard's praise of the Crusades. When curious Jews sneaked in to watch the goings on a riot broke out and they had to flee for their lives. Barricaded in their houses, the mob set fire to them and butchered those who jumped from the windows. Not a good start to Richard's reign.

Immediately after his coronation Richard started fund raising for his Crusade against Saladin (the Third Crusade). He said he would sell London if he could find a buyer. On 11 December 1189 he crossed from Dover to Calais where he was met by King Philip II of France. Their joint crusade would start from Vézelay 1 April 1190. It's as a Crusader Richard is best remembered. He 'took the cross' on hearing that Jerusalem had fallen to Muslims. It's said that Richard rode into battle carrying King Arthur's Sword Excalibur and it was Richard who first used the royal 'we'.

After her sixteen-year incarceration by her husband Henry II, Eleanor, nearing seventy, ruled England in her son Richard's absence. Deciding he must marry and provide England with an heir Eleanor set her sights on Princess Berengaria of Navarre in Spain and set out for the Pyrenees. Richard had already met her.

In the depth of winter with her future daughter in law in tow Eleanor traipsed over the Alps to find Richard. Hearing he was in Messina she travelled to Milan then Pisa and Naples. At Brindisi she boarded a ship for Messina. The arrival of the awesome Eleanor astonished the Crusaders. Life expectancy was forty.

Eleanor was there four days before she was off again. Not only could Richard not marry Berengaria because it was Lent Eleanor had received news from England that her son John – Richard's younger brother – was behaving as if her were the king. She set off for Rome before tackling the Alps again leaving Princess Berengaria to go with Richard on Crusade. On 12 May 1191 Richard and Berengaria were married in Cyprus. She was granted the manor and honour of Berkhamsted including Berkhamsted Castle as part of her dowry. Berengaria was crowned Queen of England in Cyprus by the Bishop of Evreux immediately after her marriage. It seems to have been a marriage in name only, it was very probably never consummated. Eleanor's hope for an heir to Richard's throne never materialised. His brother John would take over from him.

Back in England Eleanor sent word to Richard saying unless he returned he would lose his kingdom to John but Richard could not return. He was held captive. In November 1192 following Richard's Third Crusade, Emperor Heinrich VI of Bavaria barred his route home and took him prisoner.

Eleanor set about doing what Eleanor did best, she sweet talked his adoring subjects – by now Richard was national hero – to raid their piggy banks. Though most had never seen sight nor sign of their king, she managed to raise the huge ransom demanded for his release, thirty-five tons of pure silver. A king's ransom indeed, in today's money about fifteen million pounds.

In December 1193 in winter gales Eleanor, with chests full of silver, set sail to rescue her son. When she arrived in Germany she was stunned when the Emperor told her that her son John had offered the same amount if he did not release Richard. Using all her persuasive powers he was finally released into her care. He had been in prison for over a year.

They landed in Kent in March 1194. After paying homage at the shrine of Thomas Becket, the man his father had murdered, mother and son toured England for six weeks to thank his people for their contributions to the ransom fund. Richard went to Nottingham where John was behaving as if Richard was dead. On 17 April at Winchester, to hammer home the point he was very much alive, Richard wore his crown in state. On 12 May he sailed to Normandy never to return, leaving England in the hands of the Archbishop of Canterbury. Eleanor went with Richard and entered a convent in France for a well-earned rest.

Richard's last five years were spent fighting Philip II the man whose bed he once shared. In Limoges Richard was hit by an arrow. When gangrene set in he sent for his mother who was over a hundred miles away. She travelled day and night to reach him. One of his last acts was to send for the archer who shot him to forgive him. He then named his brother John as his heir. On 6 April 1199 age forty-one he died in his mother's arms. He was buried at Fontevrault Abbey, next to the father he betrayed. John did not attend his brother's funeral. A few days later, at High Mass on Easter Sunday with Eleanor present he horrified the congregation by shouting at the bishop to hurry up as he was hungry and wanted his dinner.

Hearing Richard's lands in Angers had fallen to Phillip of France Eleanor hurried there to take him on. Leaving his mother to fight his battles in France John sailed to England for his coronation. Eleanor did not attend. Instead, grieving for Richard, she embarked on a grand tour of her birthplace, her duchy of Aquitaine to secure it, not for John who she despised, but for England. She was seventy–seven. In four months she covered over one thousand miles.

In September she met up with John in Rouen. Knowing he was a disaster for England she tried to counsel him. She then set off for the Pyrenees to reach Castile in Spain to visit her daughter and arrived there in January 1400. She returned to France over the Pyrenees with her granddaughter Blanche to marry her off to Phillips's son in the hope this would heal the breach between England and France. Then, unwell, entered the convent again and took to her bed.

For the first time in years peace had broken out between France and England but Eleanor, Dowager Queen of England, kept a weather eye open for any sign of trouble.

She didn't have to wait long. Phillip of France decided to seize her beloved Aquitaine. Age eighty, very frail, she left her sick bed and embarked on a fifty mile journey to keep it for England. She ended up as a prisoner of her grandson, Prince Arthur of Brittany. For once her son King John came up trumps and rescued her.

She continued her journey on to Poitiers where she died in 1204. The wife of a King of France and of a King of England, mother of two Kings of England, Richard and John, grandmother to Henry III and great-grandmother of Edward I was buried between her estranged husband Henry II and her beloved son Richard at Fontevrault Abbey (near Saumur).

Alexander Neckham, Richard's childhood companion, carried out several assignments for his foster brother. One of the most remarkable scholars of his century, he was educated at St Albans Grammar School, the most prestigious in England. Invited back to teach there the abbot is said to have written punningly to him: '*Si bonus es venias; si nequam, nequaquam*' ('If you are good, come; if good for nothing, don't bother'). He taught there for some time before going on to teach theology at Oxford where he got into trouble for refusing to celebrate the feast of the Conception of the Virgin Mary. Aesop's *Fables* were first introduced into England when Neckham translated them into English. A prolific writer, his works are in the British Library.

As for Richard's wife, Queen Berengaria, it may be the marriage was never consummated. Some sources say she never set foot in England. Carvings inside the famous Royston Cave include two small figures said to be Richard and Berengaria. Her crown is floating above her head because she was never crowned in England but David Hilliam in *Kings, Queens, Bones & Bastards* says that when Richard died in 1199 she came to England. It's thought she was at Canterbury Cathedral in 1220 to visit Thomas Becket's new shrine. If she was in England did she stay at Berkhamsted Castle? Some sources say she was dispossessed of the castle by John and although the Pope ordered an interdict the matter was not settled until 1216 when John was forced to grant her a pension.

In 1229 Berengaria retired to Le Mans where she lived in poverty. She entered a convent as Sister Juliana. When John died in 1216 and his son Henry III paid the backlog due to her she founded an abbey at L'Epau where she was buried in 1230 aged sixty-five.

8

John:
Bishops Stortford;
Hertford; St. Albans

'John was a tyrant. He was a wicked ruler who did not behave like a king. He was greedy and took as much money as he could from his people. Hell is too good for a horrible person like him'. Matthew Paris Chronicler Monk St. Albans 1260.

1The word Angevin comes from Anjou the French province. As John managed to lose Anjou this made him the last Angevin king of England. By 1205, just six years into John's reign, only a fragment of his father Henry II's vast empire remained in English hands.

It's hard, thinking about John, not to think of Edmund Blackadder. Completely lacking in insight, he failed at everything. In 1185 when his father sent him to rule Ireland he was such a disaster within six months was ordered to return home. When his brother Richard I returning from the third Crusade was taken prisoner in Germany John tried to usurp him but failed. Not only did he lose just about every battle he fought, at the end of his life, he managed to lose the Crown Jewels in the Wash.

John quarrelled with everyone. He could pick a fight in an empty room. His reign started the way it was to go on. Badly. When the French barons refused to accept him and supported Prince Arthur of Brittany John took them on. He failed. He took Arthur prisoner and attempted to blind him before having him murdered. The barons refused to surrender so John lost Brittany, Poitou, Anjou and Maine. He was so useless in battle that his military defeats earned him the nickname, Soft Sword.

In 1205 when Hubert Walter, Archbishop of Canterbury, who had successfully run England for John's brother Richard, died, John nominated John de Gray his successor. The pope, who despised John (many despised John including his mother) publicly humiliated him by accepting the Bishop of London's nomination, Stephen Langton. John exiled Langton from England. The pope put John and his kingdom under an interdict and told the king of France to invade England. Under Church law the interdict – which lasted six years – meant that no religious services could be held – no marriage

or baptism was legal. As only those christened could get to heaven, babies born outside marriage were doomed to eternal damnation. An angry London turned on the Bishop who pronounced the interdict and he had to leave the country for his own safety. England then turned against John. To take revenge on the Bishop, John took Bishop's Stortford (given to the Bishops of London in perpetuity by King Offa) from him and destroyed Waytemore Castle. He then destroyed Benington Castle also owned by the Church. The pope retaliated by excommunicating him. Not that John cared.

By 1213, England had had enough of John and a council met in St Albans Abbey to debate his misrule and draft the Magna Carta to limit the power of the king. The Council practised a kind of democracy. It invited the shire reeve (sheriff) and four men from every town making it the first ever national representative body to draft a Charter of Rights, The Great Charter or Magna Carta.

In 1214 John lost the Battle of Bouvines (near Lille) to Philip II of France. Not that John was there, he was not very good at war. Philip had already taken much of John's lands in France. Not only did England lose all her revenues from France, not only was John forced to pay £40,000 for a five-year truce, at home, he had to face the barons whose lands he lost. To pay for his defeats in France, John tried to increase taxes in England. He failed. The Barons not only lost all their possessions in France they were now being forced to pay for John's ineptitude. No wonder they were furious. John's long standing quarrel with them began.

The Barons forced John to sign the Magna Carta at Runnymede in 1215. He immediately returned to Berkhamsted Castle to strengthen fortifications for war then moved his wife Queen Isabelle in. Richard Montfichet of Lech Ford (old Letchworth) Sheriff of Hertfordshire was one of the barons appointed to enforce Magna Carta. When he died on Crusade, his heart was buried under the church of St Mary The Virgin Letchworth. A small stone effigy of a knight holding a heart is still on the window sill. After his death, his family gave the manor of Lechford to the Templars to fund more Crusades.

When John reneged on promises made as he signed Magna Carta, Hertfordshire became a battleground for the civil war that resulted. John's men Walter de Godarvil held Hertford Castle and Waleran held Berkhamsted Castle while his army ravaged the lands of barons who opposed John.

The pope issued a fatwa saying that anyone who overthrew John was legally entitled to do so. In the end John caved in. He returned Stortford to the Bishops of London. Forced to rebuild Waytemore Castle at his own expense, he visited Bishop's Stortford 29 March 1216, to watch progress.

It says a lot when the great and the good of England loathe their king to such an extent they offer his crown to France. Louis, the Dauphin, arrived in Kent in May 1216 and was recognised as the lawful sovereign. Had not John died suddenly of dysentery, a second 1066 was on the horizon. The Shakespeare saying comes to mind: Nothing in his life became him like the leaving it. John's death did England a favour. It wasn't that England wanted a French king it was a case of anyone was better than John. With him out of the way and his son and heir Henry (III) only a boy the Barons decided to try again. However, they didn't manage to get rid of Louis until September 1217 eighteen months later.

Magna Carta 1215

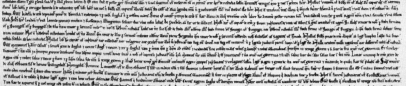

Photo Magna Carta © HK

John lost the lands in France his father Henry II died getting. His equally ineffective son Henry III also surrendered Normandy which had been in English hands since William the Conqueror. William would, if he could, have turned over in his grave (when his bloated body was placed in its tomb in Caen, Normandy, the coffin burst). Gascony alone was glad to remain in English hands because of its lucrative wine trade with England.

His father Henry II must have had a premonition about John. Although he was his favourite son, Henry left him no land in his Will – hence John's nickname Sans Terre – without earth – Lack Land. In 1216 he had in fact no land when he lost England.

On 16 December 1216, Hertford Castle surrendered to the Dauphin Prince Louis (Louis VIII). Berkhamsted Castle surrendered around the same time. John tried to leave the country but failed. Taking a shortcut across the Wash in Lincolnshire the tide rose faster than he expected and his luggage containing the Crown Jewels sank. A few days later, he died of dysentery. England survived to tell another tale.

9

HENRY III:
HERTFORD; KINGS LANGLEY;
BERKHAMSTED

King Edward, known for some reason as Edward the Confessor, built a palace and church near the monks of Westminster. To honour his hero, Henry III rebuilt the church around his shrine, giving us the Gothic building we have today.

Henry revered Edward the Confessor, the patron saint of England until Henry's son Edward I, named after the Confessor, favoured St. George. The only thing saintly about The Confessor seems to be that when his coffin was opened his corpse was intact. Pilgrims to his shrine thought he was a conduit to God. There is nothing new about the cult of celebrity. Henry also wanted a theatrical venue for the coronation of his son Edward I. All monarchs have been crowned in Westminster Abbey since William I. It was also for many years a mausoleum but later many royals were buried at Windsor.

With King John as a father what a childhood Henry III, first of his five children, must have had, and what a terrible start to his reign. As John had lost the royal regalia in the Wash Henry was crowned without delay in St. Peter's, Gloucester, with his mother's bracelet to prevent England falling to France. Only three Bishops and six Barons were present. Crowned again at Westminster in 1219 his contemporaries considered him: "The weakest in mental capacity of all the Plantagenets."

England, already in dire straits, got worse, a state of near anarchy. The barons who had asked the French for help to put down John now couldn't get rid of them and found themselves fighting France in the shape of the Dauphin, Prince Louis to save the English throne. Louis besieged Hertford Castle in 1216.

Henry's mother, the Dowager Queen Isabella of Angoulême was also under siege in her own home, Berkhamsted Castle. Her guards followed the usual procedures and took all the usual precautions to protect her such as placing pots of water along the tops of the castle walls. If the water rippled, they knew the enemy was digging underneath and rushed down to meet the enemy in fierce hand-to-hand combat. In the end, after two weeks' heavy bombardment the royal constable surrendered.

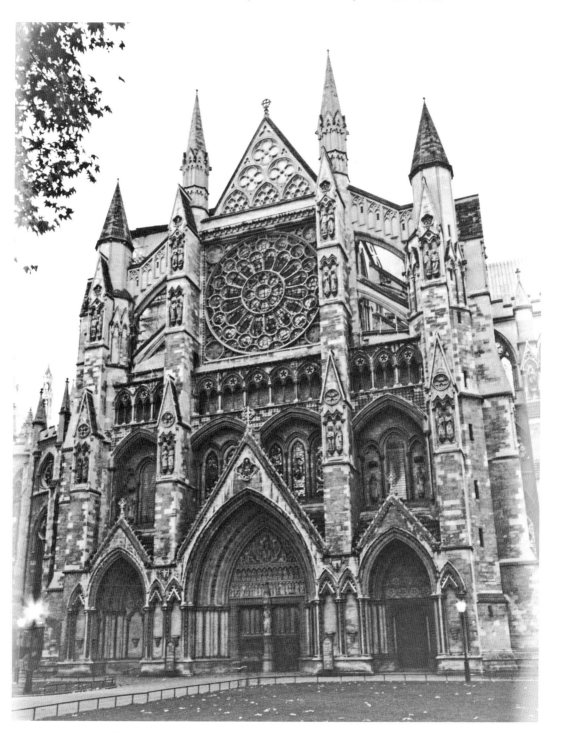

Westminster Abbey © Mark Playle

Isabella went back to France, married Hugh de Lusignan and had nine more children. On a pilgrimage to Fontevrault, Henry was distressed to find his mother buried outside the Abbey. She had after all been Queen of England. He ordered she be placed inside near his grandfather, Henry II, and his grandmother, Eleanor of Aquitaine. Afterwards, he and his half siblings set sail for England. Henry's court was not best pleased when he favoured them over old retainers.

When the French were finally driven out peace was restored in England. Henry gave Berkhamsted Castle to his brother Richard, Earl of Cornwall who used it as one of his main residences and as the administrative centre of the Earldom of Cornwall. Richard's wife Isabel died at the castle following the birth of Nicholas of Cornwall who also died. They were buried together at Beaulieu Abbey. Defeated at the battle of Lewes Hertford Castle became Richard's prison. In December 1271, he had a stroke and he lost the ability to speak. On 2 April 1272 he died at Berkhamsted Castle.

Richard's son, Edmund, 2nd Earl of Cornwall, was born at the castle. He founded a monastic order The College of Bonhommes in 1283 at nearby Ashridge which became a famous seat of learning. The building now on the site, dating from the late 1700s, designed by the architect James Wyatt, is still a place of learning (Ashridge Business School was established in 1959). Edmund left Berkhamsted Castle in his will to Henry III's son, the future Edward I.

Henry established a menagerie in the Tower of London. Mathew Paris, the chronicler monk of St. Albans Abbey, a very good artist, made drawings of his leopards, bears and the elephant. Henry knew Mathew Paris well. He liked St. Albans and stayed often at the Abbey. His visits cost the town a lot of money. He stayed a week in 1247. In 1252 took his son Prince Edward (Edward I) there for a week. In 1257 he stayed on three occasions with his wife, Eleanor of Provence. The Queen stayed there on her own in 1264.

It was Henry who re-discovered old Langley Manor House. Along with Berkhamsted Castle, it was originally owned by Robert, duke of Mortain, given to him by his half-brother, William the Conqueror. When Robert's son William of Mortain crossed swords with Henry I, Henry took Berkhamsted and Langley as Crown Property.

Henry III rebuilt the old mansion and used it as a private retreat. Only close friends and relatives were invited to stay. If the court or important guests had to be entertained he used St Albans Abbey, the Ritz hotel of its day. From then on for almost three hundred years until the Tudors abandoned it in the 1500s, Langley was the favourite private residence of Plantagenet kings. 1476 is the last recorded time it was used for a ceremonial occasion when the Abbot of St Albans held a banquet there for the Bishop of Llandaff.

It is to Henry that we owe the fabulous history of Langley (Lang – long Ley – lea) one of the most romantic places, historically speaking, in Hertfordshire. Although Robert of Mortain was the first royal to own it, Henry was the first to fall in love with the place and the first royal to build a home there. However it was not until his son Edward I and his daughter-in-law Eleanor of Castile built a magnificent palace there the nearby village became known as Kings Langley. The vast complex had completely disappeared by 1831 but the village continued to fly the royal standard until 1935.

By 1258 England was as fed up with ineffectual Henry as they had been with John, his psychopath of a father. History repeated itself. A council of fifteen nobles formed to govern the country. It included his brother-in-law, French born Simon de Montfort who put Henry, his son Edward and his brother, Richard, Earl of Cornwall under house arrest. Edward escaped and with his father managed to defeat de Montfort at the Battle of Evesham in 1265. Henry would have been killed had he not lifted his visor and shouted "Save me, save me, I am Henry of Winchester!" De Montfort was killed in battle.

Few remember much about Henry or his very long reign of fifty-six years. We remember his father John of Magna Carta fame, his son Edward, Hammer of the Scots, his uncle Richard Coeur de Lion and his grandfather Henry II but although Henry did not go on Crusade or conquer vast tracts of France his legacy was more long lasting. Little could he know that one day, a million visitors every year would cough up £15 each to wander round Westminster Abbey.

When Henry died in 1272 aged sixty-five he was buried in his magnificent creation. His burial established the Abbey as the principal royal burial place for the next 500 years. Henry's heart, as requested, was buried at Fontevrault Abbey in France near his mother.

Westminster Abbey is magnificent. Buried there are (alphabetically): Anne Neville, wife of Richard III; Anne of Cleves, fourth wife of Henry VIII; Charles II; Edward I and Eleanor of Castile; Edward III and Philippa of Hainault; Edward the Confessor and Edith; Edward V; Margaret Beaufort; Mary Eleanor Bowes Lyon; Edward VI; Elizabeth I; George II and Caroline; Henry V and Catherine de Valois; Henry VII and Elizabeth of York; James I and Anne of Denmark; Mary I; Mary II; Mary, Queen of Scots; Maud (Matilda) wife of Henry I; Prince Rupert; Richard II and Anne of Bohemia; William III.

Henry's Abbey has witnessed thirty-eight coronations: the first documented is that of William the Conqueror, the most recent is that of Elizabeth II on 2 June 1953. Before 1066 there was no fixed location for the coronation. Bath, Canterbury, Kingston-Upon-Thames and Winchester were all used. Harold Godwinson (Harold II) was at Westminster when Edward the Confessor died and it is likely that he was crowned the next day in the Abbey although there is no documentary evidence. Only two monarchs – Edward V (one of the Princes in the Tower) and Edward VIII (who abdicated) – were never crowned.

Henry VI, Edward IV, Richard III, Henry VIII, Charles I, Victoria and the Queen Mother are not buried at the Abbey. Edward VI, Mary I, James I, Charles II and Queen Anne have no monuments in the Abbey. They are buried in vaults with modern stones above as markers.

10

EDWARD I: KINGS LANGLEY; HERTFORD

Edward was named after his father's favourite saint Edward the Confessor.

After the disastrous reign of John and, except for his magnificent Westminster Abbey, the non-event reign of his son Henry III, how relieved the English were to get a proper king. Although he was the first Plantagenet king to be called Edward, England had already had three so apart from the little matter of Anglo Saxon England being invaded by France he would have been Edward IV. Alfred the Great's son, Edward the Elder, ruled for twenty-five years. Edward the Martyr was assassinated and Edward the Confessor founded The Palace of Westminster and Westminster Abbey.

This is the Edward, who to placate the Welsh for killing the Prince of Wales gave them a new one, his son Edward (II) of Caernarfon. Since then the heir to the throne is always made Prince of Wales. Edward, determined to subjugate the Welsh, invaded in 1277, defeated the Welsh leader, Llywelyn ap Gruffyd and built a ring of magnificent massive fortified castles to enforce his authority. This, understandably, provoked a rebellion so he invaded again. Gruffyd was killed in battle in 1282 and his brother Dafydd executed, ending Welsh hopes of independence. Small wonder two hundred years later Wales was so proud of Welshmen Owen, Edmund, Jasper and especially of Henry Tudor who became King of England. The tables had at last been turned.

Eleanor of Castile met Edward when she was ten and he a gangly twelve year old, so tall he was dubbed Long Shanks. He married Eleanor, the Infanta de Castile (Cockneys dubbed her the Elephant and Castle) when she was thirteen and he was fifteen although they didn't live together until she was nineteen. Her first child was born when she was twenty on the Eighth Crusade with Edward in 1270.

Henry III, Eleanor's father in law, was very fond of her. In fact everyone was very fond of her. Never mind Romeo and Juliet or Napoleon and Josephine, Edward and Eleanor had one of the most enduring of love affairs especially amazing in those troubled times. A till death do us part love match they had sixteen children. Never mind the Taj Mahal either; this is the Eleanor of all those famous crosses a grieving Edward built at every

place her coffin stopped overnight on its journey from the north to Westminster Abbey. The magnificent Waltham Cross in Hertfordshire is one of only three remaining.

When Henry III died in 1272 Edward and Eleanor returned to England. They were the first monarchs to be crowned in his father's newly rebuilt but incomplete Westminster Abbey. Since Edward, the 'new' Abbey has witnessed thirty-eight coronations the most recent of course being Elizabeth II in 1953.

Gone down in history as The Hammer of the Scots (and Welsh) Edward took the Stone of Destiny from Scone on which Scottish kings were traditionally crowned and commissioned an English oak Coronation Chair to enclose it. The chair has been used at every coronation since. The Stone was returned to its owners in 1996.

Very patriotic, wanting to foster a sense of nationhood Edward vowed to preserve the English language. He spoke French and English. Eleanor spoke only Spanish. You do wonder what language they communicated in.

Edward formed the Model Parliament bringing the Lords and Commons together for the first time. Langley in Hertfordshire was much loved by Edward's father. However, it was only in 1270 when Edward and Eleanor built a magnificent palace on the hill above the village, Langley became known as Kings Langley.

The palace even had a bathroom. The couple ordered Windsor Castle to send thirty barrels of wine for their new cellar which is still there under the present day Rudolf

Kings Langley Village Sign © Ian Pearce

Steiner School. Philippa spent so much money on the palace she got into debt so Edward, although he was very indulgent, abolished her private household. All future expenditure had to be approved by him.

With Edward often away engaged in his many battles, Eleanor supervised the construction of Kings Langley Palace. When it was finished, Edward and Eleanor spent 1286 there. Was this when 500 oak trees on the estate were felled to rebuild parts of the Tower of London? Eleanor loved it here and stayed as often as she could but the couple was not destined to enjoy their dream home for long. In 1290 Edward was in the north of England waiting for Eleanor to join him. At forty-one she had just given birth to her sixteenth child who did not survive. At Lincoln, she became unwell. By the time she got to Harby, in Nottinghamshire, she was dying. She received the last rites 28 November. Some sources say Edward was at her bedside, others that he didn't quite make it. Either way he was devastated.

Her body was taken to St Catherine's Priory in Lincoln to be embalmed. Her viscera were sent for burial in Lincoln Cathedral where Edward later put a duplicate of her tomb in Westminster. Her heart which travelled with her was buried in Blackfriars Church. Her body was sent for burial in Westminster Abbey where she was placed at the feet of her father-in-law Henry III. This meant that prayers for Eleanor's soul were said at four separate locations.

Edward ordered that her effigy be made of bronze, not wood as was the norm, and that it be covered in gold. Gold florins were imported from Italy and melted down. He paid for candles to burn at her tomb in perpetuity. They burned for two hundred and fifty years until Henry VIII who was a Tudor not a Plantagenet extinguished them.

Between 1291 and 1294 Edward ordered that magnificent memorial crosses be built at each place Eleanor's body rested overnight on the way to Westminster Abbey. The cortège took twelve days to get to London. Stopping places included Lincoln, Grantham, Stamford, Geddington, Hardingstone Northampton, Stony Stratford, Dunstable and St. Albans. At Waltham Abbey, the queen lay in state for four months before going on to Chère Reine (dear queen) Cross (Charing Cross).

Only the Crosses at Geddington, Hardingstone and Waltham Cross in Hertfordshire survive. Cromwell's soldiers used the one at St. Albans for target practice. It was demolished 1702. There are replicas at Banbury and Charing Cross. Geddington is the best-preserved of the three remaining originals although Waltham Cross recently cleaned and restored is well worth the trek. Well done Hertfordshire County Council.

A grief-stricken Edward gave Eleanor's precious Kings Langley to his son Edward (II) who was brought up there. He too loved it. Edward now stayed at Ashridge. He ordered parliament to assemble there saying he intended to stay a long time. It assembled there again in 1291. In 1295 Edward summoned parliament to assemble in St Albans.

Nine years after Eleanor's death, Edward, sixty, married seventeen-year-old Margaret, daughter of Phillip III of France. He gave her Hertford and Berkhamsted Castles. They had three children and the marriage was very happy.

In 1299 Edward returned to Langley. This is the first evidence it had become Kings Langley. State Papers say Edward summoned the bishop of Norwich, the abbot of St. Albans, and the count of Savoy to celebrate All Saints Day at King's Langley.

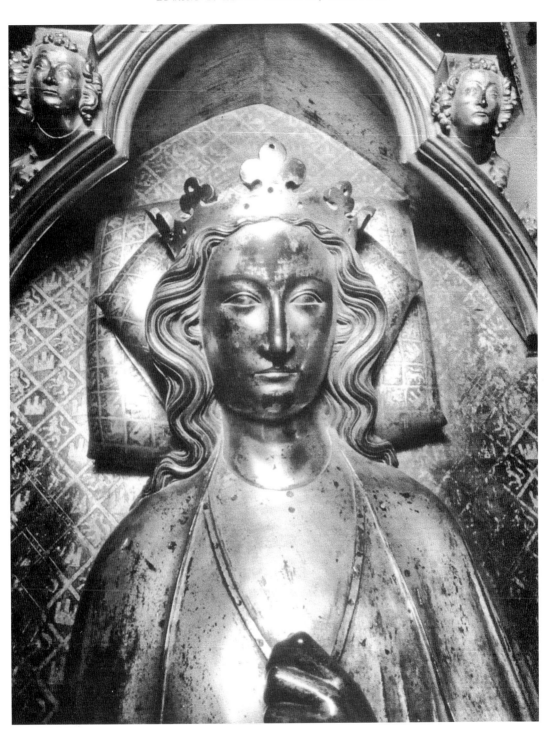

Effigy Eleanorof Castile © Dean & Chapter of Westminster

The Eleanor Cross at Waltham © MAK

To reward special services to the Crown Edward granted The Standard (flag) of Honor to Hertford in 1304. When his descendant John of Gaunt inherited the Duchy of Lancaster he incorporated the town and castle into the duchy.

As a former manor of the Honor of the Duchy of Lancaster, in 1926 Hertford was granted its ancient status of Honor by the College of Heralds. The Standard (banner/flag) has a stag and the arms of the Borough. Hertford is one of only two towns permitted to carry the Standard ahead of the Queen. The other is Launceston which holds the Standard of Honour for the Duchy of Cornwall.

Although known as the hammer of the Scots, he never quite did. Edward was on his way to fight Robert the Bruce when he died near Carlisle in 1307 aged sixty-eight. He, like Eleanor, lay in state at Waltham Abbey before being interred in Westminster Abbey. His large grey marble tomb has no effigy or decoration. The inscription "Edwardus Primus Scotorum Malleus. Pactum Serva" (Edward the First, Hammer of the Scots. Keep Troth) was not painted on until the 1500s.

In 1774 his tomb was opened and inside a Purbeck marble coffin his corpse was found to be almost complete still wrapped in a waxed linen cloth wearing royal robes of red and gold with a crimson mantle. He had a gilt crown on his head and carried a sceptre surmounted by an enamelled dove and oak leaves.

His widow, Margaret, never remarried. She said: 'When Edward died, all men died for me'. She lived for ten years after his death, dying at the age of thirty-six. She was buried at Greyfriars Church in Greenwich.

The Hertford Honor, courtesy Hertford Town Council

11

EDWARD II:
KINGS LANGLEY; ST. ALBANS

To placate the Welsh for killing the Prince of Wales Edward I gave them a new one, his son Edward (II). Wanting him to be native-born he arranged for Eleanor to spend her confinement in Caernarfon. In Wales, always referred to as Edward of Caernarfon, never the Prince of Wales, he was officially invested with the title when he was seventeen. Since then the heir to the English throne is always made Prince of Wales.

Edward II was the youngest of Edward I and Eleanor of Castile's sons. By the time he was born seven of his siblings were dead including Alphonso, heir to the throne who died age eleven. Edward was brought up at Kings Langley, his parent's favourite private residence where only close friends and family were invited, with his nurse, his doctor and his tutor. An idyllic place for a child to grow up, six miles from St Albans, the palace – as grand as the Palace of Westminster – had eight acres of parkland and one hundred and twenty acres of farmland. Edward kept a camel and a lion there.

Langley Palace was luxurious and, unusually for royal palaces, warm. All the bedrooms had fireplaces. No wonder it was among royalty's favourite places to stay. It even had a bathroom installed by Edward's mother. Whenever they were in England this is where his parents spent the winter – November to March – with their children. It had deer parks, fishponds, meadows, water mills and orchards. Royal painters made the interior colourful and welcoming. The Great Hall with its two huge fireplaces had crimson and gold walls, paintings of shields and a colourful mural of knights riding to a tournament.

Locals groaned when the large extended family was in residence. Two hundred dishes were served every day so local markets were raided for cheese, eggs, bread and beer. Worse, the royal family considered it an honour to supply the palace so very little, if anything was paid for.

One of sixteen children Edward was King by default, the youngest and only one of four brothers to survive. Sadly, his mother died when he was seven. A square peg in a round hole, Edward was irresponsible, unconventional, rebellious and his own worst

enemy. He ruled for a mere twenty years but what momentous decades they turned out to be. His reign was one of the most dramatic in English history not because of bloody wars but because Edward sacrificed his crown and his life for love. He was nothing if not loyal. He was also a good, loving, father who adored animals. What he did not love was being king.

Edward found court and courtiers boring, the lower orders were much more authentic. He liked watching artisans such as stonemasons, carpenters, blacksmiths, bricklayers, thatchers, hedgers – men with practical skills. He loved horse racing, music – he had his own small orchestra – and the theatre. He also of course loved Piers Gaveston and, after Piers' death, Hugh Despenser. No-one else loved Piers, Public Enemy Number One. Edward carried on his affair with 'The Gascon' in King's Langley. His closest friend from childhood, Gaveston made Edward laugh with his witty, irreverent, cruel nicknames for their enemies. Edward's parents' love for each other was of the till-death-to-do-us-part variety and so it was for Edward and Piers who were soul mates.

Edward is remembered for being the first English Prince of Wales, for not being like his father, Edward I, the Hammer of the Scots (and the Welsh) or his son Edward III who fancied himself as King Arthur. Both loved war. Edward II was not interested. He preferred the arts, taking it easy; doing what he wanted to do not what others demanded he should. He did have a crack at war but although he fought bravely Edward was defeated at the famous Battle of Bannockburn which ensured Scottish independence until the Act of Union in 1707. Life, for Edward, was about enjoying himself, preferably with Gaveston another fact he's remembered for. He is also remembered for being murdered in Berkeley Castle.

Good looking, tall and athletic Edward was every inch a Plantagenet. At eighteen, there can't be many things more wonderful than owning your own home to entertain friends but this is what happened when his father gave him the palace of Kings Langley. It became his favourite home but he shocked England by sharing it with his beloved Piers.

Gaveston, born in France, was brought up in the English court as a companion for Edward. Such was his influence over the besotted Prince that when the men were twenty-three the king banished Gaveston from England. Edward brought him back when his father died in July 1307 and made him Earl of Cornwall, a title reserved for close members of the royal family. Small wonder the nobles were incensed, it effectively made Gaveston, a commoner, a member of the royal circle which of course was Edward's intention. Marrying off his niece, the daughter of a royal English princess, to a French nobody infuriated the court even more. Edward gave Piers Berkhamsted Castle which did not please its owner, Edward's step-mother, the Dowager Queen Margaret of France, his father's second wife. When she finally got it back, she spent Christmas there in 1311.

His father was barely cold in his grave when Edward arranged for his niece, Margaret de Clare, to marry Piers. Five days after his father's funeral he arranged a lavish wedding celebration for the couple at Berkhamsted Castle. Edward rode over from King's Langley where he was staying to attend the wedding. Elaborate feasts at

Berkhamsted were followed by more at Kings Langley where Edward and Piers spent November and December until Edward left for Boulogne to marry the twelve- year-old Princess Isabella, daughter of Philip of France. He appointed Gaveston Keeper of the Realm in his absence. The barons were aghast. They had expected the King to choose a close family member.

When Edward returned to England Piers was waiting for him. Their public fond embrace hurt and humiliated his young bride. Just two weeks after Isabella heard wedding bells she sensed warning bells. Edward spent their first night back in England with Piers. To add insult to injury Edward gave him many of their wedding presents.

Things went from bad to worse. In February when Edward and Isabella were crowned at Westminster Abbey everyone was shocked when Gaveston turned up wearing the royal purple instead of an Earl's cloth of gold and even more shocked when he, a commoner, was given the honour of carrying the crown. His provocative behaviour at the coronation feast which followed offended all who attended. Edward's preference for Gaveston's company escaped no-one's notice. They spent the evening chatting and joking ignoring Isabella. Her uncles, who had travelled with her from France, were offended. They left early to report back to her father that Edward had publicly insulted her. To quote another princess, there was a third person in the marriage.

By this time Parliament had had enough of Gaveston and demanded he be banished from England. Edward sent him to Ireland as Lord Lieutenant. While Piers was away Edward busied himself founding a Dominican priory at Kings Langley. While it was being built, the friars stayed in the grounds in a royal lodge known as Little London. Edward had intended to house a hundred friars but settled for forty-five. He was very generous to the Order. He allowed them £150 each year and supplied them with corn. The first prior, John de Warefeld, became Edward's personal confessor. He later gave the friars money to build a church, the church where one day Edward would hold Piers' funeral.

He had something else to occupy him too. The Knights Templars were being hounded out of existence. They held their National Chapters (AGMs) in Hitchin preceptory (Temple Dinsley), one of the named places where their alleged crimes of devil worship, black magic, blasphemy, idolatry and sodomy took place. Chapters of the Order were held here on numerous occasions between 1219 and 1310.

Near the preceptory is St Ippollitts where before going on Crusade Templars brought their horses to the altar to be blessed. The crosses on the pillars inside are believed to have been cut by them. Gilbert de Clare, Margaret Gaveston's father, gave the Templars the nearby town of Baldock (arms of the town carry the red cross of the Knights and chevrons from the Arms of the de Clare's). By 1307 however the Templars were so rich and so powerful they held all authority including that of the Pope in such contempt the Pope issued a Bull ordering the Order to disband.

When Pope Clement accused the Templars of heresy, Isabella's father, Philip of France, decided to get his hands on their fortune. He arrested those in France and asked Edward to close the Commanderies in England. Edward refused. A hounded man himself, he had no appetite to hunt down Templars. The pope only accused the Templars of heresy, it was Philip who accused them of sodomy saying they were debauched, unnatural and depraved; a public dig at Edward and Gaveston.

Remains Kings Langley Priory © MAK

Edward agreed to suppress the English Order if the pope gave absolution to Piers who had been excommunicated. Supported by unlimited finances, ships, horses, friends and allies, many English Templars had long gone to ground. Temple Farm in Bengeo and Royston Cave were said to be two of their hiding places. The astonishing cave, unique in the world, under Melbourn Street has carvings of saints revered by Templars.

Victoria County History Online says: 'At the time when the Templars were all arrested by the king's order in January 1308 there seem to have been six brothers at Dinsley, since the manor was charged with the maintenance of that number between 14 February and 12 June while they were imprisoned in Hertford Castle. Whether, however, they were resident at Dinsley and whether they included Richard Peitevyn and Henry de Paul, 'brothers at Dinsley,' who were afterwards sent to the Tower of London, is uncertain. There were besides six men then living at Dinsley as pensioners of the house: one who had meals at the squires' table and five who boarded with the brothers '.

When Edward told the Pope that torture was illegal in England the Pope sent over ten of his own trained skilled torturers. Threatened with ex communication Edward, forced to allow them entry into England, ordered there must be: 'No violent effusions of blood and no permanent wounds inflicted'.

In 1309 Edward connived to recall Piers from Ireland and they spent Christmas together at King's Langley. The rows with parliament escalated. By 1311 Edward was forced to agree to the permanent exile of Gaveston. He went to Flanders but returned

secretly in 1312. When Gaveston's daughter, Joan, was born in January to his wife Margaret, Edward threw a grand celebration.

The furious, outwitted barons took up arms at Wheathampstead and assembled their forces for civil war. On 4 May they attacked Newcastle where Edward and Gaveston were staying. The pair, forced to flee by ship, left behind their money, soldiers and Isabella.

Leaving Gaveston in Scarborough Castle Edward tried to raise an army. Under siege, Gaveston surrendered and was taken to Warwick Castle. He was there nine days until Edward's cousin the Earl of Lancaster said:" While he lives, there will be no safe place in the realm of England." On 19 June, Gaveston was taken to nearby Blacklow Hill Warwick (which belonged to the Earl) and beheaded.

Piers' corpse was taken to the Dominican friars in Oxford (there is still a Piers Gaveston Society in Oxford) who sewed his head back on before Edward saw the body. As Gaveston had yet again been ex-communicated he could not be buried in holy ground so was embalmed and put in a coffin. Edward, his step mother Dowager Queen Margaret and Gaveston's widow Margaret paid for the corpse to be guarded and for the waxed cloths in which he was wrapped to be changed regularly. Edward was very generous to Margaret Gaveston and her daughter. He arranged a second marriage for her to his friend the Earl of Gloucester. They too had one daughter, Margaret. Joan Gaveston, sent to Amesbury Priory, died there age thirteen in 1325.

Edward bided his time. Ten years later, he would avenge Gaveston's death when he had Lancaster executed for treason.

The barons now forced a cornered Edward to produce an heir or else. Edward of Windsor, the future Edward III, was born nine months later. He and Isabella went on to have three more children, John of Eltham, Earl of Cornwall, born 1316 Eleanor of Woodstock, born 1318 and Joan of the Tower, born 1321 who age six was married off to King David II of Scotland.

It took Edward three years to gain absolution for Piers. When it came he left King's Langley to escort Gaveston 'home'. He ordered a special carriage with five horses to carry Piers from Oxford to Langley where they had spent their happiest days. It was here in his Royal Chapel on 2 January 1315 Edward buried Gaveston with great ceremony in an elaborate funeral. Three marquees were brought from London to accommodate as many dignitaries as Edward could muster bearing in mind how loathed Gaveston was. Isabella attended the funeral. It wasn't easy for Edward to find a cleric willing to officiate given that the Pope had excommunicated Gaveston on a few occasions but eventually, the bishop of St. Albans agreed to conduct the ceremony. A grateful Edward gave the Abbey a considerable sum of money. A head, said to be of Edward, can be seen on one of the corbels on the south side of the nave with Queen Isabella.

Stephen Potter says as the original nave collapsed in 1323 when Isabella was in France plotting the demise of her husband it's unlikely the Abbey would immortalise an unpopular, deposed, homosexual King and his (understandably) vindictive wife in the rebuilt nave. He thinks the heads are of Edward III (son of Edward II) and his wife Philippa of Hainault. However, the Coat of Arms above the woman's head are those of Isabella not those of Philippa. Also it should be remembered that when Edward

buried Gaveston, Isabella was with him at the funeral. At that time they were enjoying a reconciliation. Edward and Isabella spent Christmas 1321 at Kings Langley. She occupied his mother Eleanor's old apartment overlooking the great court and enjoyed Eleanor's private bathroom installed in 1279. Could it be that the heads were carved then? The idyll was not to last. In 1324 when Edward fell in love with Hugh Despenser, a furious Isabella had had enough. She took Roger Mortimer as her bed mate. The father of twelve children was married to a wealthy heiress.

Edward built a chantry in Langley priory where prayers were said for Piers every day. Twice a year on the anniversary of his birth and death Edward paid for masses to be said and bought new elaborate cloths to cover his tomb. Piers Gaveston might very well be still in King's Langley (bring in Tony Robinson and the Channel 4 *Time Team*).

In 1326 William, Count of Hainaut in Holland, provided Isabella and Mortimer with eight man-of-war ships to invade England and depose Edward in favour of his son in return for a marriage contract between his daughter Philippa and Isabella's son, Prince Edward. The contract was honoured, the marriage was very happy and Phillippa got on very well with her formidable mother-in-law.

When Isabella and Mortimer landed in Suffolk with an army, Edward's so called allies deserted him. He was captured and forced to abdicate in favour of his son, yet another Edward. The lad, fond of his father, agreed to be King only when Edward sent him the sceptre and crown. As he was only fourteen his mother ruled as Regent.

Edward II was murdered in Berkeley Castle. It was intended that he die of 'natural' causes but like the Russian monk Rasputin, was too robust. His jailers shaved his head and beard so he was unrecognisable. They took him along byways by night from Kenilworth. To weaken his constitution he was not allowed to sleep. He wore only a thin nightshirt expected to die of hypothermia, given rancid food and dirty water expected to die of food poisoning. Every word he uttered was repeated back to him in mockery so that he would lose his reason and was given a crown of hay.

Jailers were instructed to leave no marks on his body. According to Sir Thomas More: 'On the night of October 11 (1327) while lying in bed [the king] was suddenly seized and, while great mattress... weighed him down and suffocated him, a plumber's iron, heated intensely hot, was introduced through a tube into his secret parts so that it burned the inner portions beyond the intestines'.

His corpse was taken to Gloucester Cathedral enclosed in a lead coffin and buried three months later but no one actually saw his face. Ian Mortimer's *The Greatest Traitor* contains a letter from a Manuele de Fieschi, notary of the pope, sent to Edward III telling him that his father did not die in Berkeley Castle but with the help of his jailers managed to escape. The man who said he found the Fieschi letter, Alexandre Germain, a French archivist, published it in the 1870s. It starts: In the name of the Lord, Amen. Those things that I have heard from the confession of your father I have written with my own hand and afterwards I have taken care to be made known to your Highness'.

If Edward III received the letter he might have believed it because in 1334 he wrote to one of the alleged murderers, Sir John Maltravers, and offered him a job with a high salary.

12

EDWARD III:
BERKHAMSTED; HERTFORD;
KINGS LANGLEY

Edward III, who has been called the father of the English nation, had close connections with Hertfordshire. Like his father, grandfather and great-grandfather he loved Kings Langley and stayed there often with his wife Phillippa of Hainault, their children and grandchildren. He and Phillippa were a great team.

He gave Berkhamsted Castle to his first son, Edward of Woodstock, the Prince of Wales and Hertford Castle to his mother the Dowager Queen Isabella of France. When she died he gave it to John of Ghent (Gaunt to the English) his fourth (surviving) son.

Edward supported and was very generous to Kings Langley Priory founded by his father. He gave the friars four tuns of wine a year, access to his park, fishing rights and permission to build a weir and underground aqueduct to the Priory. Because Dominicans were not allowed to own property, he founded a convent there and asked the Treasury to grant it £300 each year to keep the Sisters and the friars. Edward also gave them land in Ware, Willian and Great Gaddesden.

Edward and Phillippa created a happy harmonious close-knit family which is amazing considering his own dysfunctional family. Because of his father's love affairs with Piers Gaveston and Hugh Despenser his parents were at each other's throats. Then there was the little question of his mother taking Roger Mortimer as her lover, ousting his father from his throne and turning a blind eye when he was murdered.

Edward and Phillippa had thirteen children. Five were boys. Dowager Queen Isabella was very close to Edward, her first grandchild. Their second son, Prince William of Hatfield, died as a baby in 1337 (Hatfield was owned by the Bishops of Ely). The third was Prince Lionel of Antwerp named after a knight at King Arthur's Round Table (Lancelot's cousin). The fourth was Prince John of Ghent (Gaunt). The fifth, Prince Edmund was born baptised and died at home in Kings Langley. They all got on very well but the next generation was eaten up with jealousy. Descendants of Lionel the third son would kick start the Wars of the Roses when they took on the descendants of John the fourth son.

Edward and Phillippa, who fortuitously, turned out to be very happy together were pawns in the plan Edward's mother Queen Isabella set in motion. To depose her husband and to put her son on the throne Isabella agreed Phillippa could marry Prince Edward if her father, the Count of Hainault, gave her ships so that she could invade England, depose her husband and put her son on the throne. He agreed.

Isabella and Roger Mortimer ruled England until Edward reached eighteen. Edward then had Mortimer executed for treason and put his mother in honourable confinement. He granted her Hertford Castle and the Town and Honor of Hertford (which included Bayford, Essendon and Hertingfordbury). Fond of his father who was kind to him, to honour his memory, Edward built an impressive monument over his tomb in Gloucester Cathedral.

When Phillippa came to England from Belgium she brought with her Sir Payne de Roët, a courtier. One day Phillippa's son John would marry his daughter Katherine. His other daughter Phillippa would marry Geoffrey Chaucer of *Canterbury Tales* fame, Clerk of the King's Works at Kings Langley and Berkhamsted.

Everyone seems to have loved Phillippa, including Isabella her formidable mother-in-law. Kind, generous and a steadying influence on her husband she was highly respected. Theirs was a very close marriage despite Edward's infidelities. She frequently acted as Regent during his absences. The chronicler Froissart described her as "tall and upright, wise, gay, humble, pious, liberal and courteous."

This is the Edward who in 1348 founded England's oldest, most famous Order of Chivalry, The Order of the Garter. A mark of special royal favour, it consisted of the King and twenty-four knights who served him personally. Edward was very taken with the idea of King Arthur and the Knights of the Round Table. The Oxford DNB says Edward probably formed it to celebrate his victory at Crécy and its motto *honi soit qui mal y pense* – shame on him who thinks badly – may refer to Edward claiming the throne of France. The garter was worn on the arm outside armour. It's not known how the much more romantic legend started. Dancing with the King at a ball, the Countess of Shrewsbury was embarrassed when a garter fell from her stocking. Edward, a notorious womaniser, tied it around his own leg and said 'honi soit qui mal y pense'.

Edward created the Prince of Wales, duke of Cornwall and gave him Ashridge and Berkhamsted Castle as part of the newly-created Duchy. The castle is still owned by the Duchy – Prince Charles has visited. The Arms of Berkhamsted include a castle with three towers with a border from the Arms of the Duchy of Cornwall. Berkhamsted Castle was one of the Prince's favourite homes. He always tried to spend Christmas there and enjoyed hunting in its extensive deer park. His grandmother the Dowager Queen Isabella, a frequent house guest, was often invited to spend Christmas with him. This is where he spent his honeymoon with Joan, the Fair Maid of Kent. It was from here he rode off at the head of his troops, many of them Berkhamsted men, to win at Crécy and Poitiers.

His father put him in charge of all English lands in France – as well as Prince of Wales Edward was Prince of Aquitaine – but things quickly fell apart following his death. You are only as good as your last battle. At the time of his death he was still Prince of Aquitaine as depicted by the fleur-de-lys on his tomb. Edward was so revered,

such a national icon, he was buried next to Thomas Becket in Canterbury Cathedral. No-one knows when his nickname – The Black Prince – originated but it was not known until the 1500s. It may be because: history has so many Edwards it was useful to differentiate him; he wore black armour; it's how the French thought of him after the carnage at Limoges, a stain on his heroic reputation.

Edward III's reign was so long (sixty-five years) and so eventful the rest of this entry, for the sake of clarity, is in chronological context.

1327 Edward grants the Castle, the Town and the Honour or is it Honor of Hertford Bayford Essendon and Hertingfordbury to his mother Dowager Queen Isabella.

In 1328 when King Charles IV of France died, his only heir was his sister Dowager Queen Isabella of England (their father was King Philip the Fair). In France women could not succeed to the throne. Although her son Edward was her brother's closest male relative, the crown passed to her sixteen year old cousin, who reigned as Phillip VI.

William I added Normandy, Brittany and Maine to England. His great-grandson, Henry II, added Anjou, inherited from his father and Aquitaine via his wife Eleanor of Aquitaine. Henry's son King John lost Brittany, Poitou, Anjou and Maine, his grandson Henry III surrendered Normandy. Now, in 1337 Philip VI took Aquitaine. A furious Edward challenged Philip's right to the throne, formally styled himself King of France and kick started The Hundred Years' War (lasted one hundred and eighteen). He toured England recruiting archers promising to pay them three pence a day if they succeeded in regaining England's lands from the French. The strategy worked.

In 1341 Edward's fifth and last son, Prince Edmund, was born to Philippa at King's Langley. Baptised there by the Abbot of St. Albans he was brought up in the nearby nursery palace at Chilterne, or Children's Langley – now called Abbot's Langley. The royal house of York took its name from Edmund's creation as the first duke of York.

1346 In August Edward won a victory against the French at Crécy (between Paris and Calais) with the Prince of Wales, sixteen, who won his spurs and became a national hero. His armour was black, hence The Black Prince. Like his father and grandfather the Prince was a natural leader on the battle field.

After the battle, the motto *Ich Dien* (I Serve) was found under a plume of ostrich feathers in the helmet of the king of Bohemia, a volunteer in the French army. To honour the old king, who, although almost blind, his horse tied to those of four knights, bravely insisted on fighting to the death, the Prince of Wales adopted his emblem and motto. Both are still the emblems of the Prince of Wales.

Edward then embarked upon the Siege of Calais. It took him eleven months to capture the key maritime port and claim it. He was determined to make an example of the Burghers but Philippa, once again heavily pregnant, pleaded for their lives hence the famous statue The Burghers of Calais. Calais remained in English hands for the next two hundred years until the French got it back during the reign of Mary Tudor. In October of the same year Edward defeated the Scots at the Battle of Nevills Cross. He took his brother-in-law, King David II of Scotland prisoner, brought him to London and put him in the Tower. He was there for some time as his subjects would not raise the ransom money to get him back (when Edward died it still hadn't been paid). Fighting a

war is very expensive, holding rich people from the opposing side to ransom was a way of paying for it. Towns and villages in occupied territories contributed rather than have their homes torched.

Edward was a man's man. Because of his victories in France, England was admired and feared all over Europe. Under him, the English became nationalistic and very patriotic. They began to shun the French language and all things French as being inferior to all things English (perhaps too they had never forgiven them for invading in 1066).

Fate moves in strange ways. Because David of Scotland was captured this meant Dowager Queen Isabella got to meet her daughter Joan again who she had not seen since she married David when she was six years old. Queen Joan was now twenty-five. It was a joyous reunion. Isabella suggested that Joan move into Hertford Castle, near enough to London for her to visit her husband in the Tower. Queen Phillippa and Queen Joan's brother King Edward often visited her at Hertford. Mother and daughter became very close.

1348 – London is struck by bubonic plague, the Black Death, killing a third of the population. Edward moves his Court to King's Langley. The infected developed black swellings in the armpit and groin, black blotches on the skin caused by internal bleeding, became feverish and began spitting blood. Edward's daughter, Joanna, died of the plague on her way to Bordeaux to marry King Pedro of Castile.

1350 – Prince John worshipped his eldest brother Edward, Prince of Wales and lived with him at Berkhamsted Castle from March 1350 until May 1355. The feeling was mutual. Edward was close to John.

1352 – King Edward divides parliament into the House of Lords and the House of Commons. Treason is defined by law.

1353 – All court cases now heard in English. Like his grandfather Edward I, Edward III was patriotic and determined to bring back English as the first language.

1354 – Autumn The Prince of Wales spent a year at Berkhamsted Castle (until autumn 1355) preparing for battle in France (again). He invited his grandmother to spend Christmas with him. Edward made plans to go to Aquitaine and for his brother John to go to Normandy. Before leaving they made pilgrimages to Becket's shrine. In the event, John had to abandon Normandy to help Edward.

1356 – Prince of Wales fights at Poitiers. King John of France now owned all the land which once belonged to England including Normandy, Anjou and Aquitaine. With Edward's army half the size of his, John demanded a hundred knights surrender as hostages including the Prince. Instead, the Prince repeated his father's tactics which proved so successful at Crècy, turned the tables on John and took him and his son Louis hostage. That night, John, who had won Edward's respect by showing great courage in battle dined in the red silk tent of The Black Prince. He was then taken to London, St Albans Abbey, Berkhamsted Castle and then to Hertford Castle. Isabella gave him a book about Lancelot and the Holy Grail. His subjects did not raise the required ransom so John spent the best part of his reign in England. He lived in Hertford in style for four years (he had ruled for only five) was granted royal privileges and permitted to travel freely. He bought horses and clothes and kept a royal astrologer. At Easter he

went to Mass at St. Leonard's Church in nearby Bengeo. While there his dogs killed a pig belonging to Master Revell of nearby Revells Hall. The King paid ten shillings compensation. King Edward now had two royal hostages, David and John. The three Kings often attended tournaments together.

1357 – King David and Queen Joan return to Scotland. When David took a mistress Joan went back to Hertford Castle. Isabella paid for her wardrobe and food and visited often with Queen Phillippa. Like Margaret of Anjou a hundred years later, Isabella was dubbed She-Wolf of France. Like Margaret she was determined to guarantee her son Edward's right to England's throne, ready to fight to the death to secure it. (Isabella managed it, Margaret did not. Her Edward would have been Edward IV had he not died in battle). By now Isabella was regarded as an elder stateswoman and Edward often turned to his mother for advice.

1358 – June. Joan and her mother visit the shrine of Thomas Becket in Canterbury. Isabella, sixty-three, not feeling well took her doctor with her. In August they were back in Hertford Castle but Isabella became worse and doctors from London were sent for. She died 22 August with Joan at her bedside. She left instructions to be buried in the red and yellow satin wedding cloak she had kept all her life and in her hands should be placed a casket holding her husband's heart, the husband she hounded to his death. She was put in Hertford Castle chapel where she lay in state for three months wrapped in her cloak. Edward paid fourteen poor people two pence each per day to guard his mother's coffin round the clock. At Hertford, the bishop of Lincoln, the Abbot of Waltham Abbey and the prior of Coventry took it in turns to say a requiem mass over her. Edward arranged a lavish funeral for her at the end of November. He ordered the sheriff of London to clean the streets and lay gravel on main roads. Her chief mourner was her grandson the Prince of Wales (reigning monarchs did not attend funerals). Watching the cortège was a close friend of the family, Geoffrey Chaucer. Edward commemorated his mother's death every year.

1359 – October Edward took his sons the prince of Wales, John of Gaunt and Edmund of Langley on his next foray into France. He also took an army of 12,000. What a sight that must have been. This time, Edward was determined to be crowned king of France. It didn't happen. Instead he agreed to terms. France would pay England three million crowns for King John's ransom; it ceded to England an enlarged Aquitaine independent of the French crown; Edward would renounce his claim to the French throne. Aquitaine was now an English sovereign state. The Treaty of Bretigny was signed May 1360.

1360 – Prince John of Gaunt and his wife Blanche of Lancaster have a daughter. John married Blanche, daughter and heiress of the wealthy Duke of Lancaster when she was fourteen. They would have four more children. His brother, the Prince of Wales is still single. One of Blanche's ladies of the bedchamber is Katherine Swynford née Roët. John's father gives him Hertford Castle for his first home. The delighted new owner embarked on a schedule of lavish improvements and transformed the down at heel castle into a palace. He employed Henry Yvele famous for Westminster Hall, Westminster Abbey and Canterbury Cathedral to work on it. Yvele the greatest master mason of the age also worked on palaces for his brother the prince of Wales. Of his thirty castles, Hertford remained one of John's favourites all his life.

1361 October. Edward, the Prince of Wales secretly weds a twice married, widowed mother of five. Worse, she is his 'kissing cousin' Joan Plantagenet, Countess of Kent. Her father, the earl of Kent, was executed by the Prince's grandmother Isabella for trying to restore the deposed Edward II. The marriage was secret because it was illegal for cousins to marry. Unusual for the day, this was a genuine love match, not a political alliance. Joan was brought up with Edward in Queen Philippa's household. They had known each other all their lives. She was as feisty as he was as fearless. As far back as 1348 Edward was buying 'Jeanette' expensive presents.

His parents King Edward and Queen Phillippa were horrified by the marriage. The heir to England's throne was the most eligible bachelor in Europe. No financial or political advantage to England would be got from this coupling. Never the less they attended a second official ceremony stipulated by the pope so that they could receive his dispensation to marry.

Joan, beautiful, stylish and an incorrigible flirt was the most scandalous woman of her age. This was not her first secret marriage, it was her third. She entered into a secret marriage with Thomas Holland when she was twelve. The following year while her husband was away on Crusade assuming she had seen the last of him she secretly and bigamously married William Montacute, Earl of Salisbury. When Holland returned to England a few years later he appealed to Pope Clement for his wife's return. When Joan, bizarrely, supported his appeal, Salisbury kept her prisoner. The Pope annulled Joan's marriage to Montacute and ordered she be returned to Holland. They were together eleven years and had five children. He was barely cold in his grave when Joan had her third secret marriage. She was not the daughter-in-law Edward and Eleanor wanted for the Prince of Wales.

Edward and Joan spent an extended honeymoon at Berkhamsted Castle. Although the royal family strongly disapproved of the new Duchess of Cornwall, they turned up in force for the wedding reception. In December the couple invited his extended family to spend Christmas with them at the castle. This would be the last time he would spend with his family for a long time. The following year he and Joan settled in France. Despite the justified misgivings of the King and Queen, Joan proved to be a model wife, daughter-in-law, mother and much loved member of the family.

Twenty years later Joan and Edward's son Richard would be on the throne during the Peasants' Revolt of 1381. Returning from a pilgrimage to Thomas Becket's shrine she met the rebels face to face on the road. They treated her with humour and respect. Wat Tyler's men were so entranced with Joan they kissed her as they released her from the Tower where she was hiding. A protective mother she was with the fourteen year old Richard throughout the rioting in London.

1361 The office of Justice of the Peace is created. The following year English officially replaces French as the national language. Blanche, wife of Prince John of Gaunt inherits the Lancastrian estates making John a billionaire, the richest man in Britain after his father the King.

The King creates the Prince of Wales, duke of Aquitaine, Prince Lionel, duke of Clarence, Prince John, Duke of Lancaster (he incorporated Hertford Castle into the duchy of Lancaster) and Prince Edmund of Langley, duke of York.

1363 The Prince of Wales and Joan leave England to take over the principality of Aquitaine. The Chancellor opens parliament in English for the first time since William the Conqueror. A proud day for the English. For the first time in three hundred years since Harold died in battle at Hastings England recovered its national pride and national identity. Thomas Walsingham, the chronicler monk at St Albans Abbey said the people were patriotic because King Edward was fiercely patriotic. They caught it from him, it was the trickle down effect.

Leaving his son Prince Louis in English owned Calais as hostage, King John was allowed back to France to raise funds for his ransom. Told that his son had escaped he voluntarily returned to captivity in England. John, popular in London was welcomed with parades and feasts. A few months later he became ill and died at John of Gaunt's Savoy Palace.

1365 The Prince of Wales and Joan have their first child, Edward, in Angoulême.

1367 Edward The Prince of Wales stays in Berkhamsted Castle before leading an expedition with his brother Prince John of Gaunt to Spain to restore the deposed King Pedro of Castile. His second son, Richard, is born in Bordeaux. He would become King Richard II and be murdered by his cousin Henry of Bolingbroke son of Prince John. The brothers would have been horrified.

1368 Prince Lionel of Antwerp, duke of Clarence, age twenty-nine, who took Violante, daughter of the Prince of Milan for his second wife (his first died in 1363) dies on honeymoon in Italy. His family is devastated. Lionel was the tallest and most handsome of the four brothers. Conspiracy theorists said his father in law had him poisoned to save face because he could not raise the enormous dowry he promised. Lionel is buried in Clare Priory Suffolk with his first wife.

Having lost his brother, Prince John now loses his wife, Blanche to the plague. She lay in state in St Albans Abbey. John was closely attached to the abbey which owns a miniature of him. At her funeral an unseemly row broke out between the Abbot and the Bishop of Lincoln as to who should take precedence at the service.

Geoffrey Chaucer's *Book of the Duchess* is an elegy to Blanche. In it, the narrator strolling through a wood stumbled on John a man dressed in black. Chaucer was a life long friend of Prince John. They met when they were pages to Prince Lionel and his first wife the Countess of Ulster. Like his father and grandfather, Chaucer was in royal service all his life until he was too old for The Great Game. Sent on secret missions to Paris, Genoa, Florence, Padua and Milan he invented secret cryptograms for Prince John. Captured while fighting with him and Prince Lionel near Rheims the king paid a huge ransom for his release and granted him a life pension.

1369 One year after Lionel and Blanche died, Queen Phillippa died of oedema (dropsy). She is the first royal whose effigy is a proper likeness. Her grieving husband lost all interest in Kingship. With the Prince of Wales in France the governance of England is taken over by Prince John. The King is rarely seen in public. His loathed mistress, public enemy number one, Alice Perrers moved in for the kill. She had served as a lady-in-waiting to Queen Philippa, now she played the queen at court and controlled access to the King. She attended a public function at Smithfield wearing Queen Philippa's jewels riding in a chariot inscribed 'Lady of the Sun'. People were

outraged by this jumped up commoner. Fearless, she even presided at King's Bench from Edward's marble throne. Thomas Walsingham official scribe at St Albans Abbey branded her as a 'shameless doxy' (prostitute).

What remained of the King's family spent Christmas at King's Langley. Lionel, Phillippa and Blanche were dead. Edward, the Prince of Wales, ill in France, was barely managing to hold on to Aquitaine. He was in Castile fighting for King Pedro when a serious epidemic of malaria and dysentery broke out during a humid baking hot summer.

1370 Prince John and Prince Edmund raise an army to fight with Edward. In France, met by his beloved brother, John was shocked to see such a dramatic decline in his childhood hero. The brothers take Limoges. Edward's first son, Edward of Angoulème dies age eleven. A distraught Prince of Wales is so ill his doctors urge him to return to England. He leaves John to arrange the boy's funeral. It may be that Edmund returned home with his body to Kings Langley for burial.

John took over the running of Aquitaine. Edward had been protecting sisters, Princesses Constanza and Isabella, the exiled daughters of King Pedro of Castile. Prince John decided to marry the seventeen year old Princess Constanza (anglicised to Constance) and help her regain her throne. He spoke only a few words of Spanish, she spoke no English. John never had designs on the English throne but did want Castile. He didn't manage to get it for Constance or for himself but did manage to get it for their daughter Katherine who married King Henry III of Castile.

By the time Constance arrived in Britain for her wedding at Hertford Castle John had embarked on a life long love affair with Katherine Swynford neé Roët a widowed mother of three. In 1368 she was appointed governess to Gaunt's children. As her father came to England with John's mother Phillippa from Hainault it may well be they had known each other all their lives. John was thirty-two, Katherine was twenty-two. Her husband Sir Hugh Swynford was fighting in France with John in 1371 when he died in mysterious circumstances. Conspiracy theorists said John had him poisoned because he wanted Katherine.

John settled Constance in Hertford Castle to look after his children by Blanche. Helping her was Phillippa Chaucer née Roët sister of Katherine Swynford. Constance rarely left Hertford, she was not interested in the English court; she wanted to regain her own court in Castile. She had Catalina her first child in Hertford Castle in the summer of 1372. She would also have her second child there. John spent Christmas with Constance and their new baby at Hertford Castle and stayed until February.

Katherine Swynford was also pregnant with John's child. He was named John Beaufort, after land John owned in Beaufort, France. He was the first of their four children born between 1373 and 1377 known in court circles as The Beaufort Bastards.

That summer John attended the wedding of his brother Prince Edmund of Langley to Constance's younger sister Princess Isabella of Castile. Finding Edmund boring Isabella became infamous for taking lovers. One was Sir John Holland, Joan of Kent's son from her first marriage. Holland was also having an affair with Elizabeth, John of Gaunt's

daughter. When she became pregnant John had Elizabeth's first marriage annulled and arranged her second to Holland.

1374 Five years after her death, John ordered Yvele to sculpt effigies of Blanche and of himself. Twenty-five years later, he and Blanche were buried side by side in St. Paul's Cathedral.

1375 King Edward never recovers from Philippa's death. Not interested in anything he is now in the clutches of Alice Perrers his greedy, grasping, mistress. He gives her the Royal manor of Hitchin. With its fair, water mills and revenue from the market it was well worth having. Once, on a Royal Progression, Edward and Phillippa visited Hitchin to watch a tournament.

Perrers was lambasted in parliament and councillors were imposed on the king. She told so many lies about her background no-one knows much about her. She said she was the daughter of Hertfordshire gentry but was probably the daughter of a Hertfordshire thatcher who got her name Perrers from her first husband a chap of low birth. She wangled her way into court and managed to nab her second husband William of Windsor – they never divorced – but set her sights much higher. While lady-in-waiting to Queen Phillippa she and Edward had four children. Sir John de Southerly, Nicholas Lytlington became Abbot of Westminster, Jane and Joan Plantagenet.

Hitchin Market © MAK

1376 King Edward gives John of Gaunt the manor of Preston near Hitchin. Convinced the Templars had buried treasure at Temple Dinsley, Preston Edward set up a Royal Commission: "To inquire touching concealed goods of the Templars in the County of, Hertfordshire". Nothing was found.

Edward, Prince of Wales, dies age forty-five. His heartbroken father suffers a stroke. His effigy in Westminster Abbey is a death mask. The stroke he suffered can be seen on the left hand of his face.

At the so-called Good Parliament Alice Perrers was banished from court. Edward reaching the end of his life retired to Sheen. The only one with him when he died, she stripped rings from his fingers and left the room leaving him to die alone. Parliament found her guilty of 'performing 'illegal acts'. Royal auditors went to Hitchin and took as much as they could to pay her debts. As well as tolls from the fairs, Hitchin Priory, The Biggin and the church were all bringing in revenues.

To show repentance, Alice paid for the building of a church in Essex. Dubbed The Whore Church, this became Horn Church when wags added horns. The area became known as Hornchurch.

As his next in line had pre-deceased him, Edward III was succeeded by his ten-year-old grandson, Richard, the second son of the Prince of Wales. What a blessing King Edward would never know his legacy would be his grandsons at each other's throats.

13

RICHARD II:
KINGS LANGLEY; ST. ALBANS

Richard is remembered for his courage during the Peasants' Revolt of 1381, his murder in Pontefract by his cousin Henry and for inventing the handkerchief. Born in Bordeaux, he was the second son – his brother died young – of The Black Prince and Joan, Fair Maid of Kent.

Richard inherited Berkhamsted Castle from his father (his parents spent their honeymoon there) and Kings Langley Palace from his grandfather, Edward III. Hertford Castle, part of the Duchy of Lancaster, was inherited by his cousin Henry Bolingbroke, son of John of Gaunt. One day, Richard would get his hands on the Duchy. Bad move. It resulted with Henry getting his hands on Richard's crown. Not that it did Henry much good. According to his son, Henry (V) Richard was on his father's conscience until the day he died.

Only nine years old when his father died and ten when his grandfather followed his son to the grave Richard was too young to understand just what Titans they were.

At seven, his father was in no doubt where his future lay. He was kitted out in full armour. At thirteen he was created Prince of Wales before setting out on expeditions abroad with his father. At sixteen he was told to make his will and make pilgrimages to the shrine of Thomas Becket. His father knighted him in France before the battle of Crécy where he won his spurs. He followed this up with a glorious victory at Poitiers. His father was fighting on two fronts at the same time, in France and in Scotland. To descend from one national icon must be bad enough, from two a heavy burden.

Although his reign started well – the fourteen year old Richard was admired during the Peasants' Revolt – England had impossibly high expectations of its new king. Did routing Wat Tyler mean he was a chip off the old block? No. Beginner's luck.

Richard spent much of his childhood at King's Langley, the favourite private residence of his grandparents, great-grandparents and great-great grandparents. It was Richard's favourite too. The land was first owned by William the Conqueror's half brother Robert duke of Mortain but it was Henry III who first fell in love with the

place and built a manor there. The palace itself was built by his son Edward I – or rather his daughter-in-law – Eleanor of Castile. Magnificent, awe inspiring and as big as the Palace of Westminster work was carried out under her personal supervision on the hill above the village after which Langley was given the epithet 'Kings Langley'.

Richard celebrated Christmas there with his wife Queen Anne in 1392. In 1393 he held court there. In 1394 the year his beloved Anne died he nursed his grief there over Christmas and New Year. Langley is first recorded as 'Langley Regis' during Richard's reign in the court rolls of 1395. He was there again in 1396 when he received 'with honour but not with love' his uncle John of Gaunt who needed Richard's permission to marry his mistress Katherine Swynford. It wasn't simply a courtesy call. Gaunt also asked Richard to grant legitimacy to their four children who went by the name of Beaufort.

1381 is remembered for Wat Tyler's rebellion. Richard is remembered for crushing it. When his mother Joan returned to London from a pilgrimage to Becket's shrine at Canterbury her way was barred by Wat Tyler and his mob at Blackheath but not only was she let through unharmed, she was given safe escort for the rest of her journey. Tyler and his men had no quarrel with Richard or his mother they targeted his tax gatherers who inspected children's genitalia to see if they were old enough to pay Poll Tax. Everyone over the age of fourteen had to pay.

Rebels, who loathed John of Gaunt, ransacked Hertford Castle (his wife, Constance had already fled). They went on to London and burnt down John's magnificent Savoy Palace. It was never rebuilt. Gaunt rescued the lead and used it to repair the roof of Hertford Castle. With his London base gone he spent more time in Hertford. Alarmed at public hatred against him and his mistress Katherine Swynford they ended their affair. Ostensibly at least.

The Poll Tax was not Richard's idea. He was not responsible. His grandfather Edward III introduced it to pay for the futile wars in France. He left massive debts for Richard who inherited a disillusioned and deeply depressed England. By the time Edward died his lands so hard won in France had all but gone. The financially crippling wars had all been for nothing.

St Albans featured prominently in the Peasants' Revolt. When local rebels killed the Abbot, Richard came to St. Albans and killed them. The Clock Tower symbolises the conflict between abbey and town. Built not long after the Peasants' Revolt it was paid for by the townspeople as a symbol of their independence from the Abbey. The tension between it and the town was not resolved until Henry VIII stripped the abbey of its power along with all religious houses in 1529.

Because the Abbott ignored King Offa's Charter of Rights given to the inhabitants of St. Albans, locals had already risen up against him three times. Their spokesman was the aptly named William Grindcobbe, apt because not being allowed to grind their own corn cobs contributed to the Peasants' Revolt. The Abbot confiscated all the mill stones in town. Grindcobbe who had been excommunicated and jailed for criticising the Abbot was a local hero. On 14 June 1381 he set out to meet Wat Tyler in London. On the way, in Islington he saw Jack Straw one of the rebel leaders burning down

Highbury Castle owned by the tax gatherers of St John's Priory in Clerkenwell. He joined in and took the rebel oath.

At Mile End in London after hearing Richard promise he would put an end to serfdom Grindcobbe returned to St. Albans. Wat Tyler, who was with the rebel priest John Ball, told him if the abbot proved too strong for him he would come with 20,000 men and 'shave the monk's beard'. When Grindcobbe told his followers about Richard's promise, they broke down the gates to the abbey park, drained the fish ponds, killed the game, removed the hedges and took the land as common land. They threw open the jail, burnt the abbey's charters in the market place and forced the abbot to draw up and seal a new charter granting the town its freedom. In it inhabitants were exempted from tolls and dues, given rights to pasturage on waste land, given permission to hunt and fish in the abbey woods and ponds, the right to grind their own corn and to elect a town government. Similar charters were granted to Watford, Barnet and Rickmansworth.

When they were in London the rebels were too many to tackle, but once they returned home, punishing them was easy. With Wat Tyler dispensed with at Smithfield, Richard with a guard of a thousand men set out for St. Albans.

When Grindcobbe heard that Wat Tyler was dead, that Richard had gone back on his word and was on his way to St. Albans he rode out to meet him. He and the other leaders were arrested and taken to Hertford jail. Grindcobbe was told unless the new charter was given back he would be beheaded. He refused. He and fourteen others were tried at Moot Hall, the site of the present day Town Hall, then drawn and hanged on a gibbet. When Richard was told the men had been cut down and given a decent burial, he ordered them dug up and put back on the gibbet. Following the public executions all men in Hertfordshire between the ages of fifteen and sixty were forced to swear an oath of loyalty to Richard.

The famous priest, John Ball, another local hero, was born in St Albans and this is where he died. Brought home to face trial he said he had no regrets at the part he played in the Revolt. An ordained priest he was one of its instigators. Sickened by the excessive wealth of the church and the nobles he preached "When Adam dug and Eve span, who was then the gentleman?....let us go to see King Richard…either he will listen to us, or we will help ourselves. When we are ready to march on London I will send you a secret message…"Now is the time. Stand together in God's name." Ball was excommunicated, arrested and put in Maidstone Prison. On 7 June, 1381, he was rescued by Wat Tyler. On 15 July he was hanged drawn and quartered in St. Albans.

Richard had planned to marry Princess Anne of Bohemia (Prague) in 1381 but the Revolt meant the wedding had to be postponed for a year. Six foot tall, slender and good looking Richard was sophisticated and cultured. A flamboyant dresser he followed continental fashions. A connoisseur of food he preferred to eat in private, washed his hands before meals and used cutlery. With three hundred cooks on the payroll, he was the first king to employ French chefs. Richard favoured cooking in olive oil and ate what he caught in the hunt. TV chef Clarissa Dixon Wright cooked some of the dishes from his recipe book which has survived in its entirety.

Anne suited him perfectly. Richard wasn't a conventional king. Not interested in war he preferred artistic pursuits. He and Anne enjoyed watching plays and both were

very interested in fashion. The Posh'n'Becks of their day whatever they wore the court copied including the fantastic headdress Anne wore on her wedding day, a pair of massive cow horns covered in gauze.

Nothing if not fastidious, Richard invented the handkerchief. Its purpose lasted hundreds of years until it was superseded by paper tissues. He was one of very few brought up in a house with a bathroom. This was in Kings Langley. Eleanor of Castile installed it; Isabella, wife of Edward II much appreciated it. By the time Richard lived in the palace was there perhaps a queue to use it? He decided to build a second bathroom. The palace had a massive boiler which was stoked around the clock. Richard had the ingenious idea of building a large Bath House, very large, the size of a small hall, immediately above it so that the room was always warm. To make sure it stayed warm he, very rare for those days, had the windows glazed.

To celebrate his wedding to Anne Richard organised a grand jousting tournament in Smithfield and appointed old family friend Geoffrey Chaucer Clerk of the King's Works to supervise the building of scaffolding to hold seating. Chaucer had already published *The Canterbury Tales*. English was now the national language taught in schools and universities. Following the successes in France by Edward III and Richard's father, The Black Prince, England regained its pride. A surge of nationalism and patriotism meant French equalled enemy and the French language fell out of fashion.

Chaucer was put in charge of hundreds of craftsmen, bricklayers, roofers and labourers with responsibility for repair and maintenance of all important royal buildings including Berkhamsted Castle and King's Langley Palace. Edward III renovated Berkhamsted Castle for the Black Prince when he created him Duke of Cornwall (ruins still belong to the Duchy. Prince Charles has visited).

Kings Langley palace was so important that during the great plague of London in 1349 the seat of government relocated there. Henry III, Edward I, Edward II, Edward III and Richard II all loved Langley which is mentioned in Shakespeare's *Richard II*. Richard would be sad if he saw it today. Only one outbuilding is left. Chaucer, totally unfitted for the post of Clerk of the King's Works, resigned after being mugged several times and relieved of the men's wages.

Richard's mother Joan lived long enough to see him marry (she died in 1385). The Fair Maid of Kent by now was less than fair, so fat she could barely walk. Strangely, she left instructions she was not to be buried near Richard's father Edward, Prince of Wales a national hero but near her first husband, 'our late lord and husband, the Earl of Kent'. She left to: 'My dear son the King, my new bed of red velvet, embroidered with ostrich feathers of silver, and heads of leopards of gold with boughs and leaves issuing out of their mouths'. He must have loved it.

In 1392 Isabella of Castile, wife of Edmund of Langley, duke of York, died at Kings Langley. Edmund was deeply attached to her. The feeling was not mutual. She found him boring, had many love affairs and didn't mention him in her will. Richard gave his uncle Edmund permission to bury Isabella in the royal chapel in the Dominican Friary at Langley and attended her funeral. Edmund, fifth son of Edward III and Phillippa of Hainault was born at Langley, his haven until death. His second wife was Joan Holland, granddaughter of Richard's mother Joan of Kent by her second marriage.

In 1394 Isabella's sister Constance, wife of John of Gaunt, died unexpectedly. During a recent hunting party at Much Hadham she was in perfect health. In July John also lost his daughter-in-law, Mary de Bohun, wife of Henry Bolingbroke. She died age twenty giving birth to her seventh child.

That same year Richard lost his beloved Anne to the plague. He was traumatised. She was twenty-eight. Childhood sweethearts they had been together since they were fifteen. He ordered that the wing of Sheen Palace where she died be burnt down.

Her funeral was magnificent but Richard's grief was heartbreaking. Unhinged, he went berserk when Richard FitzAlan, Earl of Arundel, arrived late. He seized a staff from one of the vergers and hit Arundel so violently around his head the earl fell to the ground. Three years later, in 1397, Arundel, accused of being involved in a plot to depose Richard was found guilty of high treason and executed.

Richard had already placed his tomb in Kings Langley Priory Church but when Anne died, going against tradition of Queen Consorts having separate tombs, unlike any previous king and queen of England, Richard commissioned a new magnificent double tomb so that he and Anne would be together in death. Their gilded effigies were placed on top side by side. Each wore their crown. They held right hands. Their left held sceptres. The tomb was placed in the chapel of Edward the Confessor in Westminster Abbey. The tomb was opened in 1871. Much of Anne's skeleton was missing. Her bones had been extracted by tourists through a hole in the side of the tomb.

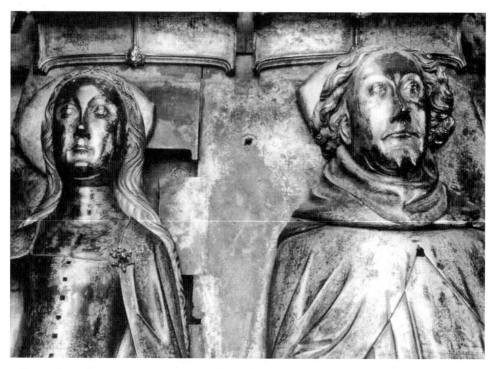

Effigies of Richard II and Anne of Bohemia © Dean and Chapter of Westminster

Richard gave his tomb in Kings Langley Priory to his uncle Edmund of Langley. When religious houses were closed after the Reformation permission was given to transfer it to All Saints Church Kings Langley.

When Constance died John of Gaunt could finally marry his mistress Katherine Swynford. This is when he went to Kings Langley to ask Richard's permission. He also asked him to legitimise their four children who went by the name of Beaufort. Richard who disliked his uncle agreed on the proviso neither they nor any of their descendants would ever lay claim to the throne. As it turned out, one did. Henry Tudor was the son of Margaret Beaufort. In July living at Herford Castle (some of Katherine's servants were buried in St Nicholas' churchyard Hertford) John and Katherine went to St Albans Abbey to ask the Abbots blessing for the marriage.

The fourteen-year-old boy King's handling of the Peasants' Revolt drew admiration from all who witnessed it. After that, Richard thought he could walk on water. He couldn't. When he tried to take control of the government, parliament demanded his followers be dismissed. Richard's refusal provoked parliament into impeaching his chancellor and creating a commission of 'Lords Appellant' to monitor his rule. When Richard declared them traitors parliament retaliated by outlawing his closest friends, some of whom were executed.

Old Tomb of Richard II, All Saints Church, Kings Langley © Ian Pearce

Although Richard submitted to the five 'Lords Appellant' and for eight years worked in apparent harmony with them and his uncle, John of Gaunt, he secretly planned revenge. In 1397 he formed a strong royalist party, arrested and tried three of the Lords Appellants. A quarrel between the other two, Thomas Mowbray and Henry Bolingbroke, gave Richard another opportunity for revenge. He exiled them both from England.

In February 1399 John of Gaunt died heartbroken by his son's absence. Katherine headed his funeral cortège with their son, Bishop Henry Beaufort. When it stopped at St Albans Abbey on its way to London the abbot refused to admit Bishop Beaufort unless he agreed not to officiate at his father's Requiem Mass. In the end after an unseemly row, Beaufort was reluctantly allowed to participate but left in a furious temper.

With his uncle John dead, and his heir Henry Bolingbroke in exile, Richard appropriated the vast Duchy of Lancaster estates. He took Hertford Castle for his new wife, the eight year old Princess Isabelle of Valois. This is where, many years later, her younger sister the Dowager Queen Katherine of Valois, widow of Henry V, would live in secret with Owen Tudor. When Richard married Isabelle he signed a twenty-eight year Peace Treaty with her father, the King of France. Richard didn't do war. The Treaty held until Bolingbroke's son Henry V renewed the English claim to the throne.

Depriving his cousin of his rightful inheritance heralded the start of Richards's downfall. In May 1399, Henry landed in Yorkshire to fight for what was his and received popular support. He raised an army and marched to Bristol. In August Richard returned from Ireland via Wales and was captured at Flint Castle. He was forced to formally abdicate at St Albans. His uncle Edmund of Langley was with him helping with negotiations. Bolingbroke, who effectively bought the throne of England by greasing palms, reigned as Henry IV.

In October 1399, Richard was taken to Pontefract Castle where he mysteriously died four months later. His death was not announced until February 1400. It was put out he died from starvation due to a self-imposed hunger strike. Richard stipulated in his will he was to be buried with Anne. Henry had other ideas. The night Richard died, he was given the last rites, embalmed, put on view briefly in St. Paul's to prove he was dead then buried in secret in King's Langley Priory church, the church built by his great-grandfather Edward II, another murdered king. The abbot of St Albans officiated at the funeral service. What, you wonder, did he think? And did his uncle Edmund who lived at Langley attend the funeral? If so, what did he think?

Even if Richard had been a strong king he could never have lived up to the heroic achievements of his father and grandfather. He began his reign with his subjects' admiration, they became deeply disappointed in him and ended by despising him. He never lived up to his first days of glory when he saved London from the mob during the Peasants' Revolt.

14

HENRY IV:
HERTFORD; KINGS LANGLEY

Henry IV, born in Bolingbroke Lincolnshire, knew Hertfordshire well. He spent much of his childhood with his parents John of Gaunt and Blanche of Lancaster at Hertford Castle, his father's pride and joy. He spent a fortune on it. As well he could. He owned a fortune. He was the second richest man in Britain after his father Edward III, King of England. Being near London it was his favourite place to stay. When Wat Tyler and his men burnt down Gaunt's Savoy Palace, his London home, he spent even more time there.

When Henry's mother Blanche died this is where his father brought his second wife, Constance of Castile, to live and where Henry's half brothers and sisters were born. When Constance died too, Henry had to adjust to even more half siblings when his father married his mistress Katherine Swynford but all seemed to get on together. John of Gaunt had good rôle models regarding happy families. His parents, Edward III and Phillippa of Hainault were very successful parents. John idolised his older brother Edward Prince of Wales (The Black Prince) and as a boy lived with him in Berkhamsted Castle for five years. Henry IV gave the castle where Richard's parents spent their honeymoon to his son Prince Henry of Monmouth (Henry V) and sent his children to be brought up there.

Henry Bolingbroke was fortunate to be part of the close knit extended family of his grandparents and spent his winters with them at Kings Langley their favourite private residence. Their son Edmund was born, died and is buried there. Henry and his cousins, including the future Richard II, son of the Prince of Wales, were childhood playmates but this didn't stop Henry from having him murdered.

In 1390 when parliament, egged on by Henry, executed close friends of Richard, he planned revenge. It came in 1397 when Richard exiled Henry. Two years into his exile Henry's father died and Richard appropriated his Duchy of Lancaster. Bolingbroke invaded England and took it back. He also took the crown. Richard signed his own death warrant when he took Henry's inheritance. Henry's half brother

Thomas Swynford may well have been responsible for overseeing Richard's murder in Pontefract Castle.

Henry had the front to hold his newly-formed royal court at Hertford Castle while Richard was being forced to abdicate at nearby St. Albans. He was crowned in Westminster Abbey while Richard was being starved to death in Pontefract. Henry put Richard's corpse on show, briefly, in St. Paul's before he took him to Kings Langley to be buried in secret in the friary church built by Edward II, another murdered monarch. You do wonder what Edmund of Langley (featured in Shakespeare's *Richard II*) who lived there thought of the murder and whether he attended the funeral. Uncle to Richard and Henry he could not make up his mind who of the two deserved to be king although Richard appointed him Regent three times. Edmund retired from court after Henry's coronation.

Why did Henry bury Richard in Kings Langley? In his will drawn up just before he was murdered he stipulated he was to be buried with Anne in Westminster Abbey. Henry must have known that, he must have studied the Will, but the Abbey, then as now, received thousands every day visiting the shrine of Edward the Confessor. Was he nervous Richard's tomb might also become a shrine? Did he choose Langley because as a private royal residence it received no visitors and was out of the way?

Did Henry have Richard's close friend and ally Geoffrey Chaucer eliminated too? When Richard disappeared, Chaucer claimed sanctuary within the confines of Westminster Abbey and was never seen again. There is no record of his death even though he was famous because of *The Canterbury Tales* and a member of the royal family (he married Katherine Swynford's sister). Chaucer, who had known both Richard and Henry since they were born, was in possession of state secrets. Like his father and grandfather he worked in intelligence. He knew Henry murdered Richard. He also knew where the body was buried.

In 1402 Edmund of Langley, duke of York, died at Kings Langley where he was born. In his will he requested he be buried in the Priory church in the same tomb as his first wife Isabella. The tomb was transferred to All Saints Church, Kings Langley in the 1500s after Henry VIII closed all religious houses including the Priory.

Visitors marvel at Edmund's ornate alabaster and black marble tomb, more fitting for a king than a duke. Thanks to *History Today* commissioning an article from the Rt. Hon. Enoch Powell MP in the 1960s and thanks to the magazine kindly sending the article to the author we know it was indeed intended for a king, Richard II.

Richard had the tomb built for himself and put it in the chancel of the Dominican Friar's church at Kings Langley. He would be buried in the chancel but not in the tomb. By the time Henry Bolingbroke had him murdered, Isabella, Edmund of Langley's first wife was in it. Did Henry know the tomb was already occupied? Surely his uncle Edmund told him? If not, he had a bit of a surprise.

In his article Enoch Powell explains that in 1394 Richard's adored wife, Queen Anne of Bohemia, died of the plague. Unhinged, he went berserk when Richard FitzAlan, Earl of Arundel, arrived late for her funeral.

Richard then commissioned a new magnificent double tomb so that he and Anne would be together in death and gave his old tomb in Kings Langley to his uncle

Edmund. Isabella, who died two years before Anne (Richard attended her funeral) was re-interred in the tomb.

It wasn't just that Richard wanted a more impressive tomb for Anne that he abandoned the old one. On it are the Arms of Henry Bolingbroke and FitzAlan, earl of Arundel. They were fixed on before he became their bitter enemy.

Of the thirteen shields which survive on the tomb one is of Edward the Confessor who Richard regarded the patron saint of England; one has three leopards, the royal arms of Richard II and another has three crowns for Saint Edmund, king and martyr. The arms of Anne's father, Charles IV, Emperor of Germany, are given place of honour.

Henry Bolingbroke married Mary Bohun in 1381. She died in 1394 giving birth to her seventh child. His second marriage was to Joan of Navarre. It seems to have been a happy marriage. When his uncle Edmund died, Henry gave Kings Langley to Joan as part of her dowry. He also gave her Hertford Castle. The couple stayed often at both places. Henry met Joan when Richard exiled him. He was given refuge at the duke of Brittany's court. Joan was married to the Duke. When her husband died she proposed marriage to Henry who agreed because he needed Brittany on his side against his enemies in France. Henry had six children from his first marriage, Joan had nine from hers. They had no children together.

Henry of Bolingbroke did not enjoy his time as King. Faced with rebellion following his usurpation, he found it difficult to enforce his rule. He spent much of his reign defending himself against plots and assassination attempts. He developed eczema and epilepsy. He had a particularly bad fit praying at the shrine of Edward the Confessor in Westminster Abbey and died three months later.

By the time he died in 1413 much of England had turned against him including his son who was impatient to become Henry V. Shakespeare's *Henry IV* has him trying on the crown whilst his father lay dying. Was that true? Henry said his father was plagued by his conscience over Richard until the day he died. He refused to be buried in Westminster Abbey the mausoleum of Kings but chose instead to be buried in Canterbury Cathedral. Did he not consider himself a real king?

By usurping Richard, Henry Bolingbroke, son of Edward III's *third* son upset primogeniture and sowed the seeds of The Wars of the Roses. Because Richard had no children, next in line to the throne was Edmund Mortimer, grandson of Prince Lionel, Edward III's *second* son. Rival claimants to the throne sprang from descendants of Edmund of Langley, Duke of York Edward III's *fifth* son simply because his grandson married Anne Mortimer. Families!

Henry IV was tolerated, his son Henry V revered, but his grandson Henry VI was another matter. Others with equally legitimate rights to the crown felt, with justification, they could make a better job of running the country. One was Anne Mortimer's son, Richard, duke of York.

15

HENRY V: KINGS LANGLEY; HERTFORD

Immortalised by Shakespeare, Henry of Monmouth was a great Plantagenet king. He fared much better than his father (Henry IV) whose reign was blighted by his murder of his cousin and childhood playmate, Richard II. Henry said that Richard was on his father's conscience till the day he died.

When Henry V won the famous Battle of Agincourt he was revered as a national hero and England basked in reflected glory. Thanks to Henry, fourteen years after his burial the murdered Richard II was reunited with his wife in the double tomb he commissioned. One of the first things Henry did as king was to go to Kings Langley and make arrangements for Richard to be buried with his beloved Queen Anne in Westminster Abbey as requested in his will. Henry ordered that candles be lit around the tomb in perpetuity.

Henry V liked Richard. A young boy when Richard sent his father into exile he assumed responsibility for him and they became close. Richard knighted Henry when they were in Ireland. Henry was with Richard when his father led the rebellion which ended with his usurpation of Richard's throne.

Although Henry inherited Kings Langley, Hertford and Berkhamsted castles he was rarely in England long enough to enjoy them. He didn't do leisure. His hobby was war. With too few battles at home to occupy him he went to France to pick fights.

Living in Kings Langley palace was Henry's step mother, Dowager Queen Joan of Navarre, who survived her husband by twenty-four years. A mother herself she got on well with all her stepchildren including Humphrey duke of Gloucester and Henry until 1419 when, to get his hands on her vast wealth, Henry accused her of being a witch, falsely accused her of trying to poison him, took her property and locked her up. On his deathbed a guilty Henry ordered her release and the return of her lands. Henry died in 1422. Joan lived at Kings Langley until 1431 when a serious fire meant she had to move to one of her other palaces. When she died in 1437 her stepson Humphrey gave her an elaborate funeral.

Henry stayed with Joan at Kings Langley preparing for Agincourt. His second in command Sir William Hungerford was recruiting men from the Hitchin area to fight with Henry. It was estimated the French had 50,000 men whereas Henry was able to muster only 4,000. He did however have the longbow. Considered an English icon, Welsh schoolchildren are taught that according to the mediaeval chronicler Gerald of Wales it was invented by the Welsh in Gwent to fight the English.

Before the battle, when a worried Hungerford wished he had 10,000 more archers a coldly angry Henry said 'You are wrong. I do not need a single extra man...' He didn't. Henry's astonishing victory at Agincourt is still talked about. In England that is.

As a not very effective soldier, Humphrey was famously saved by his famous brother in the famous battle of made even more famous in Shakespeare's famous mother of all pre-battle speeches. The Harry in the speech is of course Henry, a popular alternative name even today.

> Once more unto the breach, dear friends, once more;
> Or close the wall up with our English dead.
> ...when the blast of war blows in our ears,
> Then imitate the action of the tiger;
> Stiffen the sinews, summon up the blood,
> Disguise fair nature with hard-favoured rage...
>set the teeth and stretch the nostril wide...
> stand like greyhounds in the slips,
> Straining upon the start. The game's afoot:
> Follow your spirit, and upon this charge
> Cry 'God for Harry, England, and Saint George!'

As Duke Humphrey basked more and more in reflected glory of his brother, a national icon, he made many enemies. When Henry died young, not in battle but of dysentery, Humphrey was next in line to the throne after Henry's baby son Henry VI.

After Agincourt Henry could do no wrong in the eyes of his subjects. He gave England back its pride. Apparently Shakespeare was right. Before the battle Henry really did cry 'God for Harry, England, and Saint George'. Henry's brother Humphrey asked the Mayor of London to raise funds from Londoners for Agincourt. He did. The Mayor was the famous Dick Whittington.

Ever since Edward III decided France belonged to England via his mother Queen Isabella sister of the King of France (women were not allowed to succeed to the French throne) Kings of England fought to get it. Henry V succeeded but died before he could enjoy the fruits of his military labours. His son, Henry VI, however, was crowned King of England and France.

There was also the little matter of male pride. Henry had his great-uncle's (The Black Prince) glorious victories at Crècy and Poitiers to live up to. He matched him with his outstanding success at Agincourt.

In 1417 Henry took back Normandy for England. Charles VI recognised him as his heir when Henry married his youngest daughter, Katherine of Valois in 1420. The

child of an unstable father and a cruel mother Katherine endured a lonely, miserable, poverty stricken life until Henry claimed the French throne. She was not sorry to leave France.

At Dover the barons of the Cinque Ports waded into the sea to carry Henry and Katherine ashore. The king and queen then made their way slowly towards London to a magnificent formal reception. When Katherine was crowned in Westminster Abbey Henry absented himself in order not to detract from her day of glory. Travelling via St Albans, Katherine joined him at Kenilworth. Having won France Henry had to fight to keep it. Touring England to raise funds for more battles he took every opportunity to display his new young wife to his subjects. When Henry gave Katherine Hertford Castle as part of her dowry he could know that one day she would live there with her lover Owen Tudor or that his son (Henry VI) would spend much of his infancy with them at the castle.

By the time their son, Henry, was born at Windsor Castle seven months later, Henry was back fighting in France. He sent his brothers the duke of Bedford and Humphrey, duke of Gloucester to Windsor to bring his wife over. Katherine left the baby at Windsor. The King never saw his only child. He died 31 August 1422 aged thirty-four. The hero of Agincourt died, not in battle, but of dysentery. His son would lose all the land his father died for.

It's probable that not only had Katherine embarked on a love affair with Owen Tudor at Windsor in Henry's absence but that Henry was told about it. If there was gossip at Court his brothers would have been told about it when they collected Katherine. Writing his will in the weeks leading up to his death he meticulously put his affairs in perfect order attending to the smallest detail but made no mention of Katherine. On his deathbed he asked to see his brother, uncle and advisers but not his wife. Nor was she invited to join the funeral cortège until it was about to leave France for England at Calais.

Henry was buried at Westminster Abbey in a magnificent tomb. He left his youngest brother Humphrey, duke of Gloucester, with the guardianship of his baby son, Henry VI.

16

HENRY VI: BERKHAMSTED;
ST ALBANS; BARNET

Henry VI was the grandson of the usurper Henry Bolingbroke (Henry IV). He in turn was deposed by usurper, Edward IV. Poor Henry, born to be a monk, destined to be king of England – and France. He somehow managed to stumble through his reign until 1461 when he was deposed (briefly reinstated for six months in 1470).

His mother, the Dowager Queen Katherine de Valois was only too aware Henry would be unable to lead one nation never mind two. The future of England, let alone France, did not lay with her son who spent much of his infancy with her and Owen Tudor at Hertford Castle. This is also probably where Henry's half brother Edmund Tudor was conceived, the Edmund who kick started the Tudor dynasty in the shape of his son Henry Tudor.

Living nearby, at Kings Langley, was another Dowager Queen, Joan of Navarre, widow of Henry Bolingbroke (Henry IV). Katherine and Joan must have known each other because Joan watched Henry VI grow up. He was sixteen when she died. Queen Joan enjoyed receiving prestigious guests at Langley. In 1425 she received the duchess of Holland, who, after hearing vespers at St. Albans, rode to Kings Langley with an escort of forty horses to stay with her. In 1428 Joan entertained the cardinal bishop of Winchester, Henry Beaufort, who visited her in state. She also received Beaufort's enemy, her stepson, Humphrey duke of Gloucester.

Humphrey's mother died when he was a toddler. His father (Henry IV) married Joan, mother of eight children. She visited St Albans Abbey often and gave it many gifts of her fine needlework. Humphrey became very close to his stepmother. When her husband died and he left Joan Kings Langley Palace, Humphrey often stayed with her. He once rode from Langley to St. Albans Abbey to make offerings for a safe recovery from an illness. When Queen Joan died Humphrey paid for her elaborate funeral.

At Oxford University, young Humphrey, a very bright scholar became close friends with John Bostick of Wheathampstead in Hertfordshire who would go on to become Abbot of St. Albans Abbey. The friendship lasted till death as did Humphrey's love

of the Abbey and of Saint Alban, Europe's first Christian martyr (for Alban's story see entry for King Offa). Appalled by declining standards in education, in his Will, Humphrey left his old university his impressive collection of rare books. Duke Humphrey's Library is still there.

When his brother died Humphrey was next in line to the throne after Henry's baby son Henry VI. After unsuccessfully abusing his power to prise the baby from her, he became the sworn enemy of his brother's widow Queen Katherine. A notorious womaniser it may be that Humphrey had designs on her.

It was illegal to have sex with the widow of a king. The sentence was death. When Katherine became pregnant by Owen Tudor her Welsh servant to protect her from Humphrey, the Bishop of London invited her to stay in his summer palace in Much Hadham. Her son, Edmund Tudor, gave rise to the mighty Tudor dynasty. His son Henry Tudor became King Henry VII when he defeated King Richard III at the Battle of Bosworth (Henry VII was of course the father of notorious psychopath Henry VIII).

When Humphrey married Jacqueline of Hainault who had been given asylum in England from her husband Europe was shocked. The hounded couple took refuge at St Albans Abbey. When Jacqueline's husband died and Humphrey could legally marry her, he married instead her lady in waiting. He took Jacqueline to Hainault and left her there. His new wife, Eleanor, in later Tudor times dubbed The Lady Macbeth of Cobham, was executed for being a witch. She was accused of casting spells on Henry VI and his wife Queen Margaret so that Humphrey, next in line, would be King and she would be Queen of England.

In 1447 on arrival in Bury St. Edmunds to attend parliament, Humphrey was arrested. He died in custody just before he was about to be charged with treason. The official story was he suffered a stroke but the accepted story is that Queen Margaret, seeing him as a threat, had him poisoned.

His body was taken with ceremony to St Albans Abbey. Long ago he had asked his great friend, Abbot John of Wheathampstead permission to be buried near the shrine of St. Alban.

When Henry VIII closed religious houses because the brother of Henry V England's hero, an anointed king of England was buried there he left St. Albans Abbey more or less in peace. However a hundred years later along came arch anti Royalist Oliver Cromwell who desecrated places of worship and Humphrey's tomb was lost.

In 1703, two hundred and fifty years after Duke Humphrey died, a local chap was buried in Saint Alban's chapel, the most prestigious site in the Abbey. Anyone who was anyone wanted to be buried there. As digging progressed workmen unearthed a wooden trap door. Lifting it they found a tiny set of steps leading down to a small burial chamber almost filled by a lead coffin. Workmen were amazed to find the coffin full of a liquid smelling of herbs and a male corpse in an astonishing state of preservation. It was clear that the body had been embalmed. The liquid was alcohol or had turned into alcohol and had preserved the body intact.

Using Abbey records, the corpse was positively identified as Humphrey, Duke of Gloucester, younger brother of King Henry V. As the Abbey's only royal burial, public interest was so great that in 1715 Humphrey was put on show to tourists who paid

good money to view him. Abbey clerks acting as guides were tipped handsomely when they showed visitors the tomb. Fascinated by the liquid surrounding Humphrey many dipped in their fingers to taste it. Some women even rubbed it on their faces to preserve their skin. Locals joked they had 'dined with Duke Humphrey'.

The joke 'dining with Duke Humphrey' has two origins. The general public assumed he was buried in St Pauls Cathedral the usual mausoleum for peers of the realm. Dining with Duke Humphrey in St. Paul's meant to go without dinner referring to the beggars asking for alms at the wrong tomb.

Scientists took phials of the liquid for analysis. As the level of alcohol went down or slowly evaporated Humphrey began to decay into a cadaver. To keep the tourist trade going local inn owners gave cheap brandy to the Abbey parish clerks to keep the coffin topped up. The ploy worked until 1752. By then Humphrey's legs had been stolen and by 1786 there were only a few bones left and the skull had been robbed of all its teeth. A visitor deplored the desecration of the tomb and the graffiti on the walls. Worse, the breath of tourists had caused a wonderful wall painting of the crucifixion to fade.

However the Duke was such a draw, such a good source of revenue for the Abbey, the trap door to the tomb was not sealed until 1872 and then only because fragments of the original St. Alban shrine had been discovered ensuring the continuation of the tourist trade. All that was left of Duke Humphrey was his skull and seven bones.

In 1979 the old wooden trap door was replaced by the iron grille we see today. For health and safety reasons the tomb is not open to the public. 150 years of tourism wore away the tiny, steep, now very dangerous steps. Duke Humphrey is allowed to rest in peace although thanks to the generosity of Cathedral staff, he kindly received the author and photographers for this book. Even today the story of Duke Humphrey's tomb still catches the public imagination. Marac Andrev, a musician working in Hertfordshire is writing a song to perform with his band. It won't be at all surprising if it catches on locally. The first verse of this work in progress is:

<div align="center">

Tonight I'll be

Dining with

Duke Humphrey

Bring your spoon

There's sure to be plenty for all

There's plenty for all

let's have a ball

let's drink it all.

Some will say

such a good host

is Duke Humphrey

fingers in

there's sure to plenty for all

there's plenty for all

let's have a ball

let's drink it all

</div>

Duke Humphrey's tomb

Dowager Queen Joan of Navarre, sixty-seven, died in 1437. She was buried near her second husband Henry IV in Canterbury Cathedral. Coincidentally Dowager Queen Katherine of Valois, thirty-six, died the same year. There were strange goings on at her tomb too. More than two hundred years later, Samuel Pepys kissed her on the lips.

Henry VI inherited Hertford Castle. In 1445 when he married the wonderfully formidable Margaret of Anjou he gave her the castle as part of her dowry. The couple stayed there often. They also stayed often in St. Albans. Henry was so fond of the Abbey that in 1450 when he spent Easter there he gave it a valuable, elaborate gown to raise funds. When he realised it was the only good one he owned he bought it back. The best way to describe Henry is unworldly.

Before the first Battle of St. Albans, Richard, duke of York based with his army in Royston wrote to Henry stating his terms for peace. Richard meant for the Wars of the Roses to end with him on the throne. His claim was fairly sound. However, when he died in battle before he could try on the crown, his son or rather as it turned out, his wife's son, Edward, claimed it in his stead.

Primogeniture had ensured straightforward succession to Henry III, Edward I, Edward II, Edward III and Richard II. Because Richard II, son of the *first* son of Edward III, had no children next in line was Roger Mortimer of the House of York, grandson of the *second* son. Once Henry Bolingbroke son of the *third* son seized the throne as Henry IV bitter conflict ensued between the descendants of Edward III's sons.

The court, fed up with Richard II, tolerated Henry IV as the better of two evils. His son Henry V was revered as a national hero who won glory for England. When his son Henry VI came along England groaned. Unwilling and unable to rule it was open season as to who would be first to depose him.

Richard Plantagenet, duke of York, was the grandson of Edmund of Langley, the first duke of York. He had a claim to the throne through his mother, Anne Mortimer, sister of Richard II's heir, Roger Mortimer. Mortimer descended from Lionel of Antwerp, duke of Clarence, Edward III's *second* son. All very complicated and convoluted but under the laws of primogeniture, this made Richard Plantagenet the heir of Edward III, giving him a slightly better claim to the throne than Henry VI who descended from Edward's *third* son. Richard's father was executed by Henry V for his part in a plot to depose him and put Roger Mortimer on the throne.

Henry VI is remembered for being not at all like Henry V, his heroic father. By the time the bloody brutal Hundred Years' War ended on his watch in 1453 he had lost, except for Calais, all the lands in France his father had won. Henry did not do bloody or brutal. He was gentle, unfit for so onerous a job as King. His subjects were so frustrated by his lack of leadership noble sons of noble sons popped out of the woodwork clamouring to take his place. If a jumped up Henry Bolingbroke from the House of Lancaster could walk in and take Richard II's crown said members of the House of York one of our lot can walk in and take Henry's.

Henry VI is also remembered for the Wars of the Roses which began and ended in Hertfordshire. No-one at the time thought of them as such, it was the novelist Walter Scott who dreamed up the epithet. The first battle was in St Albans the last was in Barnet. Henry was at – can't say fought – both.

When he was twenty-four Henry married the feisty fearless fifteen-year-old Margaret of Anjou. Words can hardly describe Margaret. Energetic, inspirational, indefatigable and unconquerable until her adored son died in battle after which she lost the will to live. A woman in a man's world, although he wished she would not, Margaret fought Henry's battles for him. She symbolised the Lancastrian cause. A gentle, courteous man Henry did not do battle. There was no-one he didn't like, no-one he bore a grudge against. Like Queen Isabella before her, Margaret was given the soubriquet She-Wolf of France. Like Isabella she was determined to guarantee her son's right to England's throne. He would have been Edward IV had he not died in battle. The so called Wars of The Roses came down to who would rule England, Margaret or Richard, duke of York. In the end neither. Richard died in battle, Margaret was defeated in battle.

Margaret knew all about war. Her grandmother Yolande fought in armour and chain mail in the Battle of Baugé against Henry V's brother Thomas, duke of Clarence, next in line to the throne. This was the first major English defeat in France.

1453 brought joy and sorrow for thirty-two year old Henry. His only child was born and he suffered his first serious mental breakdown. When Duke Humphrey died Richard, duke of York, was next in line. Queen Margaret, to protect her son's birthright, removed all Yorkists from royal office. You do wonder whether there would have been a War of the Roses if it had not been for her. Henry did not want to be king of England let alone France. He was not interested in France or the vast tracts his father had secured for him, that was his father's dream, not his. All he wanted was to be left alone in peace with his books. The power struggle between England's two most important families the House of Lancaster and the House of York continued until 1485.

Richard, duke of York, and his powerful wife Cecily Neville reared many children including two future kings. One would usurp Henry's throne as Edward IV, the other would usurp his son, Edward V's throne as Richard III.

Richard, duke of York, based at Royston wrote to Henry in London stating his reasons for taking him on. He wrote to him again from Ware. Henry did not receive either letter. He had already left London. Richard led his army through Royston and Hertford towards London. Leaving Margaret at Watford Henry hoisted the royal standard in St Peter Street St. Albans and retreated from the scene of battle. He didn't care who ruled England.

The Lancastrian dukes of Somerset and Buckingham intercepted Richard, duke of York 21 May 1455 at St. Albans. Life was short and cheap. Normal life expectancy was thirty-five. Testosterone fuelled chaps who missed fighting for Henry V in France welcomed the battles between Lancastrians and Yorkists. The first Battle of St Albans was more of a skirmish. Within thirty minutes Richard had won the swords and daggers drawn battle. Henry's closest friend and chief ally Lord Somerset was hacked to death in front of the Castle Inn.

When the situation calmed down and Richard found Henry he pledged a truce and escorted him to St Albans Abbey to attend a service of thanksgiving. He later built a chapel in St Albans so that masses could be said for those killed in the battle. There were no more battles for four years although Margaret, looking ahead, asked Owen, Edmund and Jasper Tudor to mobilise Lancastrian sympathisers in Wales.

In 1460 parliament declared Richard Plantagenet, duke of York, Henry's successor. If he died his son, Edward, was the immediate heir to the exclusion of Henry's son, Edward, Prince of Wales. A furious Queen Margaret charged Richard with treason and fought him at the Battle of Wakefield where he died. Margaret, flushed with victory, decided to get rid of the House of York once and for all. She went south until she reached Dunstable, a Yorkist outpost, which she took. Then it was on to Markyate and Redbourn to St. Albans.

On the 2 February 1461 Edward, the new duke of York, defeated Henry's half brother – Jasper Tudor – at Mortimer's Cross. On 17 February the streets of St. Albans witnessed another battle early in the morning in the market square. No skirmish this time, it was long and fierce. It's said that the Yorkists put Henry under a tree to keep him safe where, so it was said, he sang while battle raged all around (some reports say he was housed in nearby Sandridge for safe keeping). This time it was the Lancastrians who based themselves in Royston. This time Margaret won. More than two thousand were killed. The second battle of St Albans was a significant victory for the Lancastrians.

When the Yorkists retreated there was a fond re-union between Henry, Margaret and Edward their seven year old son. A court was set up, presided over by Prince Edward. When asked what punishment the prisoners should receive it's said that the boy said they deserved to be beheaded.

Margaret's triumph did not last long. Six months later she was defeated at Towton and left England for France with her son. Henry went to the Tower. In June 1461 Edward, duke of York, was crowned Edward IV in Westminster Abbey.

As he and Richard Neville, Earl of Warwick, had been allies during the wars Warwick expected to be rewarded with prestigious positions but Edward favoured relatives of his wife, Elizabeth Woodville so Warwick defected to the Lancastrian side. In an attempt at reconciliation, George Neville, Archbishop of York, invited warring factions Edward, his brother George, duke of Clarence and Richard Neville, duke of Warwick to his home in Moor Park Rickmansworth. When he was washing before dinner his servant told Edward that armed men were in the grounds. Edward mounted a horse brought for him at a side door and rode without stopping back to Windsor.

Warwick managed to drive Edward into exile, release Henry from the Tower where he had been for five years and put him back on the throne. He was King for six months. Edward returned in 1471 with an army, marched on London and took Henry prisoner. St. Albans narrowly missed a third battle. Warwick arrived in St Albans on Good Friday but left for Hadley Green in Barnet the next day 13 April and waited with 10,000 men. Edward took his brother Richard duke of Gloucester with him and headed an army of 8000. Battle commenced on Easter Sunday. After four hours of savage fighting Edward won the day and 1500 lay dead on the field of the Battle of Barnet.

On that very same day, ignorant of the defeat at Barnet, Margaret and her son Prince Edward arrived in England. Landing at Weymouth, met by Lancastrian supporters, Margaret raised an army and headed for Tewkesbury. She rode through the ranks telling them to be brave including her beloved son Edward. Just seventeen he was understandably very nervous facing his first battle. Margaret lost everything including

Edward who was taken prisoner and killed in cold blood. He is buried in Tewkesbury Abbey. When Edward returned to London there was the little matter of England having two kings so Henry was disposed of.

Margaret was kept captive for four years until 1475 when her cousin King Louis of France paid her ransom in return for her signing all her lands in France over to him. Her options were to live as a rich woman in captivity or as a poor one in freedom. She died in poverty in 1482 age fifty-one. It's thought that Jasper Tudor one of her most loyal supporters brought the young Henry Tudor to see her at Souzay on the Loire when she was dying. She would have been gratified to know that one day they would destroy the house of York at Bosworth Field. Henry also destroyed the house of Lancaster. With Welsh and French blood in his veins he founded his own dynasty, the House of Tudor.

Edward IV, Margaret's life long adversary, died eight months after her. He was forty-one. In death as in life Margaret knew no peace. Buried with her parents, her tomb was destroyed during the French Revolution.

No more Hundred Years' War. No more Wars of the Roses. England was at peace at last. Until, that is, Edward IV died and the scrabble for the throne started all over again. Henry VI was the grandson of usurper, Henry IV, who had a reigning king, Richard II, murdered. Edward IV's half brother Richard III would usurp Edward's son King Edward V. Richard III in his turn would be usurped by Henry Tudor. What goes round comes round.

17

EDWARD IV:
BERKHAMSTED, HODDESDON, HERTFORD

Hertfordshire has a very, very, unusual memento of King Edward IV; a lock of his hair.

In 1789 when a new floor was being laid in St George's Chapel Windsor his tomb was found. It had been there untouched since 1483. The Society of Antiquaries gave permission for the tomb to be opened. Present was the Duke of Sussex, PM Horace Walpole and the Royal Chaplain to George III (name not known). Before the tomb was closed, three pieces of the King's hair was cut off and presented to Sussex, Walpole and the Royal Chaplain. In 1789 George III had two, one with the wonderful name of Beilby Porteus and Dr Charles Burney, father of the novelist Fanny Burney.

In 1964 a Miss Doughty of Holland Park London was on holiday on the south coast when she met friends of Edwin Paddick, curator of Hoddesdon Museum. As a result of this meeting she offered the museum a bust of her great grand-father the Revd R. W. Morice, who was Hoddesdon's first vicar in 1884.

When Mr Paddick arrived at her home to collect it she handed him a small packet folded to form an envelope customary of the 1700s saying: This is a lock of hair taken from the head of King Edward IV in 1789. You may consider it of some interest. She went on to say it had been handed down the family from her ancestor, chaplain to George III. Inside, attached by sealing wax, there was and is to this day a lock of the king's hair. Miss Doughty told Mr Paddick she would like to donate it to the museum.

The county has other connections with Edward too. In 1447 Edward's father (or as it has very recently turned out, his step-father) Richard, duke of York, preparing for the Wars of the Roses, fortified Hunsdon House owned by staunch Yorkist Sir William Oldhall.

When Richard and his seventeen-year-old son Edmund died in battle fighting the Lancastrians at Wakefield in 1460, Edward, nineteen, the new duke of York defeated the Lancastrians at Mortimer's Cross in February 1461 after which he was proclaimed king in London. He took the throne as Edward IV. England now had two kings (Edward did not have Henry murdered until 1471).

Lock of Edward IV's Hair Lowewood Museum Hoddesdon © HK

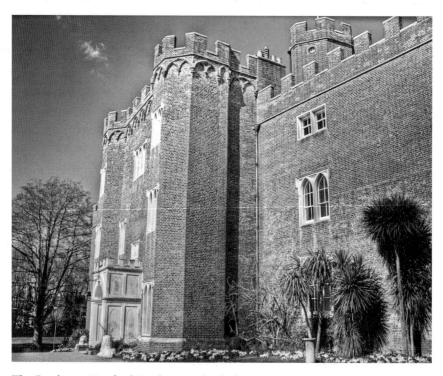

The Gatehouse Hertford Castle © Mark Playle

In 1463 Edward gave Hertford Castle to Elizabeth Woodville as a wedding present (she held court there in 1465) and rebuilt the Gate House which survives in fine condition. The gatehouse was the Castle's chief defence, protecting the royal lodgings in the inner bailey and guarded by a portcullis and a moat, which ran past the gatehouse to the River Lea. Edward IV's gatehouse has a tower at each corner, and though the archway through it has been blocked, the stones of the arch with the royal arms set above can still just about be seen. They are after all almost 600 years old. When the Gatehouse was restored in 1972 builders were amazed to find that Edward IV's work had only been hidden, not destroyed. The stonework and brick-and-timber screens that adorned the rooms have now been restored to be enjoyed by the general public on Open Days.

The castle was previously owned by Queen Margaret of Anjou, wife of Henry VI. As Elizabeth Woodville was a maid of honour to Queen Margaret it may be she already knew the castle never dreaming that one day she would own it. The bailey inside Henry II's old curtain wall built in the 1170s is now a lawn. It's hard to imagine how it looked when it was filled with the buildings used by Edward, Elizabeth and the court. Here were the royal apartments, the chapel, the great hall, kitchens and offices.

Hertford is justifiably proud of its ancient castle. Now used as council offices it is frequently opened to the public and well worth a visit. One wall inside is lined with drawings of the many royals connected with it.

Edward gave Kings Langley and Berkhamsted Castle to his mother, Cecily Neville, Dowager Duchess of York. Kings Langley is where Edmund of Langley, the first duke of York was born, lived and died. Edmund owned the royal manor of Hitchin which came down to Edward. Hitchin was well worth having for the revenues it generated.

Cecily Neville, the last royal to live permanently at Berkhamsted Castle, lived there for the last twenty-eight years of her life. The air of Hertfordshire obviously agreed with her, when she died there in 1495 she was eighty-five. The best one could hope for in those days was to reach sixty. Cecily was the granddaughter of John of Gaunt and grandmother to Edward's sons, Edward V and Richard who have gone down in history as the princes in the tower, murdered on the orders of Cecily's youngest son, Richard III.

Many secrets surround Edward IV's reign. He was conceived, born, baptized and married in secret. His predecessor Henry VI was done away with in secret as was his brother – or as it turned out – half-brother, George, duke of Clarence. Edward's two young sons, secreted away in the Tower were never seen again.

The death of Henry V's brother, Humphrey Duke of Gloucester in 1447, made Richard, duke of York first Prince of the Blood. Richard had a claim to the throne, Edward did not. None knew this better than his mother Cecily Neville. Edward's succession was very much a case of might over right. To begin with he was illegitimate. Born 28 April in Rouen he was conceived in Richard, duke of York's absence.

When Edward took the throne, the pope quickly made communication with Cecily because of her influence over her son. This rang hollow when she discovered it did not extend to her having any say in who he married. Edward, a good looking chap of six foot four and very attractive to women had, like his maternal grandfather, a high sex

Hertford Castle Edward IV Coat of Arms © Mark Playle

drive (Cecily was one of twenty-nine children). As his loyal champion, thinking that she and Edward were close, Cecily was publicly humiliated in May 1464 when he secretly married a commoner, Elizabeth Woodville. The handsome young soldier king, who could have the pick of any European princess, chose an older woman, a penniless widow with two sons. Worse, she was a Lancastrian and a sworn enemy of the House of York. Her family fought and killed many Yorkists. Elizabeth's husband Sir John Grey died fighting them at the second battle of St Albans. Small wonder Cecily felt Edward betrayed his father and his brother who died fighting Lancastrians. No wonder he did not tell her until he was forced to, four months later. In May 1465 Cecily refused to attend Elizabeth's coronation.

By 1469 Cecily, hinting that Edward was illegitimate and the crown belonged to her third son, George, Duke of Clarence, absented herself from Edward's court. Edward started showering gifts on Richard, duke of Gloucester, Cecily's youngest son, deliberately and very publicly side-lining an increasingly bitter George.

The rumour of Edward's illegitimacy started circulating in London in March 1470 put about by George after Cecily had unsuccessfully tried to reconcile him with Edward. George said that in the summer of 1441 when his father was away his mother had a love affair with an English archer called Blaybourne.

Elizabeth and Edward had ten children. The eldest, Elizabeth of York, was born in 1466, her brother Edward (V) in 1470. Elizabeth would become Queen Consort of England, the wife of Henry Tudor (VII) a Lancastrian. Cecily lived long enough to see her granddaughter on the throne.

Because of Elizabeth Woodville, Edward's court was peopled by Lancastrians some of whom were the very men who had not only butchered his father at the Battle of Wakefield but put a paper crown on his severed head deriding his claim to the throne. Edmund, her seventeen-year-old son was killed on the same battlefield in cold blood. No wonder Cecily turned into the mother-in-law from hell.

Uneasy is the head that wears the crown. After ten years Edward's became decidedly wobbly when his one time supporter Richard Neville, the earl of Warwick turned against him and challenged him in battle. On 14 April 1471 Edward defeated Warwick's army at Barnet. Unaware of his victory, Queen Margaret of Anjou, wife of Henry VI (who was still in the Tower) and their son Edward of Lancaster, Prince of Wales, challenged Edward IV at Tewkesbury on 4 May. Edward won. The Prince of Wales was among those killed. When a triumphant Edward returned to London he ordered that Henry VI be done away with.

The Wars of the Roses were over.

The only fly left in Edward's ointment was George, duke of Clarence, spreading rumours that not only was Edward a bastard his marriage to Elizabeth Woodville was bigamous. In 1477 George was accused of being involved in a plot to kill Edward and his son Edward, Prince of Wales. Edward attended his trial. George was found guilty of high treason. On the 7 February 1478, sentence of death was passed and on the 18th carried out in secret in the Tower. George was twenty-eight. What did his mother Cecily Neville make of that?

Tradition has it that he was held head down in the barrel of Malmsey (Madeira) wine in which his body was taken to Tewkesbury Abbey. Years later his remains were

exhumed. There was no sign of beheading, the normal method of execution for the nobility. It was once thought that Richard, duke of Gloucester (Richard III) did the dirty deed but if so, contemporaries were in no doubt that Edward was behind it.

In 2004, a documentary – 'Britain's Real Monarch' – was aired on Channel 4 TV presented by Tony Robinson of *Time Team* fame. It put forward the premise that the real king of England is Michael Abney-Hastings a direct descendant of George, Duke of Clarence. Mr Hastings said he was always told that Edward IV was illegitimate. The programme concluded that this is very probably the case.

Respected historian of the medieval period, Dr Michael K. Jones, revealed evidence from an entry dated July 1441 in the archives at Rouen Cathedral, which he discovered while researching the Hundred Years' War. It records that the clergy was paid to pray for the safe return of Richard, Duke of York on campaign at Pontoise, near Paris from 14 July to 21 August 1441.

Richard and Cecily's first son Henry, born in Hatfield, Yorkshire 10 February 1441, died in infancy and is buried there. Richard left for Rouen in June 1441. Is Hatfield where Cecily committed adultery with Blaybourne? Cicely's second son, Edward, was born in Rouen April 28 1442. This means he was conceived 28 July 1441. Cathedral archives also revealed that Edward's baptism, a low key affair, took place in a side chapel. In contrast, the whole cathedral was used to celebrate Edmund's christening.

Cecily's third son, Edmund, was born in Rouen 17 May 1443. He died in battle with his father. George, Duke of Clarence, was born in Dublin 21 October 1449. Her last son Richard (III) was born at Fotheringay 2 October 1452.

With the aid of Debrett's, Tony Robinson traced the descendants of George, Duke of Clarence from his daughter, Margaret, Countess of Salisbury to Michael Abney-Hastings, 14th Earl of Loudoun, in Australia. He is the son of Barbara Abney-Hastings, 13th Countess of Loudoun.

Edward Plantagenet, Earl of Warwick, son of George, duke of Clarence was executed by Henry Tudor in 1499 on a trumped up charge of treason. Clarence's daughter, Margaret, Countess of Salisbury, was executed by his son, Henry VIII, in 1541 as was her first son, Henry Pole, Baron Montagu, on trumped up charges of treason. The Clarence's had too strong a claim to the throne to be left alive. Age seventy, fighting for her life, refusing to put her head on the block, proclaiming herself 'no traitor 'the Countess was hacked to death.

Edward IV died of a heart attack at the palace of Westminster in 1483. He was taken to St George's Chapel, Windsor, where he was buried in a chapel built for the purpose although his planned tomb of black marble topped with a silver cadaver was never completed. He would be very surprised to know that a lock of his hair would one day find its way into Lowewood Museum in Hoddesdon.

.

18

RICHARD III: BERKHAMSTED

When Edward IV died 9 April 1483 his thirteen-year-old son, Edward V was proclaimed King. He never wore the crown. Instead, Cecily Neville – the last Plantagenet matriarch – who lived in Berkhamsted Castle moved swiftly to secure the throne for her youngest son, Richard.

She called a secret meeting at her London home at which she is said to have confirmed the rumour that her son Edward was illegitimate with no claim to the throne whereas Richard, legitimate, had a claim on both sides of his family. Cicely was the granddaughter of John of Gaunt, duke of Lancaster. Her husband Richard, duke of York, descended from Gaunt's brother, Edmund of Langley, duke of York. Both were sons of Edward III.

In his Will Edward IV appointed Richard, Protector of his son Edward V but his widow Elizabeth Woodville knew that her son was in danger. She sent an urgent note to her brother Anthony in Ludlow Castle (where princes of Wales were traditionally brought up) asking him to bring Edward V to London for his coronation under armed escort. Fearing for her own safety, she sought sanctuary in Westminster Abbey. She took so much with her in the way of furnishings and possessions a wall was demolished to get everything in.

Richard intercepted Anthony at Stony Stratford, arrested him on trumped up charges and moved on to London. Everyone was in mourning black for Edward except for the new young king who wore purple. In London, as was the custom, Edward V was lodged in royal apartments in the Tower while arrangements for his coronation planned for 22 June were made. On 16 June, Richard persuaded Elizabeth to let Edward's brother, Prince Richard, keep him company in the Tower.

Before the coronation, a priest was produced to say he had carried out a pre-contract marriage ceremony between Edward IV and Lady Eleanor Talbot (some sources name her as Elizabeth Lucy or Elizabeth Wayte). This made his marriage to Elizabeth Woodville bigamous, her children illegitimate and debarred Edward V from the throne.

Richard argued that as his older brothers Edmund and Clarence were dead the throne was his. This in itself is odd because although Edmund had no children, Clarence did. He and Isabel Neville had two, a daughter Margaret, later Countess of Salisbury and a son Edward, Earl of Warwick. Nevertheless Richard convinced parliament to accept him as king.

The young princes were never seen again. Rumours of what happened to them and public sympathy for their mother cast a pall over Richard's short reign. In 1674 bones of two children were found in the Tower and assumed to be those of the boys. Their remains were taken to Westminster Abbey. A white marble sarcophagus to house them was designed by Sir Christopher Wren in the north aisle of Henry VII's chapel, near the tomb of Elizabeth I. The Latin inscription (1678) translates:

Here lie the relics of Edward V, King of England, and Richard, Duke of York. These brothers being confined in the Tower of London, and there stifled with pillows, were privately and meanly buried, by the order of their perfidious uncle Richard the Usurper; whose bones, long enquired after and wished for, after 191 years in the rubbish of the stairs (those lately leading to the Chapel of the White Tower) were on the seventeenth day of July 1674, by undoubted proofs discovered, being buried deep in that place.

It was Charles II, a compassionate man, who ordered the Princes be laid to rest among their predecessors.

Elizabeth Woodville had not only been widowed and lost her young sons by Edward IV, Richard Grey, her son by her first marriage and her brother Anthony Woodville were also murdered on Richard's orders in June 1483. To escape his witch hunt, the rest of the extended Woodville family left England.

Richard was defeated by Henry Tudor at Bosworth Field in 1485. It may be that Richard's mother Cecily Neville colluded with Henry's mother Margaret Beaufort and Elizabeth Woodville to bring about his downfall. Elizabeth had her rights as dowager queen restored. Her daughter, Elizabeth of York married Henry Tudor in 1486. Elizabeth Woodville retired to Bermondsey Abbey and died there in 1492. The long reign of the Plantagenet dynasty was over. That of the Tudors about to begin.

19

HENRY TUDOR:
MUCH HADHAM; HATFIELD;
BERKHAMSTED; HERTFORD

Cecily Neville, Dowager Duchess of York, who to put it mildly, led an eventful life, lived in Berkhamsted Castle for the last twenty-eight years of her life. For twenty-four of those, she was the mother of two reigning sovereigns (Edward IV and Richard III). She left Berkhamsted Castle to her grand-daughter, Elizabeth of York, daughter of Edward IV, Queen Consort of Henry Tudor.

Cecily had twelve children. Six died in infancy. Her husband died on the battlefield as did her sons Edmund and Richard III. Her young grandsons Edward V and his brother Prince Richard disappeared off the face of the earth.

In her detailed will made at Berkhamsted Castle 31 May 1495 a few days before she died she left Henry Tudor (Henry VII) a tapestry wall hanging showing The Wheel of Fortune. The Wheel, a symbol of Fate, belongs to the goddess Fortuna who spins it at random, changing the positions of those on the wheel. Fortuna is depicted as a puppeteer. Is that how Cecily saw herself? Why would she leave anything to the man who killed her son (Richard III)? Can it be that as she walked the castle ramparts in Berkhamsted she turned against Richard? Her brother, Richard Neville, did. He supported Henry Tudor. Did he influence her? Did she suspect that Richard murdered her grandsons? If anyone knew it would be Cecily Neville. Nothing happened in the family without coming under her scrutiny.

It may be that Cecily colluded with her daughter-in-law Elizabeth Woodville and with her cousin, Henry Tudor's mother, Margaret Beaufort to get Henry on the throne and for him to take her grand-daughter Elizabeth of York as his Queen Consort. Everyone was fed up with war. The marriage would unite the warring House of Lancaster with the House of York and after thirty years of bloodshed would bring longed for peace and stability to England.

The Battle of Bosworth was on 22 August 1485. Cecily died 31 May 1495 so she lived to see her grand-daughter on the throne. Henry Tudor was good to Cecily. He paid off her debts and made sure her financial security was guaranteed. She is buried

with her husband and their son Edmund at Fotheringay, Northamptonshire. All English monarchs beginning with Henry VIII are descendants of Elizabeth of York and therefore of Cecily Neville.

The great Plantagenet dynasty ended with Cecily in Berkhamsted. The next, one of the world's most famous, began in Hertfordshire, in Much Hadham to be precise. The Tudors ruled England for 118 years, although many in Wales still regard them as their own.

How the Tudor dynasty began is now barely remembered but a story book love affair changed the course of English history. Although the Dowager Queen Katherine de Valois, widow of Henry V, was French and her servant Owen Tudor was Welsh they gave us five English sovereigns (Henry VII, his son, Henry VIII and his three children, Edward VI, Mary I and Elizabeth I) among the most well-known figures in history. Henry Tudor gave us the Tudor Rose; his son Henry VIII gave us Protestant England.

To fathom out how the dynasty began we have to go to Snowdonia in the year 1400 when Owain (after Welsh hero Owain Glyndwr) ap Maredudd ap Twdr was born. He was sent to the court of Henry of Monmouth (Henry V) as a boy. Wales had a long tradition of fighting for the Prince of Wales. Owain/Owen probably went to war in France in the service of Henry's steward, Sir Walter Hungerford. It's thought that Owen was present at the marriage of Henry and Katherine de Valois in France. If so is this where Owen first saw her?

Owen's own lineage was not without glory. From an old Anglesey family, one ancestor was the famous (in Wales) Owain Glyndwr the Welsh nationalist leader descended from Llewelyn the Great – Llewelyn the Last (Prince of Wales). Glyndwr was educated at the Inns of Court in London and married a judge's daughter. In 1400, the year Owen Tudor was born Glyndwr led a rebellion and claimed the title Prince of Wales. Owen said he was also descended from the Welsh King Coel (Old King Cole of the Nursery Rhyme) and from King Arthur.

One of the most romantic royal stories ever told, just how did it come about that Katherine, daughter of a King, Charles of France, wife of a King, Henry V, mother of a king, Henry VI became the grandmother of a king, Henry VII, via a palace servant, Owain Twdr (Owen Tudor)? Simple. They fell madly passionately and deeply in love.

How they met depends on which books you read. What is beyond doubt is that by the time Katherine gave birth to Henry (VI) at Windsor, Owen was Clerk to the Keeper of the Queen's Wardrobe – a Jeeves like Paul Burrell figure. Her household was made up of English servants so she and Owen had something in common, they were both were outsiders. Also, Katherine was probably curious about his homeland. As part of her dowry she was given extensive lands in north Wales. Some sources say that not only did she begin an affair with Owen at Windsor after the birth of her son but that Henry (V) fighting in France was told about it.

What is surprising is that no-one seems to have much bad to say about Katherine, Owen, Edmund, Jasper or Henry Tudor. Given the mores of the day, with loyalty a forgotten concept among the nobility busy slaughtering each other during the Wars of the Roses all seem to have shown loyalty and devotion to each other. Jasper's for his nephew Henry Tudor went far and above the call of duty and all were very protective

toward the vulnerable, gentle Henry VI. Owen and Edmund died fighting for him. Owen Tudor an old man in 1461 led the Lancastrian forces at the Battle of Mortimer's Cross. About to be executed he is reported to have said: 'The head which used to lie in Queen Katherine's lap would now lie in the executioner's basket'. It was thanks to Jasper's military expertise gained during the Wars of the Roses that Henry Tudor defeated the far more experienced Richard III at the Battle of Bosworth. Henry was not a natural war monger. Like all the Tudors he knew that wars drained the Treasury.

Katherine was the youngest daughter of Charles VI of France. She and Owen were the same age. During her father's bouts of insanity her childhood was blighted by poverty and hunger. Her mother left her and her siblings in squalor. Her sister Isabelle managed to escape when she became the eight year old child bride of Richard II (Londoners called her The Little Queen). When Richard was murdered Isabelle was returned to her family in France.

Henry IV, to promote peace between England and France, suggested his son Henry (V) should marry Katherine but because of Agincourt and his other military campaigns the couple did not meet until 1419. The victorious Henry V agreed to renounce the style 'king of France' provided he was named as heir when Charles died.

In January 1421 Henry and Katherine set sail for England. At Dover the barons of the Cinque Ports waded into the sea to carry them ashore. The king and queen then made their way to London to host a magnificent formal reception.

When Katherine was crowned in Westminster Abbey Henry absented himself so that his bride received all the glory. He then left on a tour to raise funds for his continuing battles in France. Hard won, he intended to keep his territories. Katherine, travelling via St Albans, joined him at Kenilworth.

By the time Henry returned to France Katherine was pregnant. She gave birth to Henry (VI) 6 December 1421 and joined Henry the following May (1422). He was by then already very ill and died in August. It was humiliating for the great warrior of Agincourt to die not in glory on the battlefield but of dysentery, the curse of soldiers for centuries.

Writing his Will in the weeks leading up to his death Henry V meticulously put his affairs in perfect order attending to the smallest detail but made no mention of Katherine. On his deathbed he asked to see his brothers, uncle and councillors but not his wife. Significantly, Katherine was not summoned. Nor was she invited to join his funeral cortège until it reached Calais and set sail for England. At Westminster Henry's funeral was held with great pomp on 7 November.

When Katherine's father, Charles VI, followed Henry to the grave two months later, Henry, her nine month old son was King of England and France. Katherine was twenty-one. Henry VI was crowned king of England in 1429 and king of France in 1431. Katherine attended both coronations.

Parliament issued a Statute, said to be instigated by Henry V's brother, Katherine's enemy, Humphrey, duke of Gloucester forbidding marriage to a Dowager Queen without royal consent. It may be that Humphrey, an incorrigible lecher, wanted her for himself.

Despite the Statute, around 1429, Katherine contracted a secret morganatic marriage with Owen Tudor though it was publicly confirmed only after her death. It's thought that they may have spent their honeymoon at her Dower House, Hertford Castle and

that she was already pregnant with Edmund Tudor. When he gave Katherine Hertford Castle as part of her dowry little could Henry V know that one day she would live there with Owen and that his son Henry would spend much of his infancy at the castle.

Both Tudor brothers, Edmund and Jasper, were born in Hertfordshire. When Katherine became pregnant, Bishop Grey of London, invited her to spend her confinement in the Bishops of London Summer Palace in Much Hadham. The baby was known as Edmund of Hadham. His brother Jasper born in 1431 at Hatfield in Hertfordshire was known as Jasper of Hatfield. Both boys were elevated to the peerage by their half brother Henry VI.

By 1434 Katherine's marriage to Owen was common knowledge in court circles when parliament granted him the rights of an Englishman (laws limited the legal rights of Welshmen) and Katherine gave him land in Flint north Wales.

No-one is sure how many children they had but by now Katherine had Edmund of Hadham, Jasper (Siaspar in Welsh) of Hatfield and Margaret, who died young. Some sources say their first child was called Owen and that he was secreted away in Westminster Abbey under the name of Edward Bridgewater. Some sources say that Katherine had three daughters, Margaret who died young plus one who became a nun and another, Jacinta, who married Lord Grey of Wilton.

In 1435, when Humphrey, duke of Gloucester became heir presumptive he took Edmund, six, and Jasper, five, away from their mother. He put Katherine in Bermondsey Abbey. The boys were brought up by Katherine de la Pole, abbess of Barking until 1442.

The Bishops of London Palace Much Hadham © Mark Playle

Katherine's last months were passed (in the words of her will) in 'grievous malady, in the which I have been long, and yet am, troubled and vexed' in Bermondsey Abbey where she died on 3 January 1437. Poorly dressed, she was put in a rough wooden coffin. All it said was 'Wife of Henry V'. It was placed next to his in Westminster Abbey. The lid was left open for tourists to gawp at her. Her grandson, Henry Tudor, replaced the original inscription which made no mention of her second marriage, with one that acknowledged her marriage to his grandfather Owen Tudor.

In 1503 her body, loosely wrapped in lead, was placed in Henry V's tomb. By then it had become strangely embalmed and displayed as a curiosity. On 23 February 1669 Samuel Pepys 'by perticular favour' planted a kiss on her mouth, 'reflecting upon it that I did kiss a Queen, and that this was my birthday'. Her corpse was still visible in 1793. In 1878 it was moved to its current resting place in Henry V's chantry. A wooden painted effigy used for her funeral is in the abbey museum.

When Katherine died, Owen was arrested, found guilty of treason and put in prison. Henry VI, fifteen, summoned him to court to account for himself. When Owen told him that he had married his mother legally he was befriended by the King and given a regular income. Henry gave his half brothers land and elevated them to the peerage, Edmund as earl of Richmond, Jasper, earl of Pembroke. They were knighted at the Tower 5 January 1453 and formally recognised as the king's legitimate uterine brothers. Owen and his sons would prove to be the king's most loyal supporters.

Katherine de Valois: wooden effigy
carried at her funeral © The Dean and
Chapter of Westminster

As for Duke Humphrey, in 1447, he died in custody just before he was about to be charged with treason. His body was taken to St Albans Abbey, to which he had been a life long benefactor. His tomb is adjacent to the shrine of Saint Alban.

In 1454 the dowager duchess of Somerset was summoned to London with her ten-year-old daughter, Lady Margaret Beaufort, England's wealthiest heiress. She was a descendant of John Beaufort, son of John of Gaunt and his mistress Katherine Swynford. The Beaufort Bastards as they were dubbed were legitimized by Richard II but banned from making any claim to the throne.

Henry granted the wardship of Lady Margaret to Edmund. In 1456 Edmund married Margaret who was twelve. That same year he died of plague in Yorkist custody at Carmarthen Castle on 1 November and was buried at the nearby church. When his grandson, Henry VIII, destroyed the monasteries, his tomb was taken to St David's Cathedral, Carmarthen. Elaborately decorated with brass figures and heraldic emblems it occupies a place of honour near the high altar.

Edmund's brother Jasper assumed responsibility for Margaret who was pregnant and took her home to Pembroke Castle, where her son, Henry, was born three months later on 28 January 1457 after a difficult confinement. Jasper was devoted to his nephew and looked after him until he (Jasper) died.

Margaret, who vowed never to remarry, married twice more. Her second marriage to Sir Henry Stafford was childless. After Stafford's death her third marriage, to Thomas, Lord Stanley of Derby was also childless. As she was a child herself when she had Henry it may be that affected child bearing. Lord Stanley would one day help her son take on Richard III at Bosworth Field and would place the crown on Henry's head.

With his brother gone, Jasper was now the main champion of Henry VI's Lancastrian cause in Wales. He was appointed constable of the castles of Aberystwyth and Carmarthen and strengthened the fortifications at Tenby. He triumphed in the siege of Denbigh where Henry's Queen Margaret joined him after the battle of Northampton.

In 1455 Jasper was at the first battle of St. Albans fighting the Yorkists. In 1461 he led an army to join the Lancastrian forces at Mortimer's Cross where his father Owen was captured and beheaded. A devastated Jasper managed to escape and was a fugitive for the next twenty-five years. He went on the run first to Ireland, then Scotland and later, as guardian to his nephew the fourteen-year-old Henry, to France where they stayed fourteen years. Jasper took the boy to London to be presented to the temporarily restored Henry VI and to be reunited with his mother. Jasper played a significant role in the restored but short lived Lancastrian regime.

At the Battle of Tewkesbury 4 May 1471 Queen Margaret was taken prisoner and her son the Prince of Wales was killed. Jasper and his nephew left for Brittany where Duke François allowed them to live in honourable confinement. The House of York was so firmly established in England they assumed they would be in exile for the rest of their lives. However, Richard III's usurpation and the persisting rumour that he murdered his young nephews in the Tower shocked England, especially, so it's said, Richard's mother, Cecily Neville, the boys' grandmother who lived in Berkhamsted Castle.

In 1485 When Richard III tried to get Jasper and Henry Tudor handed over to him, Henry, now twenty-eight, turned the tables and plotted his overthrow. He had plenty

of support from the embittered, exiled, Woodville family. Richard said that Elizabeth Woodville's marriage to Edward IV was illegal, declared publicly that her sons were bastards and then had them done away with. It may be that Elizabeth Woodville, Cecily Neville, Margaret of Anjou (widow of the murdered Henry VI) and Margaret Beaufort, Henry Tudor's mother collaborated to topple Richard. To put an end to the bloody wars which had been going on for more than thirty years, it was suggested to Henry, a Lancastrian, he marry Elizabeth's daughter, Elizabeth of York, sister of the princes in the Tower and make her his Queen Consort.

With support from the French king, exiled Woodville's and Lancastrians on 1 August 1485 Henry's invasion fleet left the Seine and on 7 August landed in Milford Haven in Jasper Tudor's lordship of Pembroke. Jasper trained Henry in the war tactics that made it possible for him to defeat the far more experienced Richard at the Battle of Bosworth Field 22 August.

Sir Robert Lytton raised troops for Henry and fought with him at Bosworth. Rewarded handsomely he built Knebworth House which remained unaltered for three hundred years. Henry Tudor's grand-daughter Elizabeth I stayed at Knebworth House in 1588. Sir Robert's daughter Helena married Sir John Brocket of nearby Brocket Hall. Henry gave Moor Park in Rickmansworth to the earl of Oxford who also fought with him at Bosworth.

Henry marched to London where he was acknowledged with the goodwill of the people as Henry VII. Jasper was prominent at his coronation on 30 October 1485. Henry married Elizabeth of York January 1486. His Tudor Rose symbolises their marriage by representing the red rose of Lancaster superimposed upon the white rose of York.

Jasper Tudor was created duke of Bedford (the only other new dukes created by Henry VII were his own sons), restored to his estates and the earldom of Pembroke, given extensive land in Glamorgan, Abergavenny, Sudeley, Haverford, Builth and Cardiff Castle. By 7 November 1485 he had married Katherine Stafford, sister of Elizabeth Woodville another union of Lancaster and York. Katherine brought Jasper extensive Stafford estates. He now had territorial authority over, and income from, a great triangle of land, from Milford Haven in the west to Essex in the east, with its apex in Derbyshire.

Jasper was one of the king's councillors in military matters. In December he was appointed to several important offices, chief among them the justiciarship of south Wales. In 1486 he was appointed lieutenant of Ireland. In 1495 age sixty-three he made his will at Thornbury, where he died on 21 December. Henry and his queen Elizabeth of York attended his funeral at the abbey Church of Keynsham near Bristol, where he asked that four priests, for whom he left maintenance, should sing masses for his soul and for those of his parents Owen and Katherine. As he left no legitimate children, his nephew Henry was his heir.

Although most of the legitimate Lancastrian and Yorkist claimants to the throne had killed each other during the Wars of the Roses and although Henry's grandmother, Katherine, was the daughter of the King of France and Queen of England, his father was the half brother of King Henry VI and his mother a descendant of Edward III, Henry's claim to the throne was still very much a case of might over right.

20

HENRY VIII:
HUNSDON; MOOR PARK

England very nearly had a second King Arthur. Henry Tudor believed his grandfather Owen Tudor's claim that not only was King Arthur Welsh but he, Owen, was descended from him. Henry VII named his first son Arthur, Prince of Wales, and was broken hearted when he died of TB on his honeymoon with Catherine of Aragon at Ludlow Castle. He was fifteen. Henry was his second son. Many of our monarchs were the second born, not born to rule, destined to rule.

Was the marriage consummated? Catherine said no. Henry Tudor, not wanting to return her dowry, persuaded his son to marry her. They were both young. They liked each other. Nature was calling. Like Dickens' Barkis, Henry was willing. Because marrying your brother's wife was unacceptable in the eyes of the Church, special dispensation was granted by the Pope. Much later, when it became clear Catherine could not give him the son he craved, Henry would use the honeymoon in Ludlow as an excuse to divorce her saying the marriage was invalid. When the Pope said it was, but that his second marriage to Anne Boleyn was not, Henry famously sacked the Pope. That's chutzpah.

Henry's main connections with Hertfordshire are through his children who were brought up here. London with its frequent outbreaks of plague was not a healthy place. Hertfordshire had fresh air and an abundance of clean drinking water, something that the city was fast running out of especially since Henry closed all wells with 'papish' names, dedicated to saints (e.g. St. Mary's Well).

Henry gave the royal manor of Hitchin, Anstey Castle and King's Langley Palace to his first wife, Catherine of Aragon, his second wife Anne Boleyn and his third wife Jane Seymour.

Henry loved his castles. He made improvements to Hertford Castle and stayed there with Catherine of Aragon. Remnants of his gatehouse, re-constructed out of the famous, fashionable Tudor brick built on the foundations of the old one can still be seen. Catherine held court here.

Cardinal Thomas Wolsey held The Moor in Rickmansworth and Tyttenhanger on long leases from St Albans Abbey. Wolsey stayed at both places with his mistress, the

daughter of an innkeeper. Their son and daughter were referred to as his nephew and niece.

In 1529 Henry VIII spent a month with Wolsey at The Moor. With him were his wife Catherine of Aragon and her lady in waiting Anne Boleyn. This is where they fell in love. In 1531 Catherine was banished to the Moor to punish her for her obstinacy on not agreeing to a divorce. In 1540 Henry gave The Moor to his fourth wife Anne of Cleves in gratitude for her agreeing to a divorce before the marriage was consummated (he didn't fancy her so they stayed up all night playing cards). Henry stayed with Anne with his fifth wife Katherine Howard. Anne of Cleves died in 1557.

The magnificent house we see today is not the one where Henry VIII visited Cardinal Wolsey, that old palace has long gone. The meteoric rise to fame and power of the social climbing, ambitious son of an Ipswich butcher was equalled by the speed rate of his demise. Wolsey lived in great splendour at Moor Park and often entertained Henry, Catherine of Aragon and her lady in waiting Anne Boleyn, a talented musician, dancer and singer and extremely intelligent. Wolsey maintained a household of over a thousand and acted more like a king than Henry. When Henry was hounding Catherine for a divorce she stayed at The Moor under Wolsey's protection. Henry who coveted the mansion would one day get his hands on it by appropriating all properties belonging to religious houses.

According to local legend Henry also visited Wolsey in Great Wymondley near Hitchin. Delamere House is on the site of an earlier house where it's said Cardinal Wolsey stayed. Thatched cottages in the village are named after Henry's wives. It's also said that when out hawking there Henry tried to pole vault over the river, the pole broke and he landed in the water. The *Buck's Head* pub sign in Little Wymondley shows the story. Henry certainly hunted in the area. Another local legend has him escaping a fire which broke out when he was staying at the Angel Inn (demolished) in Hitchin.

It was Wolsey who Henry sent to ask the pope to annul his marriage to Catherine. When he failed, a furious Henry blamed him personally. Even Wolsey's gift (sic) to Henry of his magnificent new palace, Hampton Court could not placate him. Exiled to The Moor he died shortly after, saving Henry the bother of a mock trial for treason.

Henry bought and re-built Hunsdon House near Roydon. His barrel vaulted cellar has survived. Still building it ten years later Henry created a Tudor palace with royal apartments, minstrels' gallery, moat, gatehouse and summerhouse. A frequent visitor he ate in private in the Tower. In 1536 when Henry divorced her mother Catherine of Aragon, Mary was sent to Hunsdon. Letters from there to her father and to his henchman Thomas Cromwell beg for reconciliation with the king. In 1983 during building work his original Tudor brickwork was revealed. Less than a quarter of the size of Henry's house today's Hunsdon House is thought to be just one wing.

Henry used Hunsdon House as a base for his children, Mary, Henry Carey (son of his one time mistress, Mary Boleyn), Elizabeth and Edward. Legend says it was here that Mary taught her young half sister Elizabeth to play cards. Following his marriage to Ann Boleyn and his split from the church in Rome, Henry sent Nicholas Ridley, Bishop of London, to Hunsdon to convert Mary to Protestantism. She was outraged and sent him packing with a flea in his ear. When Edward VI died, it was from Hunsdon Mary rode to her coronation. She had Ridley burnt alive in 1555.

Henry spent most of 1528 the year in Hertfordshire to escape the 'sweating sickness' in London. Cardinal Wolsey received a letter from Hunsdon saying: '...the King's grace is very merry since he came to this house, for there was none fell sick of the sweat since he came hither, and ever after dinner he shooteth to supper time'. Long after Wolsey was past tense, Henry stayed at Hertford Castle, Hatfield House and Tyttenhanger before meeting his new Archbishop, Thomas Cranmer at Waltham to discuss his divorce. Later in the year he stayed at Tyttenhanger again.

In 1530 Henry spent Christmas at Ashridge. In 1533 Mary was living at Hatfield House when Thomas Cranmer, archbishop of Canterbury, declared Henry's marriage to her mother Catherine null and void. Four months later Henry secretly married Anne Boleyn. The question is where? No–one knows. Anne may have stayed at Sopwell Nunnery near St. Albans shortly before her marriage so perhaps it was there. Wherever it was made no difference, Henry had her executed for adultery in 1536.

St Benedict Nunnery in Sopwell was a prestigious religious house founded in 1140. One Prioress was Dame Juliana Berners born in 1388, daughter of Lord Berners (there is still a Lord Berners today). Her brother fought for Henry VI in the first Battle of St. Albans. She is the world's first woman sports writer. Her *A Treatyse of Fysshynge wyth an Angle* (1496) is the first book on fishing printed in England. Her *Boke of St Albans* (in The British Library) about field sports, especially falconry is the earliest example of colour printing in England. There was a strict hierarchy of ownership of falcons. Only the king could keep a Gyr Falcon. Princes kept Peregrine Falcons, barons kept hawks, yeoman were allowed goshawk. Priests hunted with sparrow hawks, their servants with kestrels.

It was Dame Berners who gave birds collective nouns such as a siege of bitterns, a brood of hens, a charm of goldfinches, gaggle of geese, desert of lapwings, exaltation of larks, tidings of magpies, congregation of plovers, murmuration of starlings and so forth.

When Henry VIII closed religious houses, his surveyor, Sir Richard Lee bought Sopwell Nunnery, demolished it and built a house on the site (the remains are still there). His large stone medallions with profiles of Roman Generals ended up in Salisbury Hall London Colney.

Edward was born to Jane Seymour in 1538. She died two weeks later. He spent much of his infancy and youth at Hunsdon. The 1540s saw Henry's dissolution of religious houses including the priory at Kings Langley. His daughter Mary would restore the priory; his daughter Elizabeth would close it again. When Henry gave The Moor to Anne of Cleves she entertained him and his new bride Katherine Howard here. They stayed a week. Katherine was nineteen, Henry was fifty. Henry had Katherine executed in 1542 for adultery.

Henry married Katherine Parr his sixth and last wife in 1543. Mary, Elizabeth and Edward were shunted between Ashridge, Hertford, Hunsdon and Hatfield. Edward in 1546 had his portrait painted at Hunsdon showing the house in the background.

In 1559 Hunsdon House ceased to be a royal residence when Elizabeth I granted the manor to her 'dear coz' (half-brother) to Sir Henry Carey. In 1576 she stood godmother to the daughter of Sir George Carey who was baptized at Hunsdon.

Henry VIII died in January 1547. He is buried in St George's Chapel Windsor Castle next to his third wife Jane Seymour, the mother of Edward VI. He was fifty-six.

21

ELIZABETH I: MARY I: EDWARD VI: ASHRIDGE; HATFIELD; HUNSDON; HERTFORD

Elizabeth was named after her grandmother, Henry Tudor's wife, Elizabeth of York. Knowing what happened to her grandmother's brothers Edward and Richard, the princes in the Tower, small wonder Elizabeth grew up watching her back.

Of Elizabeth's many close connections with Hertfordshire the one which endures is of her sitting under a tree in the grounds of old Hatfield Palace when told she was queen of England. Was it true? It was, after all, mid November. She lived in the Palace off and on for the first twenty-five years of her life until she became Queen but rarely went back.

When he married her mother Anne Boleyn Henry renamed Queen Catherine the Princess Dowager and Princess Mary the Lady Mary. Just before Elizabeth was born Henry ordered Catherine to send him the elaborate christening shawl they used for Mary seventeen years before. She refused.

A furious, thwarted Henry, not used to not getting his own way, declared Elizabeth next in line to the throne. When she was three months old he set her up in her own impressive household at Hatfield and ordered his seventeen-year-old daughter Lady Mary to be her lady in waiting. She refused. She was banished to a room at the top of the house and looked out of the window whenever her father, who she adored, visited Elizabeth. He ignored her. He took Elizabeth to court on special occasions such as the death of Mary's mother, the cruelly deposed Queen Catherine of Aragon.

When Elizabeth was four, Kat Champernowne became her governess, life long friend, protector and mentor. One day Kat's nephew, Walter Raleigh, knowing her penchant for handsome young men would try and fail to marry Elizabeth. Kat taught the very intelligent Elizabeth astronomy, geography, history, mathematics, French, Flemish, Italian, Spanish, deportment, dancing, riding, needlework and embroidery. When she was six, Elizabeth made a beautiful cambric shirt for Edward, her half brother and successor in her father's affections. Near in age, they were very fond of each other.

Elizabeth also lived in Hertford Castle. Her prayer book dated 'Hertford 1535' is in the British Library. A facsimile is in the Castle. As Queen, when she stayed in

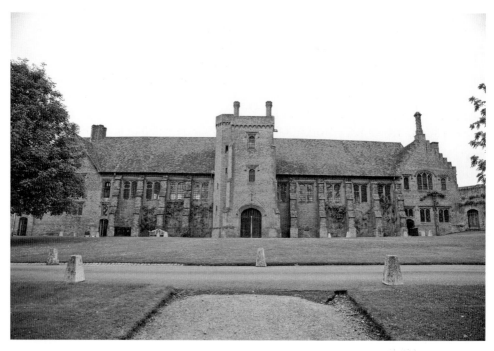

The Old Palace Hatfield House © MAK

Hertford, to save money on housekeeping, she stayed at all the great houses in the neighbourhood. When her Parliament was driven from London by the plague it met at the castle hence Parliament Square, Hertford. Queens Road takes its name from the credible local legend that Elizabeth used to climb the hill from the castle to enjoy the view from a spot afterwards known as The Queen's Bench.

In 1536 Elizabeth, three, and Mary, twenty, living in Hatfield were now in the same boat. Elizabeth's mother, Anne, like Mary's, had been dispensed with. Now, both were declared illegitimate. Both were *persona non grata*. Henry's flavour of the month was his new queen Jane Seymour and her son, Edward, now next in line.

When Edward was five he, Elizabeth and Mary lived at Ashridge before he was set up in his own court at Hertford Castle which Henry improved before his son took up residence. Edward and Elizabeth often visited each other. He lived there until he was nine when his father died. Edward was collected from Hertford and taken to Enfield to hear his father's will read out. Elizabeth, fourteen, went to stay with Henry's sixth and last wife, Katherine Parr. It was there Elizabeth met William Cecil of Theobalds, Cheshunt who would prove her most loyal supporter till the day he died.

When Katherine's husband Thomas Seymour, forty, was caught kissing or trying to kiss Elizabeth, Katherine sent her to Cheshunt to stay with Sir Anthony Denny (official Guardian to Edward VI) and his wife Joan, a relation of Kat Champernowne. Unhappy there Elizabeth asked permission to return to Hatfield. Her request was granted.

Sir Anthony Denny's neighbour at Theobalds, Sir William Cecil, was related to him by marriage; another neighbour, in Park Street, was Denny's nephew, Sir Francis

Walsingham who would one day be Elizabeth's Spy Master General. The following year in 1548 when Katherine Parr died in childbirth Elizabeth was very upset.

In 1550, Edward VI in accordance with his father's will granted Elizabeth lands to the value of £3000. When she was told that Hatfield House was to be sold to the earl of Warwick she was very upset. She persuaded Warwick to exchange it for her lands in Lincolnshire to the same value. He agreed.

Edward founded Christ's Hospital School known as Blue Coat School in Hertford. In his will, he left Hunsdon House to Elizabeth and Hertford Castle to Mary. In 1553 Edward, fifteen, died. To prevent the throne passing to the Catholic Mary Tudor the earl of Northumberland had persuaded him to declare Mary illegitimate and alter the line of succession to Lady Jane Grey. Edward agreed. The Marquis of Northampton proclaimed Lady Jane Grey, great-granddaughter of Henry VII, Queen at Ware on 14 July while Mary, at Hunsdon House, was informed she was now Queen of England She was thirty-seven, Elizabeth was twenty.

In 1554 Elizabeth was back at Ashridge, banished from court by Mary. While there the robust Elizabeth became unexplainably ill. Said to be poisoned on Mary's orders she almost died. Mary ordered her to appear at court to answer questions of treason. Elizabeth was so ill the journey took five days. She had to stop at Redbourn, St Albans and South Mimms.

When she arrived in London and was told that Lady Jane Grey, her husband and her father had been executed, Elizabeth had no illusions of why she had been sent for. She was next. Taken to The Traitor's Gate imprisoned in the Tower for over a year, it was

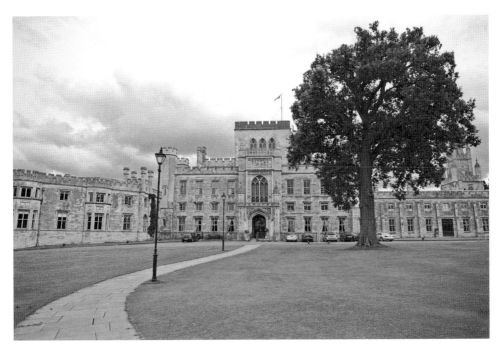

Ashridge © MAK

a miracle she ever came out. She acted with great dignity and was very popular with the people. The government was in disarray and Mary had no proof Elizabeth had committed treason. Mary and her Roman religion were hated. Two Protestants were burnt alive every week for the three years of her reign.

Elizabeth never went back to Ashridge. In 1925 her statue was removed from there and found its way to Harrow School. She was eventually allowed back to Hatfield but Mary spitefully removed Kat Champernowne the nearest Elizabeth had to a mother.

1558 started badly for Mary and ended even worse. Menopausal she had another phantom pregnancy. She was even more unpopular when a humiliated England lost Calais, its last foothold in France. On November 17 Elizabeth was at Hatfield House when she received the news that Mary had died and she was Queen. She kneeled and quoted the 118th Psalm line 23 in Latin: *A Dominum factum est illud, et est mirabile in oculis notris.* (It is the Lord's doing and it is marvellous in our eyes). She was twenty-five.

Within hours, her advisers gathered for her first Council of State in the Great Hall (now the Banqueting Hall). One was William Cecil who stayed by her side until he died. During the next week Hatfield hosted an influx of courtiers. Elizabeth officially addressed them for the first time as Queen from a makeshift throne and canopy of state. On 23 November Elizabeth left Hatfield for London with an entourage of a thousand to prepare for her coronation. She rarely, if ever, went back.

As Queen she stayed connected to Hertfordshire. In 1586 she appointed the love of her life, Robert Dudley, earl of Leicester, Lord Lieutenant of Hertfordshire. If it were not for three men who lived in Hertfordshire Elizabeth would not have died in her bed of old age, she would have been assassinated. From 1558 when she was crowned until 1603 when she died Elizabeth was saved from every attempt on her life by William Cecil of Theobalds Palace, Cheshunt, his son, Robert Cecil later of Hatfield House) and Spy Master General, Sir Francis Walsingham of Old Parkbury near Park Street. All were devoted to her, trusted no-one and suspected everyone.

The royal manor of Hitchin now belonged to Elizabeth. A very important centre, it was second to none for its grain market. Elizabeth is said to have replied to a Spanish nobleman when he was boasting of his vineyards: My Hitchin grapes surpass them, or those of any other country.

Elizabeth closed the priory at Kings Langley and gave permission for Edmund of Langley's tomb to be moved into the parish church of All Saints in the village. Lead stripped from the Priory roof was recycled at Windsor Castle. She amalgamated Kings Langley with the Duchy of Lancaster. The Tudors never used it. Was this because it was so closely associated with their predecessors the Plantagenets?

The Tudors never used Berkhamsted Castle, another Plantagenet stronghold, either. Elizabeth gave it Sir Edward Carey, a nephew of her mother Anne Boleyn. The old crumbling castle would not do for Carey who demolished the ancient historic landmark and stripped it of its outer casing of expensive stone to build Berkhamsted Place leaving the rubble infill we see today. Ironically the old castle has survived Carey's place.

The Queen often stayed at grand houses in the county whilst her palaces were being 'sweetened'. As ever looking after the pennies, she stayed with Sir Ralph Sadleir

at Standon and with Sir John Brocket at Brocket Hall. She foisted herself on her chief minister, Sir William Cecil at Theobalds on more than twelve occasions, each visit costing him almost two thousand pounds (£500,000). In 1578 she stayed with Henry Capel at Hadham Hall, his magnificent new mansion in Bishops Stortford which is still there. The town's website says that: *The Queen and her retinue came riding through the town from Little Hadham to great rejoicing, for 10s. (50p) was paid for Ringing to the Ringers when the Queens majesty came to Mr Capells and from Mr Capells thorowe the towne'.* The Capel's would feature in the reigns of Charles I and his son Charles II.

Another of her favourite places to stay was with Sir Nicholas Bacon Lord Keeper of the Great Seal in Gorhambury St. Albans. Elizabeth admired self-made men such as Bacon and William Cecil preferring their company above that of the landed gentry. Teasing him about his 'little' house he said it was of normal size but her presence made it seem small. Never the less he built a new wing for her next visit which cost him £577 (£98K) for her four day stay. The romantic ruins can still be seen.

She also stayed at Hunsdon House with her 'dear coz' Henry Carey, a rough diamond totally loyal to Elizabeth who was in fact his half-sister. Foul mouthed, intelligent and capable, Carey was the son of Henry VIII and Mary Boleyn. Elizabeth made him Baron Hunsdon. The Lordship of Hunsdon was created by Elizabeth after she granted Hunsdon to him in 1559.

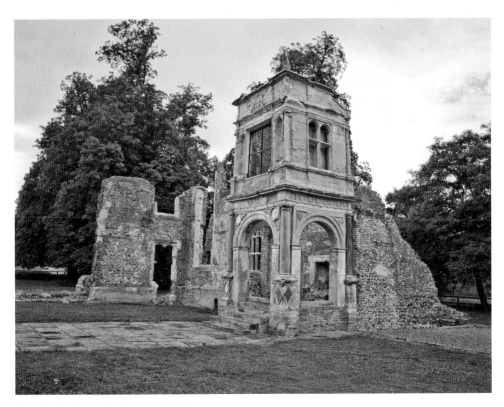

Old Gorhambury St Albans © MAK

In 1588 when the Spanish Armada was sighted, beacons were lit at Amwell, Gravely, Monken Hadley and St Albans. Sir William Lytton of Knebworth took command of forces in Hertfordshire and led them to Tilbury where Elizabeth made her famous speech about having the body of a woman but the heart of a king. Here Lytton handed his troops over to her half brother, Henry Carey, Lord Hunsdon. Sir William was a descendant of Sir Robert Lytton who fought for her grandfather Henry Tudor (Henry VII) at Bosworth Field. Sir Rowland Lytton owned Letchworth Hall. Of Norman origin, the impressive Jacobean Hall he built has survived in the present hotel.

In 1589 Elizabeth granted the town of Hertford the right to appoint a Sergeant at Mace, the symbol of Royal authority. One of Elizabeth's last visits of any length to the county was in 1593 to Hertford Castle, one of the scenes of her childhood. Elizabeth was the last monarch to stay there.

Hertford Mace Bearer courtesy Hertford Town Council © MAK

22

JAMES I: ROYSTON; CHESHUNT

From contemporary descriptions, some graphic images of James I stick in the mind.

"His tongue was too large for his mouth, which ever made him speak full of mouth, and made him drink very uncomely, as if eating his drink, which came out into the cup of each side of his mouth." (English courtiers).

He constantly fiddled with his codpiece in public. Worse, he fiddled with those of his boyfriends he called "my sweetheart" and "My sweet child and wife" ' ...

'...his eye was large, ever rolling after any stranger that came into his presence, in so much as many for shame have left the room...[he was] ever leaning on other men's shoulders... his fingers ever in that walk fiddling about his codpiece." (English courtiers).

"The king's kissing them after so lascivious a mode in public...prompted many to imagine some things done in the retiring house...' (Sir Anthony Weldon).

Homosexual or not, James knew his duty. He sired nine children with a wife he had no interest in. With a dearth of Protestants at the demise of the Stuarts in 1714 the grandson of James' daughter Elizabeth of Bohemia would succeed to the throne a George I, the first of the Hanoverians.

When Sir Robert Carey of Hunsdon House rode to Scotland to tell James he was king of England James is reported to have said he couldn't wait to leave 'lowsy Edinburgh'.

In April 1603 on his way south to prepare for his coronation James stayed with Sir Robert Chester in Royston. Once he saw Chester's house he wanted it. What the king wants the king gets He would later convert the house in Kneesworth Street and The Cock and The Greyhound inns into a royal hunting lodge at a cost of £4000 (£527K). It's still known locally as The Old Palace.

Why did the king want a house in Royston? Because the king was obsessed with hunting. If not for him the county might still be blessed with great bustards, a game species popular as food commonly hunted by falconers. James hunted them on Therfield Heath.

The world's heaviest flying bird can weigh up to three stone (42lb) so was laughably easy to hunt. A high whistle could be heard from the egg prior to hatching. Heavily built, its shape similar to goose but bigger with longer legs and a straighter neck its gait is slow. Unable to perch, it's only ever seen on the ground. Worse, its underparts and wings are mostly white. It fights to get airborne and has to run as well as flap. The males are not fertile until they reach four or five years. In 2009 the first wild chicks for more than 170 years in the UK hatched and successfully fledged in a secret location on Salisbury Plain.

As well as demolishing the Great Bustard population, it was James who practically demolished Hertford Castle. He didn't need it because hunting in the area had been exhausted by Henry VIII. He said except for the gatehouse the old buildings were 'ruinous and decayed' despite the fact that his predecessor, Elizabeth 1, had stayed there not long before. The King's day was planned around hunting. If he had a good day's hunt, James was buoyant, if not, he retired to his room which made communication with his ministers very difficult.

It was at Royston that aided and abetted by Francis Bacon, another notorious homosexual, James signed Sir Walter Raleigh's death warrant. He made many enemies over that. Raleigh's supporters including his friend John Pym never forgave him. One day Pym would make his son Charles I pay for that error of judgement.

Royston remained one of the king's favourite *pieds-à-terre* right up to his death. He spent so much time there his ministers in London found government difficult. He was there in 1605 when told of The Gunpowder Plot.

On Saturday 26 October at night a letter (in National Archives at Kew) was delivered to the London home of the Roman Catholic Lord Monteagle of Furneux Pelham in Hertfordshire. The young ambitious peer took it straight away in person to Sir Robert Cecil, Lord Salisbury, at Whitehall because James was not expected back from Royston until the opening of parliament on 31 October. The letter warned Monteagle not on any account to attend the House of Lords on 5 November.

Cecil discussed the letter with the Privy Council. Involved in the Plot was Sir Francis Tresham who didn't want Monteagle, his brother-in-law, blown up. We all know how the Plot ended. James, grateful to Monteagle, gave him an annuity of £500 for life (£69,164) plus lands worth a further £200 p.a. (£27,665).

The royal manor of Hitchin is near Royston. Did James pass through? He granted Hitchin to his wife, Queen Anne of Denmark, who gave it to their son Henry, Prince of Wales. When Henry died young it passed to his brother Charles who gave it to his wife Queen Henrietta Maria. After the Restoration she resumed possession. When she died it was held by Catherine of Braganza, queen of Charles II, grandson of James. James also gave Hertford Castle and Kings Langley Palace to Prince Henry. When he died they too passed to Charles I then Charles II.

On his royal progress from Scotland to London Sir Robert Cecil was waiting to greet James at Hatfield House, a crown property. James also stayed at Robert's home, Theobalds in Cheshunt. The minute he saw it James wanted it. Like Chester, Robert had no choice but to give it to him. When James conferred a peerage on him, he 'persuaded' Robert to exchange the sumptuous Theobalds for the old palace at Hatfield where Elizabeth I grew up. Not at all a case of fair exchange but what the king wanted the

king got. Robert must have been devastated; Theobalds is where he grew up. His father's pride and joy, William Cecil spent a fortune on it.

In 1605 wanting to impress him James entertained his brother-in-law the King of Denmark at Theobalds. In 1611 James assembled a menagerie there when the king of Spain gave him an elephant and five camels. He also kept rare albino baby hinds with their own (human!) wet nurse, flying squirrels, sables and falcons.

By the time James got to the throne London was so densely populated it had run out of clean drinking water. When Henry VIII severed connections with Rome he ordered all wells with 'papish' names be built over. By the time his daughter Elizabeth I died, the shortage had become a crisis. When a question was raised in Parliament a chap called Ingelbert put forward a plan to bring water from Am Well and Chad Well in Hertfordshire to London in a brick vault. Colthurst, a rival for the contract suggested a cheaper, open, trench.

In 1606 an Act of Parliament authorised Colthurst to bring water in via his trench. In 1607 a second Act allowed Ingelbert to bring water in via his brick vault. Both Acts were questioned in the House by an outraged MP for Hertfordshire. Colthurst took on a business partner, Hugh Myddelton, MP, goldsmith to James I and requested that powers granted under both Acts be transferred to them. In the end, the Council decides to give, not Colthurst, not Ingelbert but Myddelton, whose brother just happened to be Lord Mayor of London, permission to proceed.

The so called New River went from Amwell, Chadwell on to Hoddesdon Broxbourne, Cheshunt and into Theobalds Park where money ran out. James was so intrigued with the New River he put up half the money to continue the work in return for half the profits.

Theobalds today © MAK

The thirty-eight mile canal, half of which is in Hertfordshire, was completed in 1613. Hand cut by six hundred men, 4 feet deep, 10 feet wide, 60 feet above sea level, Thames Water engineers say they couldn't improve on the scheme today. 112 higher than where the river ends in Islington, water follows 100-foot contour line. The drop of five inches every mile means the water flowed slowly as it left Hertfordshire through Enfield, Wood Green, Hornsey, Haringey, Holloway and Islington. 150 bridges were built along the route. In some places the river was an aqueduct.

James spent a lot of time with Francis Bacon at his home, Gorhambury, St. Albans, the centre for affairs of state until Bacon fell from grace and James deserted him in his hour of need.

Because William Cecil, Secretary of State, of Theobalds married Mildred Cooke, sister of his mother, Lady Anne Bacon, Francis expected high office. Until James I came along he was disappointed. When James came to the throne Bacon enjoyed a rapid rise to fame and fortune. Within a very short space of time he was: knighted for his proposal to unite England and Scotland; appointed Commissioner for the Union; King's Counsel; Solicitor-General; Clerk of the Star Chamber; Chief Advisor to the Crown; Attorney-General; Privy Councillor; Lord Keeper of the Great Seal ('Keeper of the King's conscience' acting as Regent); Lord High Chancellor (highest public post next to the throne) and raised to the peerage, Baron Verulam, on his 60th birthday, first Viscount St Albans.

He thought he was inviolable. He wasn't. Parliament loathed homosexuals especially Bacon, James and his lover the duke of Buckingham. It couldn't get rid of the King or Buckingham but could dispense with Bacon. It impeached him – a criminal trial initiated by the House of Commons with the House of Lords acting as judges. Long fallen into disuse but still on the statute books (as it still is today) it was revived by Sir Edward Coke specifically to get rid of Bacon.

The plot was hatched almost immediately upon his receiving the last title, at the height of his public glory. Impeached on twenty-three counts of bribery, corruption and perverting the course of Justice, Bacon frantically sought an audience with James but was refused. The King who felt threatened ordered Bacon to plead guilty.

A fellow MP said Bacon's fall was due not to corruption but to 'an unnaturall crime'. Bacon's sentence included: A fine of £40,000 (£6m); imprisonment in the Tower; a ban from ever again holding office; an exclusion from Parliament and the verge of court (twelve miles radius from anywhere the sovereign is in residence). He lost everything, fame, fortune, freedom and name. Publicly humiliated he was remanded in Gorhambury at His Majesty's Pleasure.

James died on 27 March 1625. He had fallen from his horse in the grounds of his beloved Theobalds. A vindictive Cromwell passed an Act of Parliament to destroy Theobalds because it was from Cheshunt that his ill-fated son Charles I was proclaimed King at the gates of nearby Cedars Park.

James lived and died a fervent believer in the Divine Right of Kings. A king's sole responsibility was to God. He brought up his son Charles I in the same unshakeable belief. Oh dear.

23

Charles I and his son Charles II: Hadham; Cheshunt; Tring; Ware; Rye; Cassiobury; Moor Park

James I was thrown from his horse at Theobalds, his favourite country home. Seriousy injured, he was taken to London to be treated. His son Charles waited at Theobalds for three weeks to hear whether his father would live. He didn't.

And so the troubled reign of Charles I was ushered in. When Charles died, the concept of the Divine Right of Kings died with him. Charles is the beleaguered and persecuted King who was murdered, not by his people who groaned in horror as his head fell from the block, but by the parliament he held in such contempt he rarely bothered to consult it.

Although Hertfordshire was, in the main, parliamentarian, Charles was not without support in the county which witnessed three civil wars. Having started a revolution Oliver Cromwell was ready for a counter revolution. There were so many Royalist plots to assassinate him, he wore armour under civilian clothes. His Spy Master General the redoubtable Sir John Thurloe owned a farm in what is now Stevenage Old Town.

Two of the many royalists who would have liked to take a pot shot at Cromwell were Richard Fanshawe of Ware Park and his wife Ann Harrison of Balls Park near Hertford. Richard, son of Sir Henry Fanshawe, was one of ten children born at Ware Park. Ann's father, staunch royalist John Harrison, who gave Charles £17 million in today's money to pay the Scots to fight for him was bankrupted by Cromwell along with other Hertfordshire gentry including the Fanshawe's who had been in Ware since 1575.

Many royalist families found refuge in Oxford where, at Wolvercote Church at the height of the civil war Ann, sixteen, married Richard, thirty-five, mentor to Charles' son, the fourteen year old Prince of Wales. They dedicated their lives to help bring about his coronation and lived long enough to see it.

Another royalist, Arthur Capel, MP for Hertfordshire, was born and brought up at Hadham Hall. He was a descendant of the Sir Gyles Capel who chose the English Knights who jousted at the Field of Cloth of Gold near Calais where two kings, Henry VIII and Francis I met as friends. In 1642 when Charles I gathered support at York, Arthur Capel was one of the first to join him. A grateful Charles raised him to the peerage.

When Capel married Elizabeth Morrison of Cassiobury he became one of the richest men in England. He bought a hundred horses for Charles's army and paid for the king's Life Guard at Edgehill. Given his own command, he loyally fought in battle for Charles but, with no military experience, was useless. Capel remained in close contact with Charles I when he was holed up at Hampton Court. He accompanied the young Prince of Wales into exile in Jersey but returned home when the decision was taken Charles should join his mother in France.

Put in the Tower by Cromwell, Capel's friends smuggled in a rope and he managed to escape. Once over the wall, he waded across the moat and asked a Thames boatman to take him to Lambeth. The boatman betrayed him. In 1649 parliament voted for Capel's death and he was executed by Cromwell for treason. Like Charles, he was beheaded outside Westminster Hall. Capel was buried in the church at Hadham where he was baptised. It's said that he asked for his heart to be buried with Charles I. It wasn't but it was preserved in a silver box which Charles II returned to Capel's son also called Arthur Capel.

Charles I, in 1628, brought centuries of royal possession to an end when he gave Hertford Castle to William Cecil, son of Sir Robert Cecil, first Earl Salisbury. During the civil war, Cromwell based troops there. He also based troops in Hitchin and used St. Mary's crypt as a prison. His thugs vandalised the mediaeval font and stained glass windows.

In 1642 Charles stayed in Royston in his father's old house before moving on to Theobalds in Cheshunt. Here, where he was once proclaimed king, he received petitions from both houses of parliament saying they didn't want him. It was from here that he left to place himself at the head of his army.

In 1645 before the Battle of Naseby Cromwell pitched camp at Royston with a thousand horses and three hundred foot soldiers. There again two years later Cromwell drew up a manifesto of grievances and sent it to the King before moving on to St Albans. One day twenty thousand of Cromwell's men would go on strike at Royston refusing to fight until he paid them. They marched through Baldock and Stevenage on their way to London to besiege parliament but were intercepted at St Albans and paid.

Charles was given refuge in Stevenage, Baldock, Wheathampstead, Rickmansworth and Royston on his way north to meet the Scots. When a cache of letters written in a secret code to Charles were found after the battle of Naseby Dr John Wallis of Oxford University cracked the code for John Thurloe, Cromwell's Spy Master General. Cromwell's Hotel in Stevenage Old Town now on the site, was known locally for many years as Thurloe's Farm. He set up a cryptology department to dismantle The Sealed Knot, the royalist secret society and ran an oppressive security system to block royalist restoration plots. Next to Cromwell, Thurloe was the most powerful man in the country. He and Cromwell met every day.

As the situation in England worsened for the Royalist cause and Cromwell gained the upper hand, young Prince Charles joined his mother in France. When his father was on trial, he wrote to Cromwell inviting him to name any terms in exchange for his father's life. Cromwell ignored the letter. Charles only learned of his father's death when a fellow exile addressed him as "Your Majesty". Charles burst into tears and left the room.

Berkhamsted Place an imposing, palatial house owned by Charles 1 was appropriated by Daniel Axtell who arranged the trial of the King in Westminster Hall. The Axtell's were a very old Berkhamsted family. Daniel Axtell, known locally as the "regicide," was

baptised in St. Peter's Church Berkhamsted 26 May 1622. He enlisted in Cromwell's army and was promoted to Captain, Major, and Lieutenant-Colonel. In 1649, when Charles was summoned before the high court of justice in Westminster Hall to answer charges of tyranny, treason, and murder, wily Cromwell abnegated responsibility and put Axtell in charge. Although he was a grocer, after the King's murder, Axtell's republican views did not deter him from creating his own coat of arms and family crest of three silver and gold axes.

At the restoration of the monarchy in 1660, at his own trial for treason Axtell was charged with urging the people to shout "execution" during Charles' trial to make it look as if it was they not Cromwell who wanted the king dead. Like the Nazis, Axtell said he was acting under orders. He was executed at Tyburn, 19 October 1660. Many of his relatives including his son Daniel emigrated to America. In a twist of fate, during the American Revolution, a descendant of Daniel Axtell, a royalist, fought for the King (George III). In 1793 when his lands were taken from him, Axtell came to England and was indemnified for his losses by parliament. He died in Surrey in 1795, aged seventy-five. Members of the American line of the Axtell family from time to time, turn up in Berkhamsted to trace their family roots.

CHARLES II
FATHERED MANY CHILDREN BUT NOT ONE HEIR

Charles fought alongside his father against Cromwell's forces in the Civil War but managed to escape to France before his father was beheaded on 30 January 1649. In 1650 he landed in Scotland and was crowned King of Scots at Scone on 1 January 1651 but his attempt to regain the English throne failed when Cromwell defeated him at the Battle of Worcester. Charles went on the run for weeks (hiding in an oak tree at one point according to legend) before making his remarkable escape to France.

Charles II, like his father, had loyal followers in Hertfordshire including Ann Harrison of Balls Park near Hertford and her husband Richard Fanshawe of Ware. Ann's father gave Charles I a huge amount of money to fight Cromwell. Fanshawe visited Charles I when he was holed up at Hampton Court and acted as postman delivering letters from the king to his wife and sons exiled in France.

After his father's murder Charles, as Prince of Wales, asked the Fanshawe's to go to Spain to ask King Philip to fund his cause. Unable to pay him he made Fanshawe a baronet. Ann went with him. Thinking it safer to leave from Ireland they arrived in Galway to find it in the grip of plague so skirted the city walls wading through infested rubbish. Knee deep in dung, dirt, rags and fleas they boarded a Dutch merchant ship bound for Malaga. At Gibraltar the ship was attacked by pirates. Ann, locked out of harm's way below deck paid the cabin boy sixpence for his clothes and joined her husband on board to fight. They often laughed about it in later years. On their return the boat sailed into a storm and ran aground.

Fighting with Prince Charles at the Battle of Worcester Richard was captured and put in solitary confinement at Whitehall. Ann rented rooms nearby and every night lit a

lantern and went to his window to talk with him sometimes in rain so heavy it went 'in at my neck and out at my heels'. Seven years later he managed to escape to France. When Cromwell refused Ann permission to join him she went to Wallingford House, the Petty France of its day, got papers under her maiden name, hired a barge to take her and her children to Gravesend, from there boarded a coach to Dover and crossed the channel.

Charles II also had enemies in Hertfordshire. One was the son of his father's most loyal supporter, Arthur, Lord Capel of Hadham Hall MP for Hertfordshire. He had paid for and raised a troop to fight Cromwell who had him executed for his loyalty to Charles I.

In his coronation honours list a grateful Charles II bestowed the earldom of Essex on Capel's son, another Arthur Capel. Like his ancestors, he was born and baptised at Little Hadham but unlike them lived at his other country pile, Cassiobury Park, his pride and joy. His state rooms had marble fireplaces, carvings by Grinling Gibbons, and valuable paintings. His huge library included parliamentary rolls. Modelled on Versailles, his gardens had black cherry trees, a trout stream, and fish ponds.

Cromwell died in 1658 and his son Richard resigned leaving the way clear for the restoration of the monarchy. Charles rode into London on his thirtieth birthday 29 May 1660 to popular acclaim. As new Regalia had to be commissioned, his coronation could not take place until 1661. Westminster Abbey was full to bursting. One guest was Samuel Pepys who wrote about the service in his famous diary.

Charles invited Richard and Ann to join him on board ship on his triumphal return to England and rewarded Richard with the title Viscount Fanshawe. Balls Park was returned to the Harrison's. Charles appointed Richard Ambassador to Portugal and gave him his miniature portrait to negotiate his marriage to Princess Catherine of Braganza. Ann and her daughters were presented to the Queen who, dressed in black, sat on a black velvet chair on a black velvet carpet.

When Richard died in Spain in 1666, Ann brought his body back to Hertfordshire. She could not afford to bury him until 1670 and then it was in her own church All Saints Hertford near her childhood home. After hounding parliament for £5,900 back pay owed to Richard she bought a vault for him in his own church under the south transept of St. Mary the Virgin in Ware (his coffin was found in 1908). His vault and monument cost a small fortune. Ann, who mourned Richard for the rest of her life, was buried near her husband. Her memorial is in the Lady Chapel. Thirty members of the Fanshawe family are buried in the church.

After twenty years of Civil War the monarchy was restored when Charles II was crowned at Westminster Abbey. The county town of Hertford has a wonderful Mace – the symbol of Royal Authority – inscribed 'The Freestone of England by God's Blessing restored 1660'. It carries the royal arms of the duchy of Lancaster. Elizabeth I, who lived in Hertford Castle granted the town the right to appoint a Sergeant at Mace in 1589. Charles granted the town the privilege of carrying the Sword as well as the Mace. The Mace, silver gilt, is decorated with oak leaves, the rose, thistle and harp. The Sword, the symbol of Royal Justice, made in Italy between 1550-1600 has a silver gilt hilt and double edged blade 36" long. The scabbard, also Italian, dates from the time of presentation around 1680. The ornamentation includes the Royal Arms of the Duchy of Lancaster.

Above and below: The
Hertford Sword courtesy
Hertford Town Council
© MAK and The Hertford
Mace courtesy Hertford Town
Council © Mark Playle

Charles was not vindictive. He pardoned those not personally responsible for his father's death including John Thurloe, Oliver Cromwell's Spy Master General. Thurloe was arrested for high treason but never brought to trial. He was released on the condition he relinquished all secret government documents. Held in the Tower, he missed the Restoration festivities when Charles II entered London. When Thurloe was released, his knowledge and experience were placed at the disposal of the king. It's said that Charles tried to urge him back into office but Thurloe refused telling the king that Cromwell sought men for places, not places for men.

Perhaps Cromwell's son Richard had nothing to fear from the King either but at the Restoration taking no chances left for France and stayed away for twenty years. By the time he returned to England his wife had died. Richard Cromwell lived as John Clarke with the Pengelly family in Cheshunt. This is where he died but is buried next to his wife in Hursley church, Hampshire.

Charles was by nature a peace maker. Many royalists considered him far too lenient with his father's murderers. One was Colonel Silas Titus from Bushey in Hertfordshire a member of the King's new parliament. It was Titus who helped Charles I escape from Carisbrooke Castle on the Isle of Wight. It was Titus who distributed a pamphlet KILLING IS NOE (sic) MURDER urging people to assassinate Cromwell. It was Titus who lobbied and succeeded in getting Cromwell and other Regicides disinterred, propped up against a wall while they were tried for treason, found guilty, sentenced, then hanged at Tyburn 30 January 1661. They were thrown in a pit at the foot of the gibbet. Titus arranged for Cromwell's head to be displayed on a pole outside Westminster Hall where Cromwell displayed the head of Charles I. Revenge is sweet.

The corpses of Cromwell and other regicides were removed from Westminster Abbey By Royal Warrant. Cromwell was buried in a vault under Henry VII's chapel with his mother, sister, Henry Ireton and John Bradshaw who signed Charles I's death warrant. In 2009 for the first time in sixty years tourists could see where they were buried. The stone tablet is usually covered by a carpet in the RAF Chapel. It was taken up because of an infestation of moths. John Churchill, Duke of Marlborough was also there until he was moved to Blenheim Palace. The chapel which houses the vault became the RAF Chapel in 1947 to honour Allied fighter pilots who died in the Battle of Britain in 1940. The air force blue carpet with the RAF crest was sent to the Horniman Museum in Dulwich and put in a giant freezer at -30° centigrade to kill off larvae. It is now back in place.

In a lovely reversal of fate, Cromwell's empty vault was filled with illegitimate descendants of the priapic Charles II. Cromwell, a Puritan banned all forms of enjoyment including sport, going for walks on a Sunday, pubs and theatres. Sex was completely off the radar.

In 1662 Charles married Catherine of Braganza. He had at least thirteen children by various mistresses including Nell Gwyn but sadly his wife was unable to have children. The Great Plague in 1665 and the Great Fire of London 1666 also cast a shadow over his reign.

Nell Gwynn gave the county the duke of St Albans (not that it sees much of him). There is a story that Nell dangled the baby from a window of Salisbury Hall, London Colney threatening to drop him unless Charles conferred a title on him. If true it clearly

didn't work, he didn't become Duke of St Albans until he was fourteen. The story that Nell, to Charles horror, referred to her son as The Bastard until he was given a title seems to be true. Salisbury Hall, an old moated country house – now a private residence – has portraits of Nell and Charles. When Charles died in 1684 'Let not poor Nelly starve' was his deathbed wish. It was Nell, when her carriage was pelted by a disapproving mob, yelled out: 'Stop! I am the Protestant whore!' Born in a brothel, nothing fazed Nell.

The duke of St Albans, Charles (after his father) Beauclerk led a charmed life. When he married Lady Diana de Vere, daughter of the Earl of Oxford, he was given an annual pension from the Crown of £2,000 (£179,000). His post as hereditary Grand Falconer of England brought in an extra £1,500 p.a. (£134,000). In 1703 the Parliament of Ireland granted him £800 p.a. (£90,000) for publicly condemning the anti-Catholic Sacheverell Riots. In 1718 he was made a Knight of the Garter.

In 1953, the 12th duke of St. Albans, as Master Falconer, refused to attend Elizabeth II's coronation when told he could not take a live falcon to the ceremony but could carry a stuffed one. The 13th Duke, sued for unpaid income tax, left the country. The 14th Duke is a chartered accountant. The only recorded visit of any of the dukes to the eponymous town of St. Albans was in the 1970s.

Charles' favourite illegitimate son was not Charles Beauclerk, it was James (after his father's brother) Crofts who moved to Hertfordshire when his father bought him Moor Park near Rickmansworth. It was he who laid the foundations in 1670 for today's magnificent mansion which is now a Golf Club House. There are frequent guided tours.

Moor Park Rickmansworth © Jeff Shields

James loved hunting, racing, gambling, dancing, drinking and womanising and was always in debt (Samuel Pepys predicted he would never amount to anything much). Charles referred to him as 'his beloved son' and tended to treat him as if he were the Prince of Wales. No mention of his illegitimacy was made on Monmouth's marriage contract. Londoners began to view him as a possible Protestant alternative to James 11 and welcomed him wherever he went.

Crofts, born in Rotterdam, was the result of an affair with Lucy Walters, a girl from Wales, when Charles was prince of Wales. Rumours abounded they were married. Knowing that Crofts could not take the crown, Charles ensured his son's future by arranging a marriage to Lady Anne Scott, a rich heiress. James was created Duke of Monmouth and took the name of Scott.

With no legitimate children, Charles named his brother James, a staunch Roman Catholic, his successor. Arthur Capel Jnr, unlike his father, a committed royalist, was a committed parliamentarian. He loathed James and the other Catholic peers at court. He, like his father, ended up in the Tower.

In 1683 Capel, with other Cromwell leftovers, republicans and rabid anti-papists planned to get rid of closet Catholic Charles and out of the closet Catholic James. When Capel urged Charles to banish Catholics from London and exclude James from the succession to preserve England from Catholicism, Charles stripped him of his post as Lord Lieutenant of Hertfordshire.

Capel met William of Orange for talks when he visited England. William also talked with James Scott, duke of Monmouth. When Capel's hoped for uprising came to nothing he began exploring plans for an insurrection. Favouring a republic, Capel like Cromwell, believed that subjects should overthrow monarchs who violated the people's trust in this case one who had nominated a Roman Catholic as England's next king.

Capel and Richard Rumbold of Rye House, an ex army officer for Cromwell, openly declared their hatred of the brothers. Rye House is on the road from Newmarket to London. Rumbold joined the parliamentarian army when he was nineteen. Losing an eye in the conflict he was nicknamed Hannibal. He was one of the guards around the scaffold when Charles I was executed in January 1649.

There were many plans to kill Charles and James but The Rye House Plot was chosen as the most likely to succeed. The narrow lane outside the castle was to be blocked by an overturned cart, a common enough sight. Armed men in the grounds would shoot the brothers and finish them off with a sword. The planned date for the brothers' return journey from Newmarket races was 1 April but on 22 March a fire burnt down half the town. Charles and James helped with fire fighting before returning earlier than planned to London.

Rumbold was executed. Capel, arrested at home in Cassiobury, was taken to the Tower and put in the same room his father occupied before his execution. Given the fact that his father died for Charles I, Capel was likely to have received mercy from generous spirited Charles II which is probably why he was found with his throat cut before his trial. Capel certainly did not act like a would be suicide. Concerned about being poisoned he ordered his cook to prepare his food in silver dishes – silver does not harbour germs (which is why they are used for Holy Communion). His servant told

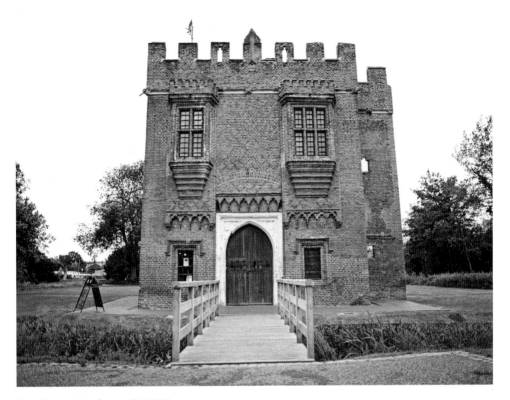

Rye House Gatehouse © MAK

the coroner that Capel ate a hearty breakfast the morning of his death and showed no signs of despair.

Lesser plotters were hanged outside the inn opposite Rye House. Conspiracy theorists said there was no plot, it was dreamed up by James to get rid of the most dangerous of their enemies in one fell swoop. The brothers knew that Richard Rumbold stood cheering under the scaffold as their father's head rolled off the block.

Said to be involved in the plot or at least to have known of it was Charles favourite son, James Scott, Duke of Monmouth of Moor Park. After the Rye House Plot, Monmouth went into hiding. He was indicted in absentia for High Treason and the government offered a reward for his capture. Charles personally examined the testimonies. Distraught to learn of his son's involvement, he exiled him for life. They never met again. Monmouth wrote to him denying all knowledge of the assassination plot.

Monmouth found sanctuary with William of Orange in The Hague. When Charles died James II told William to have Monmouth arrested. William tipped off Monmouth who left for Brussels.

It was probably Sir Henry Guy of Tring Manor who discovered the Rye House Plot. Having worked undercover all his life, Charles had no need of an elaborate spy set up like that of Cromwell. He divided responsibilities for intelligence gathering between himself, his brother James, his mistresses at the French court, Sir William Morrice,

secretary of state and his boon companion Colonel Sir Henry Guy, Groom to the Bedchamber and Clerk of the Treasury. Guy controlled secret service finances. The only son of Henry Guy of Tring and Elizabeth Wethered of Ashlyns, Berkhamsted Henry Guy II was a close friend of Prince Charles during his exile in Holland. After the Restoration with fingers in many pies he became wealthy, rewarded handsomely for what can only be called 'pimping' for the king. Charles gave him Tring Manor previously owned by his mother, Queen Henrietta Maria.

Guy became prominent in Hertfordshire, holding various offices including the mayoralty of St Albans. In London, he mixed with property developers and financiers. A familiar figure at court, Guy was appointed cup-bearer to Queen Catherine of Braganza before entering the king's household as first, a groom of the bedchamber, then secretary to the Treasury. Through his mastery of administration, heavily involved in shady dealings, he turned his post into a position of personal power and influence. Financed by Treasury pickings Guy rebuilt Tring manor (now Tring Park School for Performing Arts) to designs by Sir Christopher Wren. He also built a house in the grounds for Charles's favourite mistress, Nell Gwynne.

Guy was dismissed from the Treasury for embezzlement but, a born survivor, after he invited William III (William of Orange) to stay with him at Tring he was reappointed. When he was exposed for giving hush hush money to MPs his enemies launched an inquiry into government corruption. Guy was found guilty of accepting bribes and put in the Tower. On his release he became a close friend of Robert Harley, Lord Oxford, Secretary of State, Spy Master General to William and Mary.

Tring Manor courtesy Tring School of Performing Arts

As well as inheriting Henry Guy, Mary II also inherited Bishop Thomas Ken, her father's royal chaplain. Born in Little Berkhamsted Thomas Ken's half sister married Izaak Walton who wrote *The Compleat Angler*. Bishop Ken wrote the hymn *Awake My Soul and With the Sun*. A close friend of Samuel Pepys, Ken was one of the 'Magnificent Seven' Bishops who refused to read James II 1688 Declaration of Indulgence (to Roman Catholics) from the pulpit. Although opposed to the Catholic James, Ken refused to swear allegiance to William and Mary so was ousted from office.

Dubbed The Merry Monarch Charles's life was anything but. Not only did he suffer as a boy from the brutal murder of his beloved father, not only was he, his siblings and mother exiled from England, he endured many years of penniless wandering. Then, as King, he married a woman who could not give him an heir to the throne. Other monarchs would have replaced her, loyal Charles stuck by her.

Five years into his reign, bubonic plague, the worst since medieval days, hit Britain. Parliament and the Law Courts met, not for the first time, at Hertford Castle in 1665. A year later came The Great Fire of London which wiped out the square mile. This was followed by the Dutch invading the Medway burning English warships. Then of course came the Rye House Plot. Charles stayed cheerful throughout. He even apologised to those gathered around his bed for taking so long to die.

Charles died at Whitehall in 1685. He is buried in Westminster Abbey in the south aisle of Henry VII's chapel. No monument was erected for him but a life size wax effigy, 6 feet 2 inches tall, stood by his grave for over a century. This figure is now in the Abbey Museum. The face is said to be a remarkable likeness. He is dressed in robes of the Order of the Garter.

Because Charles II died with no issue, his brother succeeded him in 1685 as James II. Some MPs wanted Charles's illegitimate son, James, Duke of Monmouth a fervent Protestant, to succeed. No wonder James wanted Monmouth dead. Monmouth, with just eighty-two supporters landed at Lyme Regis to claim the crown only to be defeated at the Battle of Sedgemoor. Captured he was put in the Tower. The act of attainder already passed against him meant that no trial was necessary. Beheaded on Tower Hill he was dubbed 'Pretender to the Throne.' Protestants were sorry to see him go.

In 1720, Monmouth's widow Anne Scott sold Moor Park to Benjamin Styles who amassed a fortune from the fraudulent 'South Sea' investment company which collapsed, plunging thousands into financial ruin. He spent a fortune extending and cladding the mansion in Portland stone, creating pretty much the building we see today.

Under the Test Act of 1673 all officials were required to take an oath to say they did not believe in transubstantiation and to denounce practices of the Catholic Church as "superstitious and idolatrous". Incredibly James had learned nothing from his father's fate. Charles I took on parliament and failed. Now James tried it on too. When he refused to sign, his conversion to Catholicism became public knowledge. When he produced a legitimate Catholic heir it proved the last straw. Parliament ousted him in 1688 in favour of Mary, his Protestant daughter.

When Mary died without issue her sister Anne succeeded her. When she too died without issue, George, Elector of Hanover was ushered in. He may have been only fifty-eighth in line but at least, said Parliament, he was not a Roman Catholic.

24

ANNE:
ST ALBANS

Anne's reign is remembered for the Union of England with Scotland and John Churchill, the Duke of Marlborough's astonishing military victories in Europe especially at Blenheim. Anne, personally, is remembered for having seventeen children and outliving them all.

Anne had a few connections with Hertfordshire.

The Princesses Mary and Anne, daughters of James II, left court when plots to oust their Roman Catholic father began. Local legend in Hitchin has it that one of their temporary sanctuaries was in Bancroft.

Anne's Lord Chancellor, William Cowper MP – later Earl Cowper for services to the Crown in unifying England and Scotland in 1706 – lived at Hertford Castle.

Although Anne seemed very far removed in time from the murder of her grandfather, Charles I, Richard Cromwell, son of Oliver was still living in secret under an assumed name in Cheshunt. When those who signed Charles I's death warrant were hunted down and hanged and his father's body exhumed and publicly displayed at Tyburn (Marble Arch) Richard Cromwell justifiably feared for his life and left for France. He stayed away for twenty years. Using the name John Clarke, he secretly slipped back into England and headed for Hertfordshire where he had once owned Cheshunt Park, a seventeenth-century estate (now a public open space and golf course). He moved into Pengelly House near St. Mary's Church as a lodger with Baron Pengelly to whom he paid ten shillings rent a week. Pengelly House burnt down in 1888. It's thought that Old Parsonage in Churchgate was built on or near part of the site. Living incognito, Richard dressed like a farmer and saw Anne succeed to the throne he and his father had once graced. He died in Cheshunt age 86 in 1712 but is buried inside Hursley church Hampshire next to his wife.

Anne's chief connection to the county is through her close friend and confidante Sarah Churchill née Jennings of St. Albans rumoured to be Anne's lesbian lover. It was Sarah herself who said Anne preferred her own sex. For many years, Sarah, who was close to Anne for more than thirty years, was the power behind the throne.

The notorious Sarah was the youngest of five children of Richard and Frances Jennings. Her grandfather, Sir John Jennings was High Sherriff of Hertfordshire, her father was MP for Hertfordshire. The future Sarah Churchill, Duchess of Marlborough, born in June 1660 at Holywell House, St. Albans was christened in St. Albans Abbey and spent her early years at another family home, Water End House (dates from 1549) in Sandridge near St. Albans. She very probably saw the Fire of London, visible from St. Albans, from there in 1666.

When Richard Jennings met James, duke of York, Sarah's sister, Frances, was appointed maid of honour to his wife, Anne Hyde. Because Charles I had borrowed so much money from so many and because his son Charles II could not repay the debts it was common practice for claimants to be offered places at court instead.

When Sarah's father died in 1668 (he is buried in St. Albans Abbey) with her mother and sister already at court, Sarah moved to London. According to Ophelia Field's *The Favourite: Sarah, Duchess of Marlborough*, the name of her mother was closely linked with Court mistresses. She may have been a Madam, a pimp who procured mistresses such as Nell Gwynne for the King. She was certainly dubbed a bawd in contemporary satires.

At Court, Sarah and Princess Anne the duke of York's daughter played together as children. Anne may even have played with Sarah at Water End House. The friendship grew stronger as the girls grew older. They were inseparable for many years before Anne became queen, long before Anne dreamed she would ever be Queen.

Water End House Sandridge © Mark Playle

When she was thirteen Sarah entered court as maid of honour to the duke of York's second wife, the fifteen year old Mary of Modena, a staunch Roman Catholic. This is when Sarah first saw John Churchill, the duke's page. He was the son of Winston Churchill, a royalist made bankrupt by Cromwell because of his support for Charles I. He, like Sarah, was found a place at court because a grateful Charles II could not repay the vast amount of money his father had 'borrowed'. Sarah and John's subsequent love affair would last more than thirty years. At Court, Sarah also knew Charles II's favourite illegitimate son, James Scott, duke of Monmouth.

In 1685 John Churchill fought for James II against the duke of Monmouth at Sedgemoor. Later, Churchill, because he wanted England to stay Protestant, joined forces with William (of Orange) and Mary and Anne.

Sarah was Anne's closest companion for almost thirty years. Many reliable sources say they were lovers. Whenever they were apart Anne wrote passionate letters to Sarah saying how much she missed her. She signed herself Mrs Morley. Sarah was Mrs Freeman. In some of her letters Anne is clearly hurt and offended that Sarah never invites her to Holywell House, her home in St. Albans. To appease Anne and to get her off her back, Sarah introduced her to her cousin Abigail Hill to keep her company during her frequent long absences from court. Bad move. When Abigail replaced her in Anne's affections Sarah publicly accused Anne of "having noe inclination for any but one's own sex". Not that Anne neglected her royal duty. To ensure an heir she married Prince George of Denmark. She became pregnant seventeen times but gave birth to only five living children all of whom pre-deceased her.

Sarah often saw John Churchill at court parties and balls with his mistress, Barbara Palmer, Duchess of Cleveland, a discarded mistress of Charles II. John Churchill intended to marry into money. When she was seventeen Sarah and her sister Frances inherited family property in St. Albans so John Churchill proposed. They married in secret. Both were staunch Protestants in a Catholic court. Anne, Sarah and Churchill opposed James II's pro-Catholic views and were appalled by his determination to return England to Catholicism.

When James II was deposed, Sarah and Anne drew even closer. Anne relied on Sarah more and more during the rule of William of Orange (William III) and her sister, Mary. Mary who resented their close friendship demanded Anne dismiss Sarah. When she refused Mary evicted Sarah from her lodgings at Whitehall. Anne responded by leaving court with her. They stayed with mutual friends.

William and Mary died childless. Anne was next in line. When she was crowned in Westminster the Abbey in 1702 she had to be carried in a chair by Yeomen of the Guard. Because of her love for brandy (her nickname was Brandy Nan) she suffered from gout so crippling she was unable to walk.

Sarah was promptly created Mistress of the Robes, the highest office at court that could be held by a woman, Groom of the Stool, Keeper of the Privy Purse and Ranger of Windsor Great Park. The most influential woman in Britain, leading public figures turned to her in the hope that she would influence Anne to comply with their requests. Her knowledge of government made her a powerful friend and a dangerous enemy.

Sarah Jennings © Hertfordshire County Council

Sarah and John Churchill lived in Holywell House St Albans. She said she hated seeing her children's sad faces at the window whenever she had to leave to attend the Queen. Holywell House was the Churchill's favourite retreat. Churchill rose to head the government partly as a result of his wife's intense friendship with the queen. The Duke was made a knight of the Order of the Garter and Captain-General of the army.

In February 1705, after his astonishing victory at the Battle of Blenheim he became John, Lord Churchill of Sandridge. Anne and a grateful Parliament gave him the royal manor at Woodstock with 16,000 acres. Blenheim, the greatest of great military victories, changed the balance of power in Europe in Britain's favour. It made John Churchill the most famous man in Britain. Increasingly Sarah could rarely bother to attend court preferring to oversee the construction of Blenheim Palace. Bad mistake.

The Churchill's built a grand house in the grounds of Holywell House where Sarah's mother still lived. It had orchards, fish ponds and a grand library. This is where their children were born. Sarah said it was their only real home and she would not swap it for anything. Sarah and John were England's first self-made celebrity couple.

By the time the first anniversary of Blenheim came round, the couple had fallen out of court favour so they celebrated in a marquee in the grounds of Holywell House. By then Britain was weary of war. Marlborough had served his purpose and Sarah was replaced in Anne's affections by her new soul mate, Abigail Hill, now elevated to Lady Masham.

Anne had put up with Sarah's cruelty to her because she had no-one else to turn to – Sarah was famous for telling the Queen exactly what she thought of her and never flattered her – now that she had Abigail the tables were turned. In 1710 Marlborough was dismissed from government. In 1711 Sarah was removed from court. She was so incensed she threatened to publish Anne's love letters to her. A popular, lewd, song did the rounds about her fall from St. James to St. Albans. The Churchill's left England and did not return to Holywell House until after Anne's death and George I of Hanover was proclaimed king.

John died of a stroke in 1722. Sarah survived him by twenty-two years. In 1736 she paid, in today's money, four million pounds to build the Marlborough Almshouses in Hatfield Road St. Albans for widows of army officers. They are still used today. Sadly Holywell House where John Churchill, the hero of Blenheim lived, was razed in 1827. The way Britons treat their heritage is nothing short of shameful.

Queen Anne had seventeen children. By outliving them all she ended the Stuart dynasty. George, Elector of Hanover was suggested as her successor but Anne would not allow his name uttered in her presence. Hell Hath No Fury. It had been his intention to marry Anne. Until he clapped eyes on her. Oh dear.

When England was scrabbling round for a Protestant monarch and finally settled on George, fifty-eighth in line to the throne he at first refused point blank to accept the post saying the English murder their kings. Besides Charles I, Edward II, Richard II, Edward V (the prince in the Tower) and Henry VI were all murdered. King John and James II, although got rid of, did at least keep their heads. The Four George's of Hanover had very little to do with Hertfordshire. Indeed the first two had very little to do with England a country they loathed to the extent they spent hardly any time here and never bothered to learn English.

25

VICTORIA:
BROCKET; HATFIELD; WELWYN, KINGS LANGLEY; HITCHIN

The death of Princess Charlotte, only child of George IV, created a succession crisis and a mad rush among his brothers to produce an heir to the throne. A marriage was quickly arranged between William, duke of Clarence and Princess Adelaide at a double ceremony with his brother, Edward, Duke of Kent and Princess Victoria Saxe-Coburg. Although William had ten children by his mistress the actress Mrs Jordan he had none with Adelaide so Edward's daughter Victoria was named his successor. William and Adelaide were very fond of Victoria but, like her, loathed her mother.

Victoria often visited Dowager Queen Adelaide, widow of her uncle William IV, at the magnificent Cassiobury Park. When Adelaide moved there a private entrance was built at Watford station for her. Improvements were added for Victoria's visits. The station building has survived.

The Capel family, the earls of Essex, owned Cassiobury from 1628 until 1922. They lived in the house for 250 years. When the 6th Earl died in 1892, the paintings and valuables were sold off. Watford Urban District Council bought the house and razed it in 1927. The grand staircase used by Queen Adelaide and Queen Victoria was sold to the Metropolitan Museum, New York.

Victoria was also a regular visitor to The Grove in Watford. With its three hundred acres and two lakes, it was one of the most fashionable mansions in the UK. The rivers Gade and Grand Union Canal run through the grounds. Invitations to stay were sought after. Architect Edward Blore added a third storey, ground floor and huge staircase to display Earl Clarendon's collection of Old Masters. George III, his queen and court stayed here as did the Duke of Wellington. Because it's conveniently near London this is where the aristocrats 'weekend in the country' started. Victoria, her son Edward VII, Horace Walpole, Lord Palmerston et al would arrive on Saturday and return to London Monday morning. This was one of the great political houses of the nineteenth century where the great and the good chewed over the issues of the day. At least The Grove has not been demolished. It's now a luxury hotel.

Victoria also stayed at The Frythe in Welwyn where the Wilshere family had lived since 1545. It was the Wilshere's right, at every coronation banquet, to serve the sovereign with the first goblet of wine. Victoria's visit is commemorated over a door in the south-west wall of The Frythe.

Victoria's main connections with Hertfordshire were through three of her Prime Ministers. She adored William Lamb, Lord Melbourne, of Brocket Hall.
When he died her new favourite PM was Robert Cecil, Lord Salisbury of Hatfield House. She loathed Lord Palmerston, Melbourne's brother-in-law because of his lurid sex life. While staying as Victoria's guest at Windsor Castle, Palmerston entered Lady Dacre's bedroom and tried to seduce her. Lord Melbourne saved him from being removed from office. When Victoria asked Lord John Russell to sack him she was told it wasn't possible as he was very popular in the House of Commons. However, in December 1851, when Palmerston publicly congratulated Louis Napoleon Bonaparte on his coup in France he did sack him. Six weeks later Palmerston brought down Russell's government.

Palmerston first Premiership lasted three years. His second began in 1859 when he was seventy-five. Parliament was dissolved in 1865. Although by then eighty-one Palmerston was elected again. Before he could take up office he died at Brocket Hall.

The present Brocket Hall was built in 1760 for Sir Mathew Lamb MP. His wife was one of the many mistresses of the Prince Regent (George IV). A frequent visitor to Brocket, he had his own Prince Regent Suite. Lamb's first son held wild parties at the Hall and built a racecourse there for the Prince. His second son, William, married the

Brocket Hall © MAK

infamous Lady Caroline Ponsonby, granddaughter of Lady Spencer. She spoke French and Italian fluently and was skilled at Greek and Latin. Theirs was a love match. On her death bed she said William was the only man of honour she had ever met.

The sober, steady, sensible William, inherited the estate from his brother. In the 1820s at the Hertford Assizes, William Lamb presided over the inquest of the most notorious murder of nineteenth century Hertfordshire in the Artichoke pub, Elstree. John Thurtell, a wealthy gambler, had a grudge against fellow-gambler William Weare, a solicitor, whom had cheated him at cards. He invited him to spend a weekend gambling at William Probert's cottage in Gills Hill Lane Radlett (still called Murder Lane) Radlett. They travelled from London in Thurtell's gig on 24 October 1823. As they neared the Wagon and Horses, Watling Street, Thurtell shot Weare but missed so slit his throat. Probert and another gambling friend, Hunt, dumped Weare in Elstree. When the gun and knife were found near the cottage, Probert turned King's Evidence.

When Thurtell and Hunt came up before William Lamb Thurtell was charged with murder, Hunt with being an accessory. They were sentenced to death and Thurtell's body was ordered be anatomised. Hunt's sentence was commuted to transportation and he was shipped to Botany Bay.

Thirty-year-old Thurtell dressed for his execution on 9 January 1824 in a brown greatcoat with a black velvet collar, breeches, gaiters, and a waistcoat with gold buttons. Plays and ballads were written about the murder, which caught the imagination of many writers including Walter Scott, Charles Dickens and his friend Edward Bulwer-Lytton of Knebworth House.

In 1835 William, Lord Melbourne became a personal mentor to the young queen Victoria. They adored each other. When they went to the opera together, unable to conceal her teenage crush, she was often booed in public and called 'Mrs Melbourne' (one day she would also be called Mrs Brown).

Victoria stayed with Melbourne at Brocket Hall in 1841. Writing to the King of Belgium she said her 'visit to Brocket naturally interested us very much for our excellent Lord Melbourne's sake. The park and grounds are beautiful.'

Lord Melbourne died at Brocket in 1848. As he was childless his sister Emily Lamb inherited. Much to Victoria's disgust, Emily married her lover, Henry Temple, Lord Palmerston. Palmerston died of a heart attack at Brocket Hall. Local legend has it that he died in flagrante delicto with a chambermaid.

Brocket Hall was no stranger to scandal. Lord Byron and Melbourne's wife, Lady Caroline Lamb held centre stage there managing to out debauch a debauched Regency society. Before *Childe Harold* was published Byron was *persona non grata*. He needed Caroline (she read the proofs) and wrote ten times a day asking her to run away with him. Instead, Lady Melbourne, Caroline's mother-in-law, encouraged him to marry her niece. When he told Caroline their love affair was over she tried to kill herself. It was Caroline who said that Byron was 'mad, bad and dangerous to know'. She, her mother-in-law Lady Melbourne and sister-in-law Lady Emily Cowper (later Lady Palmerston) between them bedded most of Regency London.

Robert Cecil, Lord Salisbury, Victoria's Prime Minister three times, was her second favourite. He died at home in Hatfield House and was buried in the grounds. He said:

'English policy is to float lazily downstream occasionally putting out a diplomatic boathook to avoid collisions.'

In 1846 Victoria and her beloved Albert spent a weekend at Salisbury's Hatfield House to attend a state ball. A grand bedroom was redecorated for the occasion and three pairs of large, ornamental, commemorative iron gates, cast in a Paris foundry, were erected. The royal procession left Cassiobury for Hatfield after lunch, accompanied by two Companies of Herts yeomanry, Lord Salisbury and Arthur, duke of Wellington. Four triumphal arches were built at Hatfield, where a band greeted Victoria with the national anthem.

Under Salisbury, Britain reached its apogée. It held the balance of power in Europe and its Empire covered much of the globe. Deeply interested in religion, Cecil rebuilt the nave of Hatfield parish church. He was one of the first to install a telephone and electricity in his house.

Although Digswell Viaduct was opened by Queen Victoria, 6 August 1850 she was so frightened of its height she refused to travel across it. Small wonder. The construction, still mightily impressive today, an homage to engineering, it's 97 feet high at its centre. Built to carry the Great Northern railway over the Mimram Valley, it was designed by William Cubitt, the architect of Kings Cross station. Built with thirteen million bricks made near the viaduct it has forty arches.

Victoria's journey had to end at Hatfield where a there was a Royal Waiting Room directly opposite Hatfield House main gateway. It was in use until the vandalism of the 1960s. She travelled on to Digswell by horse and carriage. Local legend has it Victoria never lost her fear of heights. On her visits to Balmoral she left the train, travelled by coach across the valley and met it on the other side.

On one visit to Scotland the royal train stopped at Hitchin so that William Ransome, a lavender farmer, could present her with a bottle of lavender oil.

In 1877 Robert, earl of Lytton of Knebworth House, Viceroy of India, organised the Delhi Durbar ceremony in which Victoria was made Empress of India. Also In 1877 when the tomb of Edmund of Langley, duke of York, was repositioned in All Saints Kings Langley Victoria commissioned a splendid stained glass east window commemorating her life.

Victoria's son, Edward VII and his mistress Alice Keppel were frequent guests of Jennie Jerome, widow of Lord Randolph Churchill, at Salisbury Hall London Colney. Keppel shocked the impoverished Clementine Hozier the future Mrs Winston Churchill by advising her to become the mistress of someone with money.

Lady Churchill scandalised society by marrying handsome, penniless George Cornwallis-West, twenty-five, the same age as her son Winston. She was forty-five. They rented the lovely Elizabethan moated mansion with grand staircase and oak panelled rooms and gave great parties at which guests punted on the moat. In 1906 when Edward VII stayed with Jennie at Salisbury Hall Alice Keppel was with him.

A frequent guest to Salisbury Hall was the American actress Maxine Elliott of Hartsbourne Manor, Bushey Heath also said to be a mistress of Edward VII. Maxine's parties were even more talked about than Jennie's. Guests arrived by new fangled contraptions called airplanes. The whole of Bushey Heath turned out to see them

Above and below: Digswell Viaduct © Mark Playle

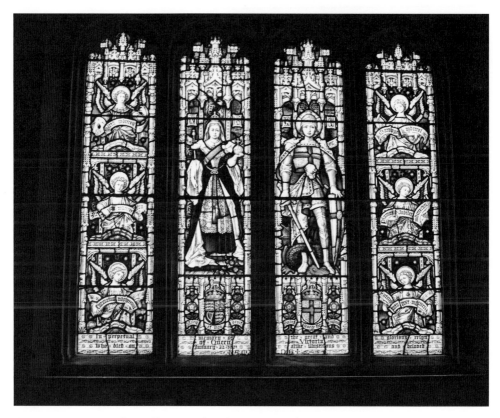

Queen Victoria's Window, All Saints Church, Kings Langley © Ian Pearce

land. At Hartsbourne, Maxine installed central heating and bathrooms (unheard of in England) and built a suite onto her private rooms for 'Kingy'. In 1910 Edward VII invited himself to stay with Maxine at Hartsbourne telling her he intended to visit her on his own. Nervous of gossip, she invited his circle of friends. In the event he died before the visit took place. In 1920 Maxine threw a grand ball at Bushey for the ill fated Edward, Prince of Wales and his brother Bertie, future husband of Elizabeth Bowes Lyon of St. Pauls Waldenbury.

26

GEORGE VI: HITCHIN; ST PAULS WALDEN

In 1937 Queen Elizabeth, watched by her husband King George VI, unveiled a plaque in All Saints Church, St. Pauls Walden, near Hitchin.

> HM Queen Elizabeth was born in this parish 4 August 1900.
> Baptised in this church 23 Sept 1900 and here worshipped.

In 1980, however, as Queen Mother, she dropped a bombshell. Putting the cat firmly among the pigeons, she told a local journalist she was born, not 'in this parish' but in London, blithely leaving in her wake a myriad of unanswered questions. Not that the ensuing and continuing post mortem bothered her. The Lady Elizabeth Bowes Lyon seems to have been born blessedly free from the existential angst which besets many of us.

In 1900, her father appeared before the Hitchin Registrar and was fined, not for registering the wrong place of birth for his daughter, but for failing to report a birth within the statutory forty-two days.

It's highly unlikely that the mystery of where The Queen Mother was born will be solved in our lifetime. As for being late in registering the birth, perhaps that can be put down to the glorious 12th. Her father, Lord Glamis, as he was then, was a devotee of grouse shooting. The Lady Elizabeth was born on the 4th August.

The Rev. Tristram Valentine, vicar of All Saints, christened Lady Elizabeth Lyon at the fourteenth century font after morning service on Sunday 23 September 1900. The congregation stayed behind to watch the ceremony and see the Bowes Lyon family out in force. One hundred years later, as part of her birthday celebrations the Queen Mother attended a service in All Saints. When she died, her devoted daughter HM Queen Elizabeth II attended a private dedication ceremony of her memorial placed between All Saint's and The Bury.

Claude Bowes-Lyon (the hyphen seems to be arbitrary) Lord Glamis, inherited St. Paul's Waldenbury, The Bury, from his grandmother along with the nearby Strathmore

Arms and The Woodman Pub in Whitwell. He would become the 14th earl of Strathmore.

Born in 1855, Lord Glamis was religious with a strong faith. His mother was the daughter of a clergyman. In 1881 he married Cecilia Cavendish-Bentinck, daughter of a clergyman. After their wedding in Petersham they caught the 5.05 to Hitchin, spent their honeymoon at The Bury and lived there as Lord and Lady Glamis. It looks as if all their children were born there except, it seems, for the Lady Elizabeth.

Their children were: Violet (1882-1893); Mary (1883-1961); Patrick (15th Earl) (1884-1949). His son Timothy born in 1918 became the 16th earl; John (Jock) (1886-1930); Alexander (Alec) (1887-1911) Injured in the head by a cricket ball at Eton he died young age twenty-four; Fergus (1889-1915) in 1914 spent his honeymoon at The Bury. He was killed at Loos; Rose (1890-1967); Michael (1893-1953). When Michael was due, Lady Violet went to stay with her grandmother. Tragically she died age eleven of diphtheria seventeen days after Michael was born. Her funeral was held before Michael's christening. Michael was a prisoner of war during the First World War. Then came Elizabeth (1900-2002) and her beloved brother David (1902–1961).

On succeeding his father to the Earldom in 1904, Lord Glamis inherited large estates in Scotland and England, including Glamis Castle, St Paul's Walden Bury, and Woolmer's Park, near Hertford. Lady Strathmore died in 1938. The earl, eighty-nine, in 1944.

Born at The Bury, 'home' (Glamis Castle was where the family spent their holidays) the youngest born, David, lived there for most of his life. He married Rachel Spender Clay in 1929 whose mother was the Hon. Pauline Astor, daughter of William Waldorf [Astor] 1st Viscount Astor. They had two children. Davina, born in 1930 and Simon in 1932.

During the war David worked for the SOE (Special Operations Executive) Churchill's Secret Army. In 1941 he was at the British embassy in Washington and New York. He knew President Roosevelt. As Sir David Bowes Lyon KCVO he was Lord Lieutenant of Hertfordshire (title dates from Henry VIII) the monarch's personal representative in the County from 1952 until his death. President of the Royal Horticultural Society Sir David organised a World Orchid Conference. He died in 1961 of a heart attack while staying with his sister, The Queen Mother, in Birkhall on the Balmoral estate. She found him dead in bed. The funeral service was held in the local church at Ballater. The royal family then accompanied his coffin on the night train to London and on to Hitchin and St Paul's Walden where he was buried.

The Queen Mother often stayed with his widow Rachel to whom she was close. Lady Rachel did good work for the local community. In the 1960s, she and Mrs Doris Devenish of Stevenage successfully raised funds to build the Leonard Cheshire Home in Hitchin. This was at a time when the disabled were rarely seen in public, hidden from mainstream society, not talked about. Baron Cheshire VC, the youngest Group Captain in the RAF, laid the foundation stone. Lady Rachel died in 1996. At the time of writing (2010) Mrs Devenish is ninety-two and still lives in Stevenage. She describes herself as a healthy wreck with all her marbles.

Davina Bowes Lyon married John Dalrymple, Earl of Stair. Her brother Simon, Lord Lieutenant of Hertfordshire 1986-2007, lives at The Bury with his wife, Lady Caroline,

a Professor of computer studies. They married in 1966 and have four children. Rosemary (b. 1968), Fergus (b. 1970), David (b. 1973), and Andrew (b. 1979). The Queen Mother visited her nephew throughout her life. HM Queen Elizabeth II still visits her cousin.

The Honourable Elizabeth Angela Marguerite Bowes Lyon, ninth child and youngest daughter of Claude Bowes Lyon, later 14th Earl of Strathmore, spent much of her childhood at The Bury with her brothers and sisters.

The children nicknamed the garden statue of a gladiator The Running Footman.

Lady Elizabeth, her romantic red cloak flying behind, raced Bobs her Shetland pony around the grounds.

The children had French, German and English governesses. Elizabeth and David's English governess from 1904 to 1913 was Marion Wilkie of 'Lopside', 58 Dacre Road, Hitchin who cycled to The Bury every day until her health gave out. After that Elizabeth and David were taken to her for lessons in a pony and trap. The children also had dancing lessons in the ballroom of the Sun Hotel, Hitchin. Miss Wilkie, an experienced teacher, died in 1955 age eighty-one. From time to time requests are made to North Herts District Council for a Blue Plaque to be put on her house in Dacre Road.

The family nanny, Clara Knight, daughter of a local farmer was one of twelve children. In 1926 in the Strathmore town house in Bruton Street, London, Clara would one day also be nanny to Lady Elizabeth's first child the present HM Queen Elizabeth II. Nanny Knight was with the royal family for forty-five years. When she died in 1946 David flew from America to attend her funeral.

St Pauls Waldenbury © Jeff Shields

The Running Footman © Jeff Shields

The Earl and his family spent nine months at The Bury, three at Glamis Castle. Although it had fourteen bedrooms The Bury had only two bathrooms. There is an amusing anecdote that one year when the earl left with his family to Scotland he asked a local builder to install a third bath as economically as possible while he was away. He came back to find a brand new bath side by side with the old one.

The Bury has been in the same family since 1725 and is still owned by the Bowes Lyon family. The red brick Queen Anne house has hardly changed since it was built. Neither have the forty acres of gardens which are open to the public every year under National Gardens Scheme. To walk through the grounds is to understand why the Queen Mother loved it so. It's a mini paradise.

The Elizabeth Bowes Lyon connection with St Pauls Walden lasted a century. Her own children the Princesses Elizabeth and Margaret stayed in her old nursery and rode her old rocking horse. There is a photo of the princesses taken there. As duke and duchess of Kent, when the couple stayed at The Bury they took their daughters shopping in the nearby old market town of Hitchin. Favourite haunts included William Upchurch Antiques in Bancroft and Paternoster & Hales stationery shop in Sun Street.

St Paul's Walden Bury is where The Queen Mother played her first game of tennis and smoked her first cigarette – a Woodbine. It was at The Bury too she finally accepted a marriage proposal from Prince Albert, Duke of York, second son of King George V.

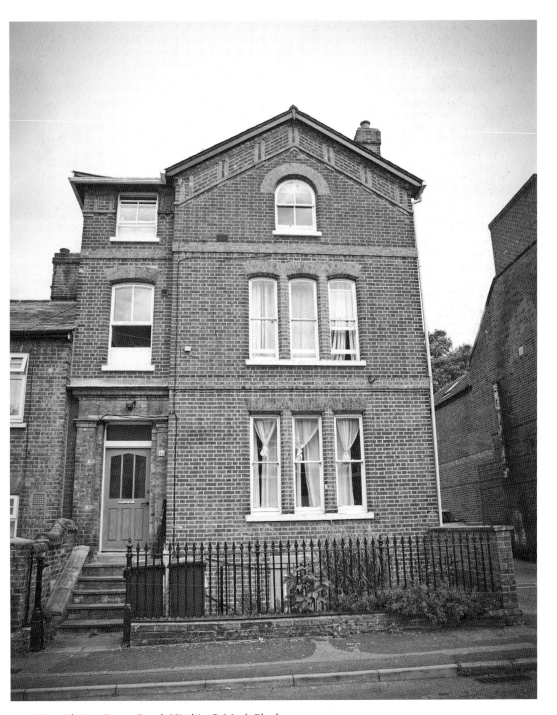

'Lopside' 58, Dacre Road, Hitchin © Mark Playle

Five years older than Elizabeth 'Bertie' was a shy, unconfident, highly strung young man with a nervous stammer. No wonder. His father said: "My father was scared of his father, I was scared of my father and I'm damned well going to see that they're scared of me." He insisted on deference. Albert, left-handed, was forced to write with his right hand and wear splints on his legs because he had knock knees. He met the extrovert Elizabeth at a ball in 1920 and was instantly attracted. Many men were. She loved to party and was an excellent dancer.

'Bertie's first visit to The Bury was in 1921. Compared with his family home it was modest, unpretentious and delightfully un-grand. He felt at home there. The Bowes Lyon family was a welcome relief from the cold atmosphere and frosty countenances in palaces where he could do nothing right in the eyes of his critical, fault finding father. Elizabeth's laid back family was a breath of fresh air. He wanted to be part of it and who could blame him. His parents dressed for dinner every evening even if they were alone. The Queen always wore her tiara.

One weekend when 'Bertie' begged to spend the weekend at The Bury, Elizabeth said it was not possible as, apart from Cook, there was no staff around. She was alone there with her mother who was unwell. Ignoring her protestations, he turned up anyway. Bertie courted Elizabeth assiduously for three years. She said that although she loved all her friends she didn't love any enough to marry him.

'Bertie' first asked her to marry him in 1921 and again in 1922 but Elizabeth turned him down 'terrified of facing so public a life'. In January 1923 he visited the Strathmore's again at The Bury. Elizabeth's brothers told her to say yes or let him marry someone else, it was not fair to keep him dangling. Finally, on Sunday 14 January she accepted his proposal. A delighted King set the date for the wedding as 26 April.

On marriage at Westminster Abbey Elizabeth became the Duchess of York, the first commoner to marry into the British royal family since Anne Hyde married James, another duke of York in 1660. James was also born second in line to the throne. He too ended up as King by default (his brother had no legitimate heirs).

In 1926 the Duke and Duchess of York spent the weekend at The Bury before their tour of Australia and New Zealand. In 1931 she modelled the garden of her new home Royal Lodge Windsor on those of The Bury down to commissioning a copy of Charity, one of its garden statues.

Neither Elizabeth or 'Bertie' could have known it at the time but soon, in a twist of fate, Elizabeth would indeed face 'so public a life'. They would be crowned King and Queen of Great Britain and Northern Ireland. No-one ever dreamed that one day Edward VIII would abdicate. The last monarch to do so (forced by his cousin Henry of Bolingbroke) was Richard II. On 11 December, 1936, on the abdication of 'David' as Edward VIII and the accession of 'Bertie' as George VI, Elizabeth became queen consort. They were horrified. She never forgave Edward, afterward Duke of Windsor, for having abandoned the throne. In 1937 she and the King were appalled when Edward and his wife paid a formal visit to Hitler. The more the public learned about the exiled couple the more it realised it had had a narrow escape and the more it respected George and Elizabeth. His hard work and conscientious devotion to his country made him a hero during the carnage of the war.

In 1938 the King and Queen spent a weekend at The Bury with her beloved brother David and his equally loved wife Rachel.

After 'Bertie's' death of lung cancer in 1952 and the accession of her daughter Elizabeth II, she became known officially as HM Queen Elizabeth, the Queen Mother.

In July 1969 The Queen Mother staying at The Bury decided to pay an impromptu visit to the nearby picturesque village of Ashwell. To commemorate it, the poet David Holbrook who lived there wrote *Nearly Caught in Bed by the Queen Mum*;

> Oh, help! Here comes the Clerk to the Parish Council:
> I dive into my clothes – 'just changing after gardening!'
> Surprise! A royal Personage visiting the village!
> Supposing they had brought Her Majesty round here?
> Ah, well – render unto Caesar the things that are Caesar's.
> Holding one breast and the curved small of your back
> I was a soul in bliss: worshipping the majesty of your body
> I would have had to say: here, Madam, like the angels,
> I am lost in perpetual contemplation of an infinite glory
> If only for an hour ...

The Queen Mother accepted invitations from all over the county saying a visit to Hertfordshire was very much a return home. In 1983 she opened The Queen Mother Theatre in Hitchin, the only theatre in Britain named in her honour.

After her death when the mystery over her place of birth was rekindled in the newspapers, there were probably a few wry smiles at The Bury when the Bowes Lyon family found its private affairs under public scrutiny. After the monumental scandal of her ancestor Mary Eleanor Bowes Lyon, gossip is surely taken in its stride.

The first wife of George Bowes – Coat of Arms is three bows – a multi-millionaire owner of coal mines, died young. Devastated, it took George twenty years to consider remarrying. When he did, he chose Mary Gilbert who lived at The Bury, St Paul's Walden with her parents. A kind young woman, she never turned anyone away from the door empty handed and always gave them food, clothes and sometimes shelter.

Her father, Edward Gilbert, paid for the chancel at All Saints Church. He was responsible for the beautiful garden at St Paul's Waldenbury spending much of his time energy and money on it including the lawn in front of the house. The new fashion was simplicity with meandering walks through the woods. Formal, geometric landscaping had gone out of fashion along with neatly clipped hedges and trees sculpted into cones, pyramids and spheres. He added a summer house and a statue now known as The Running Footman, a copy of a classical statue of a gladiator.

Edward Gilbert died in 1762. He was in his eighties. When her mother died too, Mary inherited The Bury and lived there on and off all her life. She too loved gardening and added shrubberies and flower beds.

George Bowes so admired the gardens at The Bury that when he and Mary Gilbert married and went to live near Durham he had the gardens at Gibside, her magnificent new home, redesigned along the same lines. A cultured man, he played the harpsichord,

Tirsi's Urn St Pauls Waldenbury © Jeff Shields

collected fine furniture and paintings including Rubens and had a huge library with many books on architecture.

He delighted in his daughter Mary Eleanor who showed an early talent for botany. She had her own garden and splendid Green House. As an adult she would send William Paterson to the Cape to collect plants, some of which are said to be still thriving in gardens of The Bury. Mary Eleanor Bowes was very well educated. In 1769 she published a play *The Siege of Jerusalem*.

Her father died when she was eleven and left her his vast fortune (around £50m today) accrued through operating a price fixing cartel of coal mine owners in the north of England (his nickname, locally, was the Tsar). Mary's mother returned to the south and bought 4 Grosvenor Square, London. She and Mary stayed at The Bury as and when the fancy took them. All her life Mary Eleanor loved dogs and owned many. One, Tirsi, is buried under a memorial urn in the grounds of The Bury. It's still there all these years later.

Mary Eleanor Bowes, the wealthiest heiress in Britain, possibly Europe, was snaffled up by John Lyon 9th Earl of Strathmore on her eighteenth birthday. He had the title, she had the money. With no male heirs to carry on his name, George Bowes will stipulated that any husband of his daughter must take his name. The earl changed his name to John Bowes, Mary styled herself Bowes Lyon. The wedding reception and honeymoon were at The Bury. When the honeymoon was over, Mary was reluctant to leave pleading illness.

Mary Eleanor's husband spent her fortune restoring Glamis Castle, his country seat. Apart from being the breeder of his five children John Lyon ignored Mary. Their first son John became the 10th Earl. Their second, George, was born at St Paul's Walden. The third, Thomas, the 11th earl, married Mary Carpenter of Redbourn in Hertfordshire. Her grandfather was a plumber. Their son, Thomas became the 12th earl, another son Claude became the 13th earl. His son Claude, the Queen Mother's father, became the 14th earl.

By the time John Lyon died in 1776 on his way to Portugal to find a cure for the TB he was suffering from, Mary was pregnant by her lover, George Gray (a friend of James Boswell).

When her husband died, Mary took back control of her fortune. And her body. She induced an abortion by drinking 'a black inky kind of medicine' and went on to have two more. Pregnant by Gray a fourth time, she resigned herself to marrying him and they became formally engaged. However, before she could marry Gray, Mary Eleanor, for all her intelligence, was tricked into marrying an Anglo-Irish fortune hunter 'Captain' Andrew Stoney (nicknamed Stoney Broke).

Her foolishness cannot be entirely condemned. Evil has its own attraction. He had already managed to kill off his first wife, the heiress Hannah Newton, to get his hands on her fortune. He knew exactly what he was doing. Ruthless, calculating, charming, irresistible, controlling, magnetic, psychopaths are all these things. They fool everyone.

Stoney did his research. He knew Mary was pregnant and about to marry Gray. He knew she was a romantic who liked having her fortune told. He knew that Gray,

like her husband, was dull and that she craved romance. He knew she loved flirting and had a high sex drive. Very personable, enjoying his dead wife's money it was not difficult for him to wangle an introduction to Mary and he became a regular visitor to her house in London.

He also staked out The Bury. When Mary went to stay with her mother for Christmas 1776 to discuss arrangements for her imminent marriage to Gray she received a romantic letter from Stoney. In it he said that on the following Thursday, at one o'clock, he would meet her in the garden. 'There is a leaden statue- or there was formerly – and near the spot (for it lives in my remembrance) – I shall wait'. Was this The Running Footman? Mary probably sneaked him into the house under her mother's nose. She now had two lovers.

Christmas and New Year over, on 13 January 1777 Mary Eleanor was told that Stoney was mortally wounded after fighting a duel to defend her honour. Henry Bate, editor of the *Morning Post,* had published scurrilous articles about her. In fact Stoney had himself written the articles criticising the countess and faked the duel with Bate to appeal to Mary's romantic nature.

George Gray called on Stoney to thank him for defending his fiancée's honour. A flattered Mary asked Stoney for the sword he used and hung it above her bed. Stoney told Mary his dying wish was to marry her.

An alarmed George Gray visited Mrs Gilbert at The Bury. Mary not knowing her own mind consulted a fortune teller who told her to choose Gray. Instead, Mary Eleanor, for some reason, chose Stoney.

Her descendant Lady Elizabeth Bowes Lyon as a child had her hand read by a palmist at a local fête in St. Paul's Walden. She fared much better. 'She says I'm going to be a queen when I grow up! Isn't it silly?'

On the 17 January Stoney was carried on a stretcher down the aisle of St James's Church, Piccadilly where he married Mary Eleanor Bowes Lyon. In compliance with her father's will, Stoney changed his name to Bowes. Mrs Bowes, waiting for her daughter's wedding to Gray, knew nothing about it. Mary sent a friend to The Bury tell to her.

Mary had to marry someone quickly. A few months after the wedding she gave birth to Gray's daughter. Stoney did not register the baby's birth until November. No forty-two day rule in those days. Mrs Bowes died in 1781 it was said broken hearted by the irresponsible actions of her feckless daughter. Mary and Stoney's legitimate child, William Bowes, was born in 1782 the year a Hertfordshire man, George Carpenter, sixty, married a plumber's daughter, eighteen. Their only child married Mary Eleanor's youngest son, the 11th earl of Strathmore.

Stoney, discovering that Mary had secretly and cannily made a pre-nuptial agreement safeguarding the profits of her estate, forced her to sign a revocation handing control to him. Squandering her wealth, he subjected Mary to eight years of physical and mental abuse. Stoney raped the maids, took prostitutes into the home and fathered numerous illegitimate children. He kept her prisoner in her own house before abducting her and her daughter from her first marriage (who he tried to seduce) by taking them to Paris. In 1784 brought back to England under a court order Mary and her daughter took refuge at The Bury.

Finally, in 1785, Mary, with the help of loyal maid, her dearly loved companion Mary Morgan managed to escape and filed for divorce through the ecclesiastical courts. After losing the first round in court, a determined Stoney with a gang of thugs intercepted Mary's carriage, gagged and abducted her. He took her north, beat her and carried her around the countryside on horseback during the coldest winter of the century. The country was alerted and Stoney was arrested. He was found guilty of abducting Mary and sentenced to three years in prison. He lost the divorce case and his battle to hang on to her fortune.

The sensational trials were the talk of eighteenth century London where there was an insatiable appetite for gossip (there were fifty-three newspapers and magazines). Down but not out Stoney bought shares in a newspaper and in it published Mary's 'Confessions' he forced her to write early on in their marriage so that he would always have a blackmailing tool. An initially sympathetic public began to turn against Mary when she embarked on a love affair with her lawyer's brother.

In 1793 Mary had her portrait painted showing The Bury in the background, where she arranged meetings for painters of botanical subjects. Her books on botany are still in the house. Mary retired to Hampshire with two of her daughters, her loyal maid Mary Morgan and her beloved dogs. When Mary Bowes Lyon, Lady Strathmore, died in 1800 she left The Bury to her second son George Bowes Lyon. She is buried in Poets' Corner Westminster Abbey. Stoney died in 1810. In 1841 William Makepeace Thackeray wrote *The Luck of Barry Lyndon* based on Mary's astonishing life. Stanley Kubrick, equally fascinated with her amazing story, made a film of the book.

The strangest thing about the stranger than fiction horror story of Mary Eleanor Bowes Lyon is that Stoney had a tailor made blue print. His meticulously planned campaign to get his hands on her fortune was surely modelled on the successful abduction of another Hertfordshire heiress by another Irish bounty hunter ten years previously.

Lady Cathcart was also abducted – from Tewin Water near Welwyn. Her husband was also an Irish psychopath. He also kept her prisoner. He too fought a duel. Maria Edgeworth, like Thackeray, fascinated with her story also wrote a novel about it. *Castle Rackrent* was massive bestseller. It can be read free online.

Mary Eleanor Bowes was a rich coal miner's daughter. Lizzie Malyn was a poor brewer's daughter. Both craved adventure. Both wanted a more exciting life. Both got it. Lizzie Malyn married Squire Fleet a brewery owner from Battersea for his money. His country home was Tewin Water. Her second husband, Captain Sabine of Queen Hoo Hall Tewin was the love of her life. Her third in 1739 was Charles, Lord Cathcart, who she married for a title. In 1745 her fourth husband was Colonel Hugh McGuire who married her for money and incarcerated her for twenty years on his estate in Ireland. Unlike Andrew Stoney's fake duel, McGuire fought a real one and died of his injuries in 1764. Lady Cathcart was sixty-five.

Maria Edgeworth, who found fame through *Castle Rackrent* was brought up in Northchurch near Berkhamsted in Edgeworth House which is still there. Her father was an Irish aristocrat whose country seat was in Edgeworthtown in Ireland where Lady Cathcart was often talked about at dinner parties. It was common knowledge in Ireland that McGuire went looking for a rich wife and found Lady Cathcart.

One morning soon after the wedding out together in the carriage McGuire abducted her. By the time they reached Chester her relatives had sent a lawyer who confronted him in an inn. Because the lawyer had never seen Lady Cathcart and didn't know what she looked like, McGuire paid a servant to impersonate her and convince him she was going to Ireland of her own free will to live on McGuire's estate. Embarrassed, he begged her pardon and made his way back to Tewin. To ensure they would be in Ireland before the ruse was rumbled McGuire sent muggers after him who beat him up and robbed him

It was a frequent dinner guest of the Edgeworth's, Sir Peter Nugent, who rescued Lady Cathcart from her filthy room when McGuire died. She was scared stiff, in rags, wearing a red wig. When told of McGuire's death, she didn't believe it thinking it was another of his tricks. Nugent helped her return to Tewin Water, her magnificent mansion.

Castle Rackrent was in fact 'Donore' where Lady Cathcart was incarcerated. It was owned by Nugent. He said that when her ladyship was locked up and McGuire entertained it was his custom at dinner to send his compliments, informing her that the company had the honour to drink her ladyship's health begging to know whether there was anything she would like sent up. The answer was always, 'Lady Cathcart's compliments, she has everything she wants'.

You do wonder. Did Mary Eleanor Bowes Lyon never hear tell of Lady Cathcart?

ENDS